D0484883

How to Grow as a Photographer

How to Grow as a Photographer

a Photographer

Reinventing Your Career

TONY LUNA

**ALLWORTH
PRESS**
NEW YORK

© 2006 Tony Luna

All rights reserved. Copyright under Berne Copyright Convention, Universal Copyright Convention, and Pan-American Copyright Convention. No part of this book may be reproduced, stored in a retrieval system, or transmitted in any form, or by any means, electronic, mechanical, photocopying, recording, or otherwise, without prior permission of the publisher.

10 09 08 07 06 6 5 4 3 2

Published by Allworth Press
An imprint of Allworth Communications, Inc.
10 East 23rd Street, New York, NY 10010

Cover design by Derek Bacchus
Interior design by Mary Belibasakis
Page composition/typography by SR Desktop Services, Ridge, NY
Cover photo by Jeff Babitz

ISBN: 1-58115-446-1

Library of Congress Cataloging-in-Publication Data
 Luna, Tony.
 How to grow as a photographer : reinventing your career / Tony Luna.
 p. cm.
 Includes index.
 1. Photography—Vocational guidance. 2. Photographers. I. Title.

 TR154.L86 2006
 770.23—dc22

 2006010843

Printed in Canada

Dedication

To My Wonderful Paula,
you are my support and my inspiration, and you will always be
My Princess Morning-Noon-and-Night.

Contents

Acknowledgments

If it is true that it takes a village to raise a child, then it takes a community to write a book. A community of family, friends, teachers, co-workers, industry professionals, and acquaintances who have all, over time, contributed to the development of this work. I would venture to say that if you were to do a word search of the most commonly used words in this book, you would probably find the highest frequency with the following words: *inspiration*, *encouragement*, *support*, *opportunity*, and a *love* for what you do. All of those words have an elevated sense of "thank you" associated with them because they do not exist without the loyal people who have supplied them.

Thank you especially to my family: to my wife Paula, who cleared the way for me to sit down and write this book, which has been on my mind for so many years; to my daughter Mendy, who continues to be "The Little Lady Who Changed My Life"; and to my granddaughter Delaney, who patiently waited for her Grand Papa to finish writing a sentence or a chapter, so we could have our special time together. Of course, thank you to my incredible parents Mama Dee and Papa Julio, who always believed in me and encouraged me to use my talents in service to others; and to my sister Dollie, who carries on in their name.

A large helping of thanks has to be given to Dan Wolfe and the staff of Wolfe and Company Films for putting up with me as I continually asked them for feedback. And to the incredible faculty and staff of the Art Center College of Design,

especially those in the Photography and Imaging Department, who expand my world daily and have given so much to the world of photography for so many years. I also want to express my special thanks to my first "Reinventing Your Career in the Creative Arts" class through the Art Center at Night Public Program, who allowed me to pick their brains each night of class in an attempt to validate my findings. The reflections from all these sources and more have led me to believe that insight is foresight tempered by hindsight, and that we can all learn from each other when we work in an atmosphere of trust.

I remember talking to Tad Crawford, founder and publisher of Allworth Press, for several years about this book before he asked me when I was going to write it. His simple question set me off on an incredible journey, one that might still be a dream if he hadn't opened the door. He and the staff of Allworth Press, especially senior editor Nicole Potter-Talling and associate editor Monica Lugo, have been extremely supportive and have given me the opportunity I needed to go beyond talking and to set milestones for myself so this work could become a reality. Beyond that, the writing of this book has allowed me to meet and talk to some of the most influential photographers of our era, people whom I might never have met otherwise. I can never give enough thanks to the extremely talented people who agreed to be interviewed and who lent their candor, insight, and inspiration so that we might learn a little about ourselves.

Obviously there are many others I could mention, but time and space do not allow for it. Maybe they will be the inspiration for another work because, as you will see in this book, one creative act requires another, and another. It is my wish that this work will help you to take on that project you have always wanted to do, and that you will refer to it from time to time for *inspiration, encouragement, support, opportunity*, and a *love* for what you do as members of the creative continuum.

Introduction:
Two Friends and a Dream

*If a day goes by without my doing something related
to photography, it's as though I've neglected something essential
to my existence, as though I had forgotten to wake up.*
—Richard Avedon

Are you fed up with cheap clients? Have you had it with shortsighted competition? Does the erosion of fees in our industry make you sick? Does it bother you that far less talented people get the work you think you should be doing? Does it concern you that what used to be called mistakes are passed off as "cutting edge"? Has a personal tragedy in your life caused you to reevaluate whether or not you are on the right career path? Have you awakened with the feeling that somehow the world is passing you by? Are corporate politics and other people's agendas too much for you to handle? Do "downsizing," "rightsizing," outsourcing, and layoffs have you turned upside down? Are you bored executing the same old work, but do it because it is "safe"? Do you find yourself continuously lamenting about the "good old days"?

If you answered "yes" to any of these questions, then you have come to the right place, and now is the right time to do something positive about your future!

Things are not the same anymore. It might be unsettling and hard to admit, but you may not have the same enthusiasm for your work that you used to. You look back at the body of work you have accomplished and you do not get the same joy out of it that you once did. Self-doubt creeps in and begins to erode your willingness to work. You look around and think of the early days, when you could not wait to pick up your camera and shoot anything because everything was captivating. If only you had known that things would turn out this way. If only there was some way you could have anticipated it all and taken some strategic measures before things started to fall apart.

I know exactly what you are feeling. I have had those feelings myself a number of times over the past thirty-plus years that I have been in the creative arts, specifically in the photography and film industries. When I take a critical look back at those times, it seems that certain events were almost cyclical. The economy takes a dive, or you lose a big client, or styles change, or maybe you just get bored with executing the same type of work day in and day out. Whatever the reason, the effect is the same: you know you have to make a change, but you are not sure where to begin.

In my latest career incarnation as a creative consultant, I have met with extremely talented creative entrepreneurs who contact me while they are hyperventilating about how they have *lost it* and don't know what to do. Or I receive calls from people who are floundering and want to take their careers to the next level, but are confused about where and how to begin this next chapter in the story of their career. And then there are those who have an idea in mind of where they would like to take their talents, but they are afraid of taking the risks their new directions will require.

In order to find the underlying dynamics involved in career reinvention, I began with my own introspection, and then went on to conduct research into the reasons why successful artist-entrepreneurs felt compelled to reinvent their careers, and how they went about doing so. Just mentioning the word "reinvention" elicited some interesting responses from the people. Some did not think of the changes they had taken were reinventions, but were more like evolutionary stages. Some preferred the words "rejuvenation," "rediscovery," or "recreation."

Let me give you a case in point. The following is from a conversation I had with Ken Merfeld, who is doing some of the most interesting and inspired work I have seen recently by bringing together 1860s collodion wet-plate photography and today's digital technology. Here is what Ken had to say:

I think I've not been so much of a reinvention as a constant evolution as an artist. A constant reinterpretation of oneself and one's work and decisions as to how wide the path of the artistic journey can be, or how many directions it may branch out into. My energy and my lighting seems to be good for people, and I like people, I like shooting people, so I started with fashion, swimwear, and lingerie accounts. I also like solving more complex creative, conceptual lighting scenarios. So I then segued into shooting advertising and corporate, movie posters, and lifestyle assignments.

But all the while I was shooting commercially, from day one, I've always been working on a portrait project from my heart. It's a personal portrait project that encompasses interesting people—people I find interesting or intriguing. Most of them are a little unusual. For example, my fashion work led to my shooting portraits of women, but not as models, as women—portraits also of women with their children and portraits of women wearing masks, and nudes. This work started to flow back into my commercial work, which led to editorial assignments and lifestyle assignments and shooting kids. I also love animals. So, one of the side chapters of my personal portrait project was shooting people and their pets—the magic bond between man and animal. This body of work led to the animals and pet world commercially. I've shot for every pet food company there is as well as every breed of dog that probably walks this earth.

I've also been long fascinated by "people on the edge." It's a quality that I relate to and am comfortable around. I've been fortunate enough to get below the surface. So I have photographed bikers, tattooed people, gang members, and little people. I've shot lady wrestlers, transvestites, identical twins. I've shot 167 sets of identical twins; it's like looking at part of *The Twilight Zone* in the world of portrait photography. I've spent years working with, studying, listening to, and learning all of these people, all the while refining and defining what it is that I do or bring to my world of portraiture.

So this ongoing personal portrait project has kept flowing back into my commercial work, because I feel that I can shoot anybody. I feel I can get into any individual and bring out an element of truth. I've shot swing dancers dancing on the water, babies in diapers, men and women of world vision. All because I've never stopped the side project from my heart and it's for absolutely no one else other than myself. It's been for my own personal satisfaction. It has been my balance device for me to exist in this crazy exchange of commerce and art revolving around image-making. It has become my place to go. I call it my "safe place," so to speak, for no one other than myself, and it has really kept my passion and my energy alive.

So I have been a constant evolution, a constant work in progress, somewhat like a Slinky, a children's toy with an interwoven set of somewhat related subject matter moving a direction that always seems to have a life force of its own. My heart has always fueled my personal work. My personal passion has managed to bridge or flow back into my commercial work, so I've managed to exist in this shrinking, ever so demanding, rapidly changing world of image-making. My latest evolution or reincarnation is my reinterpretation of my personal portrait project via the 1860s process of wet-plate collodion. It is the ultimate hands-on personal truthful process, and has an uncanny interpretive, mesmerizing quality to it that is totally fascinating in its uniqueness and the photographic gift that it provides. This has become my latest chapter in how I have evolved and hopefully will start to also spill back into my commercial work.

Whatever we call the phenomenon—reinvention, reincarnation, reinterpretation, evolution—when we take the time to delve into its intricate workings, we find it leads us to some very interesting and personally enhancing conclusions. These conclusions are more universal than I originally thought. The circumstances may initially seem unique, but the processes of 1) realizing something has to be changed, 2) coming up with a plan for change, 3) executing that plan, and 4) embracing change and the new opportunities the plan provides were consistent. On top of that, this investigation has also revealed that if we want to stay ahead of the game, there are a number of proactive steps we can take that empower us and give us the momentum to move toward the actualization of our creative capabilities. Sure, you can sit around moping about how great things used to be, and how the world has changed, but after a short while, you realize that this is just a waste of time—valuable time that you could use to do something constructive about your future. Go ahead, allow yourself five minutes of self-pity, then pick yourself up and ask yourself the question, "I am sure other photographers have gone through this—what have they done to turn their careers around?"

An Anecdotal Look Back

Back in 1972 (during the Jurassic Period), I had been working as an artist representative/studio manager with my business partner, photographer Dan Wolfe, for approximately one year. I had left an agonizingly boring bureaucratic job (sounds redundant even as I write it) with the Los Angeles County Probation Department to work in the exciting world of photography with Dan, an Army buddy who had recently graduated in photography from the Art Center College of Design. I didn't just *like* working in the commercial creative arts; I loved it. Everything about it absolutely fascinated me. It was exciting, educational, it involved meeting

interesting people, there was travel to places I had never seen; it had an element of adventure, and was even, I don't know, a little glamorous.

However, there was one drawback. My first year in this visual-arts industry I made a total of $1,875, and that, even by 1971 standards, was not enough on which to live. I was at a crossroads: stay in photography and lead an entertaining, fulfilling, and quite possibly poor life, or go back to my civil-service job and lead an utterly predictable, secure life (we will address this subject later) that would, in short, be Thoreau's life of "quiet desperation." In a moment of inspiration I decided to look up the phone numbers of other artist representatives who worked in the field of photography in Los Angeles. To my surprise I could only find four listed in an industry sourcebook. To my greater surprise, the first three were rude, obnoxious individuals who told me they weren't about to give away any trade secrets, and that they had gotten to their level by making it up as they went along and I would have to do the same! They all had this distinctive way of abruptly hanging up when they were done talking to me. But, thank God, I made a fourth call.

The fourth call was to Pete Van Law, who represented well-known commercial photographer Cal Bernstein, for whom Dan had assisted the previous year. Pete listened to my story and then he said that he knew of Dan's work and Dan would make it because he was a good shooter and, most importantly, he wanted to succeed. He said I should go by my instincts and persevere, and then he said the most important thing he could have said to me. He said, "Stay in touch."

Stay in touch. A simple phrase but it implied I had a future. It indicated that I could make this thing work. It made me feel as though I had a colleague. It was then that I vowed that if I ever could make a go of this I would be as forthcoming as Pete had been to me. The industry, I figured, would go nowhere if we were to think and operate in an isolated, insulated manner. In a way those three words are the reason why I consult, why I teach, why I produce, and why I am writing this book thirty-plus years later.

The Magic of Photography

Over the years, I have had the honor of taking some of my professional experiences and turning them into the subject matter of classes, seminars, workshops, and lectures. I have met with talented people who yearn for the solutions to the business concerns that keep them from doing what they love most: capturing and creating images. The talents of these people have been diverse. Their backgrounds, cultures, ages, and a multitude of other factors have been even more diverse. But one thing common to all was the fact that at some time the magic of the camera took hold of their lives. They were able to take a little box filled with a capturing medium with them wherever they went, and they could store their visions, and later could share their work with others. What a marvelous way of life!

Before he became a professional photographer, Jay Maisel studied painting at Cooper Union School of Art and Engineering. The school used one of his photographs for a double-page spread in a college publication. In his words, "That really got me. I think seeing it in print was so incredible. To see a double-page bleed picture of mine, it infected me. The day I got my degree in painting I decided I don't want to do this. I want to be a photographer." Right there on the spot he decided photography would become his life's work. Since that fateful moment he has seldom been without his camera around his neck. Everywhere he goes he is constantly looking for one more beautiful shot, one more divinely inspired reflection, one more face that will define our existence, and punctuate the world we live in.

It's the mystery that takes hold of you first. You learn a few basic things about focus, composition, lighting, perspective—and then the technical things go from something mechanical to an extension of yourself. That mystery roots itself as passion and, pretty soon, all you can think about is the next shot. You walk down a street and the telephone poles line up for you, or a ray of sunlight bounces off a window and into your imagination, or a shadow belies an illusion and you gasp at the wonder of it all. All at once you are hooked. You dream about your next composition, you sketch out ideas on napkins, you learn a new way of communicating without saying a word. If necessity is the mother of invention, then passion is the lover that invades your most mundane thoughts and elevates everything you once saw as ordinary to a new level of spectacle.

Creativity and Commerce

Soon you find you can't keep your images to yourself. You have to share them. Others look at them and their compliments encourage you to do more. You give them away at first to admirers, and then the thought strikes you that you could actually get paid for this kind of work. It isn't long before you realize the commercial potential of your art, and you entertain the idea of making a living with your newfound form of expression.

Then cold reality hits you: there is more to commercial photography than creating pretty pictures. There are rules, forms, policies, bureaucracies, permits, releases, terms and conditions, contracts, purchase orders, intellectual properties, and on and on, which have been put in place by the photographers before you and are meant to protect you but you swear will kill the passion in you.

At some point, you accept that if you are to continue down this road and succeed, you will have to learn about the business side of creative commerce. The lectures, classes, and workshops you attend all indicate that most successful photographers spend more time every day dealing with business issues than actually taking pictures.

But because everyone is different, you have to find your own way to balance the *commercial* side and the *art* side or commercial art. You deal with business issues

when they arise, and you either ignore or are not aware of the rest. It would be great if you had a way of knowing what pitfalls lay ahead, but you figure you will take care of them when they present themselves. It's the oldest diversion in the book: if I don't think about a problem, it won't be a problem. If only it were that simple.

The Three Elements of Success

After years of working with creative entrepreneurs, I have come to recognize what I call the "Three Elements of Success." They may sound simplistic at first, but they may ring true once you have given them some serious thought. Generally speaking, there is nothing harder to arrive at, and yet nothing simpler once it stands boldly before you, than the truth. Let's consider their subtle impact. Every successful person I have interviewed—and *successful* is as widely defined as the people I have talked to—has alluded to how they had to deal with three distinct topics as their art and their perspective evolved.

The first element is Passion. As I mentioned earlier, you have to get hooked first. Everything on our green earth starts with passion. Passion gets it all rolling, and passion stokes the fires that keep you growing. This is the stage that Joseph Campbell describes as a call to "follow your bliss." Please understand, this is not the same as "Do your own thing," which is just egocentric self-gratification and has no greater, intrinsic social value. "Follow your bliss" is an imperative to find your unique talent and embrace its power. By following your bliss, you are fulfilling an important role in a continuum of creative people, you are a link to the creative past and the future, and you are allowing that collective consciousness to survive and to flourish as it is fed by your individual contributions.

But the problem with passion alone is that you can't continuously stay in that state without being consumed by its demands. Creative passion is a high-maintenance paramour. You have to come down to earth from time to time and see if you are still connected to manifest reality. You need a plan to put your passion in context and relates to the conventions that will allow your work to be experienced and appreciated. This Plan is the second element, in other words "Use your head." At this stage you have to be street smart and know how the world works. Planning allows you to find the correct path for your passion so you can channel your multiple energies instead of imploding from the overwhelming onslaught of ideas you are creating. Mozart was a genius, arguably the most prolific and brilliant composer of all time. He created symphonies, concertos, serenades, country dances, vocal music, operas, and other musical masterpieces. He also died at the age of thirty-five, poor and without the fame he thought he deserved.

Now, once that plan is put in place you have to figure out a way to keep your Passion and your Plan flourishing. You need a way, a system to help you Persevere. This final element I like to call the "Work your rear-end off" stage. You have to make a commitment, a covenant with your work in which you will not let it suffer: you will

not let it die on the vine. Perseverance is tough, especially when you feel you are losing your grip on your work, or clients are no longer calling, or you realize you need to grow but everyday circumstances are creating barriers to your growth. There are times when you have to redefine your goals in order to keep going, but keep going you must. There is a reason there are endless clichés about perseverance, "Hang in there," "When the going gets tough…" and "No pain, no gain." They were invented to remind us that there is honor in hard work, which makes success taste even sweeter.

Struggling with the Stages

Whenever someone contacts me for creative consultation, I first listen closely to his or her story. Listening is the key. Within the first few minutes it becomes clear which of the issues—Passion, Plan, or Perseverance (or some combination of the three)—the person is wrestling with. Maybe she lost sight of the wonder of her passion; or she is confused about how to proceed with her art; or she is just tired and needs a boost so she can carry on. We all go through these periods. We need a little help from our friends sometimes. It is perfectly normal—actually necessary—to stand up and take a look around to see if you are doing the right thing, to see if you are getting the most out of life, and giving the most of your talent. It's all about the Creative Process, a step-by-step progression of original thoughts. Through vision, talent, and hard work, a work of art is made manifest.

Once you tap into the flow of the Creative Process you get caught up in it and it becomes a way of life. If you have ever had the feeling that happens while you are creating, and you let the work go through you, as though you were a conduit for a larger energy, then you know what I am referring to. If you acknowledge the fact that sometimes, no matter what, you need some outside insights to help you grow so you can tap back into that energy, then you understand why I am writing this work. And you understand why you chose to pick up this book in the first place. If you wish to achieve the goals you have envisioned for yourself, you will intuitively recognize the importance of keeping a balance between following your heart and using your head, and, at the same time, dedicating yourself to the energy you will need to consistently work your rear-end off. It's a simple equation with profound implications.

This book can also be of immense value for those photographers who are just starting out. Here they can see what those who have preceded them have had to deal with, and they can anticipate what to expect as they build their own careers. The thoughts expressed within these pages will act as an ever-present mentor, ready to guide emerging professionals as they find their own way.

Regardless of whether you are a mid-career professional or a newbie, this book will provide you with ways to monitor your progress. We all need to read the signposts along the way or we become lost. The observations in this work are the result of years of interacting with creative entrepreneurs and finding the commonalities in

our unique areas of interest. In this book are excerpts of interviews and anecdotes by luminaries in our fields, such as Barbara Bordnick, Dean Cundey, David Fahey, Mark Edward Harris, Ryszard Horowitz, Douglas Kirkland, Bob Krist, Jay Maisel, Phil Marco, Pete McArthur, Eric Meola, Ken Merfeld, Pete Turner, Jerry Uelsmann, Nick Ut, Dan Wolfe, and others. And there are interesting insights from lesser-known but equally intriguing contributors. There are questions by artists searching to enhance their capabilities, and there are suggestions on how to get back to the job of creating.

As you will see, the way I have approached the subject matter is to identify a topic, examine my own personal experiences, talk to experts in the field and measure their responses against my observations, deconstruct the material to its most common components, and then reconstruct the essential elements so each topic has the broadest application based on experience and truth. In other words, the conclusions I draw are process-oriented from the general to the specific and back to the general, as though I were rebuilding a complex mechanism. The stories, charts, graphs, diagrams, aphorisms, and anecdotes are all presented in the hope they will help you visualize your own place in the creative continuum, so you can give due consideration to your next steps and execute the best possible outcome with your gifts. One more thing—forgive me if at times I sound a little preachy. I am on a mission. The choir will understand.

There are no trade secrets here, no hidden agendas, and no mystical incantations to your personal muse. And most definitely, you must keep in mind that I believe there is no one universal way to achieve reinvention enlightenment. This is not the traditional "how-to" book with regimented steps, lesson plans, checklists, or score-cards at the end of each chapter to help you keep tabs on your progress. It is more of a "pick-and-chose-after-seeing-what-others-have-done" book, with examples of how other professionals have dealt with the obstacles they have confronted. Each of us has to find our own way, or else there is no individual meaning, no personal triumph. You may read the thoughts in one of the interviews and find nothing more than an interesting story, and there may be times when some of the views expressed may even seem contradictory. But you may read another observation and be moved because you feel you are reading your own story seen from a slightly different angle. And that different point of view may open up a door of understanding that will take you to another level, a higher plane from which you can see new possibilities.

There is just common sense presented here, with humble admiration and a lot of appreciation for the wonderful evolved artists I have had the honor of dealing with over three decades. Keep in mind that this has in part been made possible because two Army buddies decided one day to share a dream that has continued to be challenging, sometimes exciting, always educational, at times adventurous, a little glamorous, and yes, absolutely fascinating as they dared to create, and occasionally found they had to recreate, their own futures.

Embracing Change

Transition Analysis

And, you know it's wild; I mean I live with change.
Change is the biggest part of our life.
—Pete Turner

Like almost everyone, I had always been under the impression that either you were born with creativity as a dominant trait or you were not, like athletic skills or a math gene. It never occurred to me that creativity has component parts that, when analyzed, provide a course of action to help us reach our own personal goals of self-expression. In the early 1990s, I had the good fortune of meeting a wise, somewhat irreverent, and extremely creative man, psychiatrist Dr. David Viscott. He taught me many things—some of which I will present later in this book—but one thing he impressed on me was the need to consciously study the creative process, especially as it related to my own personal growth. This self-study would eventually lead to a larger appreciation for the way ideas become manifested and how those manifestations become gifts for future generations.

Back then I had been in a creative funk for some time. I was making good money, but there was something missing from my life. There was a lack of fulfill-

ment, which was becoming more burdensome. One day I was driving back from yet another ad agency meeting when I heard a promo on the car radio for one of Dr. Viscott's weekend seminars. That ad stuck with me and I told my family about it when I got home. Apparently they sensed something was wrong with me as well, because they instantly agreed that I should look into attending the intensive three-day workshop on the topic of creativity that Dr. Viscott was going to deliver in Ojai, California. I was a little apprehensive when I signed up, but something told me it was the right thing to do.

When I first arrived at the workshop, I looked over the program and I quickly figured I would attend maybe a third of the lectures because I did not need, or wasn't interested in, the rest of the presentations. There were topics such as: Finding your Passion, Overcoming Creative Blocks, Keeping the Energy Alive—you know, New Age jargon, psychobabble, for an audience of fluffy-headed devotees. The venue had a nice pool, and I thought I would be spending a good deal of the weekend working on my tan and thinking of possible movie scripts.

However, from the moment Dr. Viscott started talking that Friday afternoon I was mesmerized. Sitting in the audience of three hundred or so people, I felt he was talking to me and me alone. I was amazed at how receptive I was. A few times I had to stop from underlining whole paragraphs and putting asterisks all over my notes. Everything seemed so important. It was not the man that impressed me so much as it was the clarity of thought and the way the program itself evolved. Something happened that weekend, and it was nothing less than the crystal-clear realization that I had been going in the wrong direction. I had better start paying attention to my personal creative imperative or else be stuck with an unfulfilled, boredom-riddled life. It was on my drive back home, through the expansive orange groves and rolling hills between Ventura County and Los Angeles that I resolved to work toward the understanding of this elusive and empowering entity called "the creative process" as it applied to me.

From Tragedy to Community Outreach

A few years after that encounter, the Los Angeles riots of 1992 erupted. Dr. Viscott, a well-known Los Angeles radio talk-show host at the time, was accosted one evening during the riots and managed to fake a heart attack, causing his would-be assailants to run away without hurting him. The next night Dr. Viscott made an appeal on his radio program for the people of Los Angeles to come forward and start a grass-roots movement to help rebuild the city. Somehow I became the chair of the Arts Committee within our newly formed nonprofit organization, U.P., Inc. From that first meeting, we discovered there were three issues that needed the most attention and the ones we could actually do something about. They were education, housing and urban planning, and the arts.

I learned many things in my new role working with at-risk children. We developed free programs in photography, videography, music, writing, mural painting, and other artful ventures. Two things that intrigued me were 1) how the young people naturally gravitated towards art forms that allowed them to discover themselves, and 2) how the mentors got more out of each session than they thought they would. One of our first projects resulted in garden murals. The young people of Los Angeles painted two-miles worth of burned-out walls in the inner city. It was a wonderful thing to see artists from various disciplines work with children and to experience something creative coming forward to bring unity to our city. The programs ultimately helped hundreds of young people gain access to education and employment in the arts, and our efforts were rewarded with the knowledge that we made a positive difference.

Shortly thereafter, I began working as a creative consultant with mid-career professional artists who had lost their zeal for their work. I didn't just become a creative consultant overnight. It was a long process where I would help one artist with his creative business problems, and that person would refer me to another, until I found a need existed in the marketplace for someone who understood the problems artists faced and could help them to deal effectively with those problems. Those challenges affected freelance photographers and staff photographers, assignment photographers and stock shooters, corporate and fine-art photographers, and filmmakers—all types of shooters who were having problems. They needed organization, advice, and a little motivation.

After a short consultation I would struggle to find a way to pinpoint what was most important to my client, and I would look back on my own experiences to define how to approach each case. Immediately I realized the need for an efficient method to cut through the distractions and the long, involved discussions of how cruel the world was and get to the heart of what was ailing my clients. Then I remembered Dr. Viscott saying that he listened closely to the voices of those who called into his radio program to determine which stage of pain they were experiencing, and then asked pointed questions to draw them out, to help them resolve their discontent. If they sounded angry, chances were that they were dealing with an unresolved pain in the past; and if they sounded anxious, they were probably anticipating a painful event in the future. That simple paradigm started me on a quest to define the stages creative people experience when they are confronting change and to figure out how I could use the definition of each stage as a starting point to help them find their way back to what was most important to them creatively.

Transition Analysis: Five Stages of Creative Evolution

Drawing on my experiences as a producer, an artists representative, a teacher at the Art Center College of Design, an administrator in a nonprofit arts organization, and

a writer, I started to sink my energies into trying to understand the mysterious circumstances that allow us to revitalize our talents and reinvent our lives. In other words, I needed a way to analyze the transitions we experience and to explain the various stages we go through as we progress creatively. I needed to be able to identify at what point my clients had stalled out, and then help them get unstuck so they could move on. No small task, you might say, but one that has turned out to be very rewarding.

As I searched I decided to use Joseph Campbell's five stages of the Hero's Journey as a guide. Campbell's first stage is the call to adventure. The hero becomes aware that something must be done to resolve a challenge. Second, the hero calls upon his mentors and allies to help him assess the danger and find the protection necessary to guard him during his quest. Third, he has to find ways to deal with the guardians of the treasure and formulate his plan of attack. Fourth, he has to put it all together, implement his well-thought-out plan, and deal with his challenge face to face. And finally, our hero triumphs as he brings back the treasure to the community, where the hero's journey is validated and his valor is celebrated. The Hero's Journey speaks metaphorically to the nature of meeting and overcoming challenges that universally reside deep within our subconscious.

The first thing that I needed was a visual representation, a simple design that would help me explain the conclusions. I needed a representation that would give order to random ideas and help me create a context that could be tested. To do this I envisioned an ellipse that started at the foot of an ascending spiral, because there is an undeniable evolutionary spiral effect that continually aspires to rise above itself, if you will, within the creative process. The process does not move backward. It may stall out from time to time, but it does not normally work in retrograde. Every piece of art you create, and which every other artist creates, adds to an immense existing body of work, and each contribution provides a platform for the next, constantly leveraging our comprehension, appreciation, and aspiration for a more inspired artful product.

At the starting point on that ellipse is the first stage, which is Recognition. The best way to describe Recognition is to imagine that you are blithely going along through life when something happens and your world is suddenly faced with a significant change. It could be good fortune or it could be a terrifying, overwhelming, catastrophic change—or just something so out of the ordinary that you do not know how to deal with it. It could even come in the form of a perceived uneasiness as you realize that you have fallen into the dread of mediocrity. I remembered attending a lecture delivered by the acclaimed poet Robert Bly titled, "The Horizontal Line and the Vertical Line in Art and Poetry." In that lecture he drew a long horizontal line, which he said represented time, the time we spend doing ordinary things as we live out our everyday existence. But then circumstance, a vertical line, arbitrarily inter-

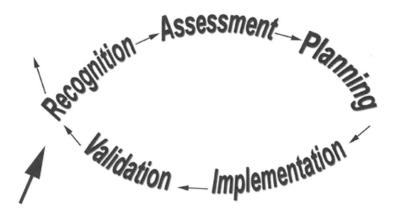

Transition Analysis: Five Stages of Creative Progress

sects that horizontal line, and that is the point at which all good art has its beginning. Why? Because the challenge of the new circumstance requires a new response, a resolution of equal or greater proportion—a response that allows us to get back to and continue on with our horizontal line existence. Or—and here is the good part—possibly the event lifts us to a higher plane of existence. He gave vivid examples of artists (Picasso and El Greco), writers, poets (Dostoyevsky, Mark Twain, and William Carlos Williams), and others whose most dramatic works were ignited by powerful events that changed their lives. That explosive intersection point, where circumstance disrupts our common ordinary everyday existence, I call the Recognition stage. At this point, Recognition alerts us that there is a challenge to our normal existence; something must be done if we are to proceed. If there is no Recognition, or worse, if there is denial and the call to action is ignored, then the subject is doomed to spirit-numbing mediocrity.

Once we realize and accept there is a problem or challenge, we are compelled to move along the evolutionary cycle to the second stage, which is Assessment. Here's where things get tricky. We have to be ready for an honest appraisal of what can realistically be done to bring about change, and what will allow us to create achievable goals. Yikes—that last sentence had a lot of emotionally charged concepts like honesty, reality, and achievable goals. However, there is no movement unless we can truthfully create goals that will help us grow, that are not totally out of reach. In Assessment we collect all the right tools, ask the experts and visionaries, do the research, get all the information together so our risk is calculated, not haphazard and foolhardy. "Calculated risk" need not be an oxymoron. It can be a motivation if executed with educated consideration. How many times have we stopped short of trying because we would have to confront something

that seemed insurmountable? How many chances were lost because the excuses became the biggest obstacles? What would our lives be like if only we had taken the risk? The Assessment stage is all about honestly staring risk in the face and accepting the challenge.

But how do we effectively put into motion the decisions we have made once the Assessment phase is sincerely addressed? This is where the third stage, Planning, comes in. This phase lets you use your head. The Planning stage gives you empowerment because it has a large dose of a sense of purpose. Let me give you an example here. Almost seventeen years ago my home burned down. That was definitely a change in my status quo, a challenge to be dealt with. The fire was caused by a freak electrical accident, which the fire investigators for the city and the insurance company said could not have been avoided. My first reaction was anger that this traumatic event had happened to my family and me and that our already busy lives would become much more complicated. Into my busy days, already crowded with production issues, I had to squeeze in dealing with the insurance company, the bank, the dismantler, appraisers, restorers, the architect, and contractors. There were endless details to be gotten through before we could return to what I once called normal.

The anger was followed by a sense of helplessness and other classic symptoms of loss. The fire and its aftereffects were so disruptive that I had to work hard every day at not feeling so stranded by destiny that I would be immobilized. I would catch myself just staring out the window or boring my friends with my problems. I realized that the disaster had taken control of my world and I had to regain that control before I could get myself and my family's life back together. I needed a plan to get that sense of control back. As a family we started with small steps to recovery. We gathered receipts and made lists for the insurance company, and we had family meetings to make sure everyone was being taken care of. Planning for little achievements allowed us all to feel as though we were getting back to having some sense of control.

That sense of control was empowering and gave us the energy to rebuild our home even better than it had been before. In the end our already close family became even closer. You don't have to have your home burn down to come to this realization, but you do have to accept the fact that a good idea goes nowhere unless there is a structure around it that gives it form and provides a means for visualizing your unique goals. For my family, visualizing small steps and then creating larger, shared goals helped us to focus on what was important.

The fourth phase of creative transition is the hardest physically because it is the sweat-equity phase, which I call Implementation. This is where the hard work, the perseverance factor, comes in. You have to be committed to the execution of your strategic plan. You have to reserve the time to do it. It does not get done by itself.

You still have to go out and shoot the picture, and process it, and do the post-production on it, and edit it, and present it, and complete the body of work that eventually becomes the gallery show, or the annual report, or the coffee-table book, or the ad campaign, etc. This is what you live for, so it isn't so much work as an opportunity, it's a chance to finally show the world what you see, and how you see it. We are so fortunate. We get to do what most people only dream of. We capture images of life being lived. We define our reality, if only a fraction of a second of it at a time. Putting your plan into action is a verification of your sincerity as an artist. Implementation of your plan is your way of exercising your privilege, of sharing your gift, of progressing up the evolutionary spiral of creativity.

This leads us to the final fifth phase, which is Validation. The results of your creativity have a life of their own. They cannot be hidden in a box, or a drawer, or shoved under the bed. They must be shared! By shared I mean they could be hung on your wall, or shown at an art sale, or licensed for great sums of money, but they must somehow be seen. The showing of your work gives validation to the process, to your labors of love. Dorothea Lange could have hidden her photographs of migrant workers during the devastating days of the Dust Bowl, but we would not know of the hardships those people endured. Howard Bingham could have secreted away his images of Muhammad Ali, but then we would not have that unique eyewitness chronicle of America and its struggles through the latter part of the twentieth century. By allowing your work to be seen, both you and your viewers are given a new inspiration, and this provides the spark for new interpretations which lead to—you guessed

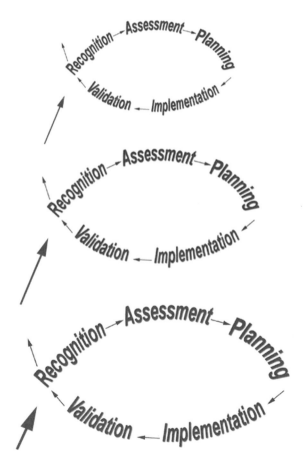

Transition Analysis: The Spiral of Creative Evolution

it—the next Recognition phase for yourself and others, so the whole process can begin anew.

The process is self-perpetuating, but it must be tended to by each individual artist and by the artistic community in general. It must be entrusted to each generation and be robust enough to withstand the inevitable onslaughts, but it must be anticipated and nurtured.

It is important to note a very important subtext of this book. Indeed, it is the subtext of an actualized life: change is not only a part of the creative process, it is a requirement. Nothing moves up the evolutionary spiral without going through some change, some transformation. If we are static, if we do not take action, we cannot grow. Change seldom presents itself in a neat and ordered manner. Sometimes it appears as a good thing, sometimes as a terrible thing. Change is neither intrinsically good nor evil, but it exists nevertheless as an occasion we can measure our progress by. The real challenge is what we do with that change. We define ourselves by how we handle change, and Transition Analysis is a tool we can use to monitor that change. Transition Analysis is not an attempt to explain the creative process; rather it is a construct that helps us to understand how far we have come and how to anticipate change.

Essentially the only constant in life is change. In sometime subtle and sometimes dynamic ways, change rules our lives— our bodies change, the seasons change, and every moment brings with it the possibility that the next will not be the same. It could be better, it could be worse. We accept change but we do little to prepare for it, especially when it comes to how it affects our careers. I am amazed at how little thought people give to this essential act of living, how little attention we pay to how we transition between roles and how it affects our livelihoods and our lifestyles.

Transition Analysis lets us view a series of milestones and evaluate how far we have come in our own personal reinvention, and it also gives us a view of what to expect as we move from one stage to another. Recognition helps us acknowledge the need for change. Assessment does three things: 1) it gives us some talking points on how to honestly understand what we have going for ourselves; 2) it empowers us to seek advice; and 3) it helps us understand how we can use our skills to make the best choices. Planning gives us strategies on how to use our skills to their best advantage and how to set a course of action with alternatives—so we are not discouraged in case our first plan runs into problems. Implementation assists us and encourages us to stay with our plan and keep motivated. Validation gives us proof of how effectively we have dealt with change and encourages us to move on. And just so we do not become complacent, as soon as we have celebrated our accomplishments in the Validation phase, we are aware that we have to be vigilant to recognize that another round of self-examination is not too far off in the distance—in short, we are about to begin again.

In this book, which could also be called *The Photographer's Journey* or *The Artist's Journey*, we will look at how other photographers and artists have approached their own creative challenges and gone beyond mere survival. And because each of us is unique, it is interesting to see how each contributor has approached change differently, with his or her own "innovative problem-solving,"—sometimes overcoming great obstacles, always looking for a way to improve their circumstances. By using Transition Analysis as a method for recognizing the signposts along the way, we will study a framework for effective change. And here is a challenge I issue to you, the reader. While reading the comments and observations included in this book, see if you can identify with some of the situations and construct a meaningful outcome to your own story. It is the story you own, so take possession of it. Don't wait for catastrophic events to awaken the possibilities within you. Be realistic, be preemptive. This is not a fantasy, but allow yourself to visualize the best possible scenario for your circumstances. Be aware and create the life you would really like to be living.

So, if you are ready for a little adventure in self-discovery, read on with an open mind and an open heart. Sometimes the journey will be smooth, sometimes it will be bumpy, so buckle up, hang on, and enjoy the ride.

Recognition

There's Something Wrong: Some Soul Searching

You have to believe in yourself, you have to be a believer in what you are doing, and foremost you have to be able to defend and articulate what you are all about.
—Ryszard Horowitz

In chapter 1, we read that the Recognition stage of Transition Analysis is the first stage, because it is the awareness phase. There is a challenge to the status quo that requires a personal, direct, and sometimes immediate response. "Awareness" is a powerful word. In order to have awareness, you have to be able to step outside your mundane conditions and look at yourself with a sense of objectivity. Not an easy thing to do, because emotions get in the way. If everything is moving along apparently smoothly, then why upset the apple cart? From time to time, we have to have the wherewithal to shake things up and learn the reach of our

potential. Sometimes the signs that it is time to move on are all around us, but we refuse to acknowledge them because we don't want to rock the boat. We would rather not admit that we will actually have to put forward the effort necessary to swim to shore before the sinking ship ultimately goes down.

Reading the Handwriting on the Wall

There are usually telltale signs that something is not right, if we bother to heed them. Say you are a freelancer, and you pick up the phone one day to call an old and loyal client. After repeated calls, you realize that client isn't going to return your calls any more. Or you buy the newspaper and find out that a company you do freelance jobs for has merged with another company. Where there once were two companies, each with an art staff of twenty, the merger will mean the combined company will restructure and reduce the total art staff. The others will be let go. Chances are some of those people are clients you have developed over the years who you counted on to send you work. The prospect of retracing your steps is daunting.

Or you start hearing rumors of layoffs and cutbacks at the company you work for. You notice co-workers whispering among themselves and then openly discussing *what if* scenarios. Conversations abruptly change the moment you walk in the room. You start seeing "How to Write a Resume" manuals left around on co-workers desks; or worse yet, you go to the office printer and see a resume that has been left on the printer tray.

These feelings of betrayal, abandonment, and corporate-versus-individual priorities are all too common. I hear these stories over and over again with slight variations, but always with the same results. They come from normal people who are beginning to feel paranoid. They may even come from people who are, by all outward appearances, doing well but are missing something in their lives, something vibrant that came when the work they were doing had meaning.

If you have chosen the life of a creative person, you signed on (whether you did so consciously or not) to the idea that sometimes you have to fix it before it is broken. Let me ask you something. Have you ever worked tirelessly at your art, and while you were doing it, experienced this overwhelming feeling that this was the best work you had ever done, only to wake up the next morning, take a look at it and wonder why you had spent so much time on that worthless piece of wrong-minded junk? Sure you have. We all have. If we were happy with every piece we ever executed, we would never push ourselves to do more. The creative process demands it of us. This is just another reminder of how change is at the very core of the creative experience, whether that project is your latest piece of art or your own career path.

Now think of your career as another one of your works of art. The path you have chosen has been constructed from an exquisite mixture of talent, background,

dreams, and luck. But most importantly, it was your awareness at that moment of decision that allowed you to make the choice that changed your life, for better or worse. When we look back at our lives, it is those decisive moments that jump out as the reasons why we are where we are right now. Those are the "decisive moments" that Henri Cartier-Bresson caught so eloquently on film—the points at which we had to make a choice, even though we may not be certain of the outcome, but the best choice we had at our disposal. We don't remember every breakfast, every commute, every meeting, but we remember every consequential referral, every successful achievement, every painful disappointment, and every happenstance that turned out to be life-altering. It's as though we can stand next to ourselves and watch as we went through the motions that took us to another level.

Let me give you a personal example. I remember clearly a cold September evening in 1965 when I was standing in a line with a bunch of new soldiers—we had all just gotten our orders to report for Basic Training, for boot camp. I started talking to the guy standing next to me, and it turned out he and I were headed to Fort Ord, California, to report for duty on the same day. In a spontaneous moment we decided to go to Fort Ord together, maybe because we could save some travel money, mostly because it seemed like a good idea to have a buddy to share the experience. The ironic thing is, that buddy I just happened to meet that evening is a man I have been friends with ever since, and we have been in business together for over thirty years. I can remember the smallest details of that first meeting, but I mostly think of what might have happened if I had decided to go to Basic Training alone.

I also clearly remember several years later when he asked me if I'd like to work with him. As I said before, I was working at a job I knew was a dead-end but which paid fairly well, had exceptionally good benefits, and didn't require much of me. When I asked a wise old co-worker at my civil service job if I should go off to work with my friend the photographer he said, "Well, look at it this way. You are twenty-six now. You have been working for the County Probation Department for five years. That means that in fifteen years you'll be forty-one, you can retire with a pension and then you can do what you want to do." Those words shook me to the very foundations of my being. I would have to wait for fifteen years to do what I wanted to do. Why not start now doing what I wanted to do? Was a pension at forty-one a big enough incentive to defer my chances to see a bigger side of life for a decade and a half? I immediately knew my answer. That was a moment of recognition that required very little debate.

Sometimes the decision is made for us. We are fired, lose a major account, or get injured or ill and can't do the things we used to do. But the future presents itself to us in many ways, and we have to be open to the probabilities that come along with the possibilities.

Some Pivotal Events

The first photographic job I brought in for Dan Wolfe Studio was a local editorial assignment for the *Los Angeles Times* Sunday supplement, *HOME* magazine. When I took in the transparencies for the first job Dan had shot for them (photos of roses for their special January Rose edition), I overheard the managing editor and the senior art director mention they needed someone to shoot food for an upcoming issue. While spreading out the rose photos on the light box, I casually slipped into the conversation that Dan loved to shoot food. They looked at each other knowingly and whispered, "He shoots food, very interesting." I walked out of their offices with our first food assignment. Eventually he shot a cover and a spread nearly every week. Dan shot lots of other types of local editorial and collateral jobs, but the food work kept coming in and gave us something to build a business on.

After a year or so we wanted to reach a larger audience, so we contacted *Sunset*, and another year or so later we pitched Meredith Publishing and began working for *Better Homes and Gardens* and Meredith's other publications, doing editorial on a national scale. Then a real coup occurred when a small publication named *Bon Appétit* made its way onto the national scene, and the people in charge decided to have Dan shoot their covers and feature stories. It was a great match, because they wanted food preparations that looked elegant but were relatively easy to make. Over the next two years, *Bon Appétit* became the fastest growing publication in the United States with a readership that seemed to grow exponentially.

Eventually, ad agencies that ran ads in national consumer magazines started to call, because they saw that Dan's work was a new approach to food photography. He used a 35mm camera, which produced more intimate results than the large-format cameras our competitors used. So the national consumer magazines began sending layouts for national food ads. While Dan shot, I repped and produced the shots for him. We had a steady clientele of some of the biggest food and liquor purveyors nationally and, eventually, internationally.

Then, one day, a creative director at J. Walter Thompson, Barry Wetmore, called and made an astonishing proposal. JWT had the Kawasaki Motorcycle account in the United States, and Barry was looking for a food shooter to photograph his motorcycles! It seemed he wanted a different look than the usual "bike shooters" were producing. He was looking for a photographer who could capture that soft, sculptural, overall light that food shooters were fond of. Barry recognized that one of the most important things motorcycle buyers looked at in a motorcycle ad was the detail of the motor and other mechanical components, and lighting for detail would get their attention. That acknowledgment and leap of faith—he had to sell the idea to the skeptical hierarchy at J. Walter Thompson and to Kawasaki—opened up a whole new direction for our business. Dan began shooting motorcycles, all-terrain vehicles, and jet skis for the major players in that advertising arena.

But that's not the half of it. While shooting bikes and other sheet metal for several years, and after logging a lot of miles between L.A. and other parts of the world, we got an intriguing call from a small, aggressive, up-and-coming ad agency in Los Angeles. They had a new personal-computer account and wanted to produce ads in which the products had a friendly yet professional presence. The creative director for this agency, Chiat/Day, was a long-haired visionary named Lee Clow, and the product was the brand-new Apple Macintosh. The year was 1984. The agency hired Dan to shoot the print ad campaign, which was launched in a big way: the agency bought all of the ad space in a special edition of *Newsweek*. Only Apple ads appeared in the publication. Dan had the opportunity to work with some of the most innovative art directors and creative staff at Chiat/Day. It is one of only a handful of times that I know of where an ad agency bought the entire advertising space in an international publication.

That wave of good fortune lasted a few years. Then some of our art director friends suggested Dan start shooting commercials. With the help of some very talented film people, Wolfe and Company Films was launched, and we began shooting both print ads and live-action commercials for our long-time motorcycle clients. We also began to work again for our long-standing food clients.

But even a good thing can get exhausting. The repetition of more than ten years of tabletop food, plus a recession in the early 1990s, caused us to admit it was time to change. This time we both knew it was time to make a big, meaningful move. I remember asking Dan, "What do you love to do most?" His answer, after a period of soul-searching, rocked my world. He said the two things he enjoyed most were taking pictures (still, video, film—it did not matter) and flying. You can imagine my response. How could we just up and go from tabletop food to aerial photography/cinematography? As usual, in his matter-of-fact style he said, "Well, just tell people I am shooting a bigger tabletop."

Here we are, in a new era in our business with the development of Wolfe Air Aviation, a division of Wolfe and Company Films. The combination of talents, technology, enthusiastic clientele, and all the experiences that have preceded us has allowed Wolfe Air Aviation to work for clients as diverse as the major motion picture studios, some of the most recognized ad agencies, the United States Air Force, the Royal Canadian Mounted Police, NASA/JPL (Space Shuttle and Mars Rover research), and a host of other forward-thinking clients. And the prospects for discovering new opportunities continue. A few years ago we worked on a small aerial segment of the Emmy Award–winning documentary *The Face: Jesus in Art*, which was a two-hour PBS production that focused on images of Jesus Christ as interpreted by various cultures around the world. It was a new adventure that has opened up a new chapter of documentary and feature film making for us.

An Anecdotal Case History

So what are the lessons learned? I have drawn a rough chart based on the story I just recounted, to tell it visually and to make a point. It is a story of challenges, decisions, and growth. The X-axis signifies time, from 1971 to the present, and it shows the types of projects we worked on during that period. Obviously the world has not been as clean and precise as I have drawn it; but, generally speaking, the progress has been toward larger or more visible accounts and new forms of expression. The Y-axis is anecdotal and refers to our growth in income. It isn't entirely accurate, but it gives us a reference for our progress. The Y-axis could also signify "Fame," or "Accomplishment," or "Recognition," or anything you want it to signify. So the question remains, what can we learn from our personal histories, and how do they provide insights for those of us who are looking to take their careers to a more fulfilling level?

First of all, this journey (like your own unique journey) has not been linear by any means. Of course there were some dead-ends, bad deals, and missed opportunities along the way. I focused, however, on the points of recognition at which new opportunities presented themselves and offered a chance for change. Sometimes those points of change were due to happy coincidences; sometimes they were simply due to a feeling that something was not going the way it was supposed to and something had to be done to move on. Disenchantment is not necessarily a bad thing. It can be a warning sign that there's trouble ahead, and you better take corrective action before you fall into a rut—and find it is harder to get out the longer you stay in.

And so it was that I started knocking on doors early on, and one was answered at the *Los Angeles Times*. I had no sales experience. I didn't know that much about photography outside of what I learned assisting my friend. But I knew I had to make a start somewhere, and with each new assignment I gained experience, confidence, and enthusiasm. And I believed in my partner's ability to deliver the job professionally. Every occupation has its own unique jargon. Learn it and you can sound like a pro. However, being a professional is more than just learning a vocabulary and strutting around acting like you know what you are doing. I often ask my students to define a "professional," and they usually answer that a professional is a person who gets paid for his work. I tell them that's only part of the answer—a professional is a person who gets paid for being able to anticipate a problem and take care of it *before* it becomes a problem. Professionals get that insight through experience, training, and the drive not to make the same mistake twice.

Three Recurring Phases

Let's look a little closer and see what the graph can tell us. When you get that first glimpse of the new direction and all the possibilities, you are in a glorious period that I call the Creative Ascent. You have something people want, and you are more than willing to share it with them. You are the "next thing," "the hot item," "the person of the hour," and they want to be associated with you. They all want to claim they discovered you, and your success reinforces their own good judgment. You are the recipient of the adulation of people you know and people you have never met. That adulation is rooted in the positive reinforcement you received when you took your first baby steps, or performed in front of the assembled family when you were a youngster and got applause. Life is good, and success, however you define it—as fame, money, or acclaim—is on the rise with no end in sight.

But after a while (usually years), you are approached by clones of the first wave of clientele and you are asked to do the same type of work that typified your climb to stardom. You use essentially the same setup of lights, the same lenses, the same approach—because it is what everybody wants. Eventually that work is no longer challenging, but you talk yourself out of your lack of enthusiasm because they are still calling on you. This period is the Plateau of Mediocrity. You put up with it, you are good at what you do, and it doesn't take a lot out of you to repeat the exercise. Still, the more you repeat it, the more of an exercise it is, an act of going through the thoughtless paces, giving them what they want, but leaving you creatively wanting. There's no doubt about the execution, only a shallow sense of security. Maybe along the way you have made commitments to a larger overhead, or a mortgage, or a growing number of people who now depend on you. You got into this work because you wanted to explore your art, but now you have become a manager and have little time to shoot the work you would like to be shooting. You would like

to change, but that would mean you would have to deal with the ordeal of letting people down. It must be the feeling that a young singer has when they have a hit song early in their career, and thirty years later they find themselves singing the same song, the same way they did way back when, but now they are singing that tired song in a bowling alley outside of Las Vegas.

However bad it might seem, the Plateau of Mediocrity is not the worst fate. It could be that, after your short stint in the limelight, your clients desert you for the next "new thing." The phone doesn't ring as frequently, the layouts dwindle, competitors who have adopted your style begin to lowball your estimates, your revenues fall, and you slide into the next period, the Valley of Despair. You panic and look around to find a way to climb out of this despair. You are filled with questions. Why did you wait so long to see the reality of the handwriting on the wall? When will you stop beating yourself up over your unwillingness to change? When will you be able to dig yourself out of this morass and start your new creative assent?

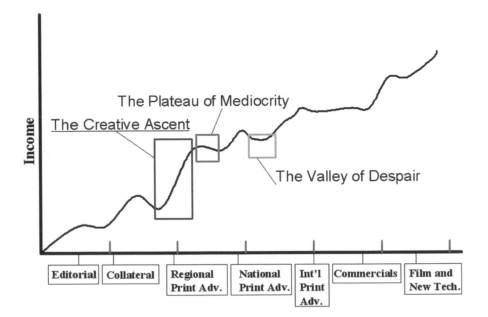

Anecdotal Case History: Comparison of Stages

I've seen these circumstances too many times. I've lived these situations myself. I have talked with hundreds of highly successful artists and they generally agreed that there were times when they didn't know how they were going to keep going after a setback, but somehow, some way, they made it through.

Empowerment through Retrospection and Visualization

It's that "somehow, someway" that concerns me. The answer can't be that nebulous. There has to be a more rational approach one can take to move on, rather than relying on that vague "somehow" to miraculously save one every time and take one to the next level of one's career. It is obvious to me that if we could put that process into a bottle, we could distribute it to a very hungry market.

See if any of the following stories sound familiar. One of my early contacts on this topic was an automotive shooter who was making a lot of money, traveling all over the world, and was at the top of his game shooting for the most prestigious motorcycle and car companies. But here's the conflict he faced: he had just missed out on a good deal of his son's first year of life because his car shooting caused him to travel most of the year. It just didn't seem right for him to be sacrificing that much. It went against his core values, and he needed an alternative that would allow him to be home, give him financial stability, and also address his artistic desires to use his photographic skills. We will find out more about this remarkable artist in chapter 12.

Another contact told how she worked for a small firm with a handful of employees. The person above her did not appear to show any signs of leaving, and she could not move up the corporate ladder. The company was so small there was nowhere to move laterally. When she asked her boss about advancement, she was told she would be the first one to move up as soon as the person above her left the company. She felt frustrated because she couldn't grow professionally and the jobs assigned her were not creatively fulfilling. She was young and anxious to move up and felt the need to, in her words, "accelerate" her career.

On another occasion, a friend called me and told the following story. He worked in a very small shop, and his boss had already had several businesses and had no reason to grow the present shop. My friend told the boss he wanted to leave, and the boss said he realized that if the young man wanted to leave, he was free to do so. My friend was torn because the boss was so agreeable and he didn't want to leave him high and dry, but he also needed to be in a more stimulating environment. He said that his boss was the perfect example of someone who had hit the "Plateau of Mediocrity."

And then there was the referral who worked for a large military-industrial corporation. He started working there shortly after leaving art school. Because he had worked there for a long time he had gotten to the top of his pay grade and had acquired a top-level security clearance. One problem he faced was that most of the artwork he had produced was of a highly sensitive nature, and it could not be seen by anyone other than government officials. He wanted to share his art but that was impossible under the strict security circumstances. On top of that frustration was the recent but now constant pressure of budgetary cutbacks by the government, coupled

with no room for advancement. When he started the job, he had a sense that his work meant something and that he was part of a very important team. But now that same sense of loyalty he experienced in the beginning was gone, especially with the other employees paranoid and protective of their jobs. In the process, he felt he was just an ID number and a line on a budget sheet, and that nobody cared about him or his work. The good feelings he had when he started had soured, and now he was looking for a way back to the joy he used to have when he was creating his art back when he first left school.

Yet another contact had taken a good job with a solid graphic-design firm shortly after college graduation. She had worked there for a few years, until she got married and decided to leave it to raise her family. Now, twenty-plus years later, her children are grown and starting their own lives, and she has been experiencing what she calls an "aching in my heart to be creative." She said she had gotten off her creative path and was ready to get back on. She summed it up beautifully: "When I do my art is when I feel at home."

Factors That Caused a Change of Direction

Change takes on many diverse appearances, sometimes due to technology, sometimes due to the people we meet and how they affect our lives. In an interview with Douglas Kirkland I asked him, "What are some of the events that have caused you to change your artistic directions during your career?" He answered:

Well, one major one was in the early days, Type C printing. When I was in Buffalo, the year would be late 1958 or early1959, one of the studios was one of the first to have a Type C line. So I learned the color wheel and the whole business of making color prints and dealing with them. Each print in those days took an hour and a half to process.

Another major element for me was in 1991. I was in Camden, Maine, at a seminar Kodak had set up for digital learning, and that was a big turn in my life. It was during the earliest versions of Photoshop. I had used computers for the ten years previous, but with not with my pictures. And suddenly computers coming in made a very major change, which obviously we are seeing today.

Working with Irving Penn was clearly another one, being in that world. I also worked briefly in another studio in New York called Photography Place and I rotated between photographers. It was an associate's studio. It gave me an enormous amount of learning, because, to go from one photographer to another, maybe two or three different ones in the same day, you learned how they worked.

Now how do you adapt yourself to change? You have to constantly be living it, questioning it, asking yourself what is interesting to explore? The other thing is when you have a quiet period—as I did, a lot of people did in the early 1990s—you realize there is a turning point when publications like *Time* and *Newsweek,* who hired me a lot, simply stopped calling. Almost all publications sort of stalled out for about a year [from around 1990 to say about 1993] and again there was a real rebuilding. What did I do? I really got involved in my digital world, into Photoshop and the computer. I didn't just sit around. This was not the time to be depressed or go on a holiday or something. You learn and you keep rebuilding, and exploring, and questioning—and that's what it's all about. You do not waste time. If you really are a photographer, you are the same as a painter, or a writer, or a musician. You have to live it, breathe it. And you have to find ways of remaining contemporary by exploring and questioning and being sensitive to what is going on—and see how, in your mind, you fit into this, or what you can bring to the table that is better than what's currently there.

I then asked, "Who has inspired you to change directions?"

There have been people all through my life, going back to my high school teacher—Irving Penn was the most formidable, I mean, with what he had done. But I have an unusual person I'll mention who was Gordon Parks. I was in New York working at *LOOK*, and was a member of the ASMP. I went to one of the meetings one night and Gordon was showing some of the work he had done with a boy from Brazil. They eventually showed a film on him, kind of a life story, a boy from the barrio in Rio, and it was a wonderful story, and at the end of it I introduced myself. He had seen my work and he was very flattering. We had lunch and he got an opportunity for me to go to *Life.* And my bosses at *LOOK* were very competitive and that idea didn't please them at all, and, to make a long story short, I was prepared to leave, but, instead, my income that year at *LOOK* ended up tripling because there was competition for me.

And I have an enormous respect for Gordon because he's done every-thing in the world, not only great photography but music and film. This man has no barriers. He has always been a great inspiration. No one was more disadvantaged than Gordon. He was the thirteenth child from a family of thirteen. He had every possibility of things going wrong. He learned to play a piano in a brothel. He was a porter on trains. It goes on and on, but he eventually got to do his art through the Farm Security Administration, and he made the most of it. You have to know your strengths and build on every possibility. Don't let things slide through your fingers.

Douglas Kirkland: Gordon Parks at the Piano

So there you have it. Douglas pointed out how technology, instinct, planning, and influential and inspirational people like Irving Penn and Gordon Parks all played a role in shaping his career. The Douglas Kirkland that was so energetic taking the photographs of movie stars mid-century is no less vibrant today, and he does more than survive—he thrives on his photography.

Sometimes you get surprisingly unpredictable answers from successful photographers when you ask what were the circumstances that caused them to change career directions. Jay Maisel once told me, "I know I have to change when I have become too successful." He didn't come across as arrogant. He was just pointing out that success is a double-edged sword, and we must never get too caught up in what is being said about us. One of the secrets of career longevity is never allowing yourself to buy into excessive praise or an excessive put-down.

Individual Journeys

Eric Meola had a different take on the question when he said, "I don't think I changed careers as much as accepted that I always wanted to make my own images, not make images for other people." That kind of rugged individualism is a dominant

characteristic among the professionals I spoke with. Eric has been able to recognize that his integrity was the driving force to his success.

Our journeys of self-discovery can take many turns, because the medium is not only the message, it is the means. Here is what Phil Marco had to say when I asked him what were some of the events that caused him to change direction in implementing his work:

Well, I think that film has affected my point of view. That is, motion film. One day I thought of a great visual, and I said to myself, wow that's a great idea, but how do I get it to move? I knew then that the crossover was complete, and my mental apparatus and everything else was moving in the direction of designing in movement as opposed to stills. It was also clear to me that if I wanted to achieve the expertise and quality that I had attained in print, I had to temporally set it aside, and make a total commitment to film.

From the early 1980s to the late 1990s, I was totally committed to film. During that time I directed well over two thousand commercials, worked on twelve features, won numerous Clio's and Cannes Lions, and formed a close working relationship with Martin Scorsese, creating graphic visuals and special effects for his films. I also developed a large following in Europe and traveled there for assignments on a bimonthly basis.

In the mid-1990s, because of my print background, a number of agencies encouraged me to shoot the print as well as direct the television commercials for their clients, which gave them a campaign signature with total visual and design continuity. This eventually led to the rekindling of my love affair with print, and I found myself again bridging both print and film.

One big change is the new methods and tools that I learned to efficiently solve and execute design and conceptual problems. For example, when I started my photography career in the 1960s and through the 1970s, I used strobe to light exclusively. As a [director of photography] in film, I learned to use and appreciate tungsten lighting and the infinite variations and control it can bring to a scene or an object. The tools and knowledge of software I gained as a special effects director were extremely helpful as I reentered print photography in the digital age. As a film director I learned the value of collaboration. I feel that my twenty-year hiatus [from still photography] into film was a very auspicious personal decision, because the experience greatly enhanced my visual and conceptual horizons.

So, that's where I am right now, and I like to think of myself as a work in progress and evolving. I would like very much to get more involved in creating installations, that's a medium that really fascinates me. My personal print work is moving into the fine-art and gallery venue, and I'm in the midst of publishing two books.

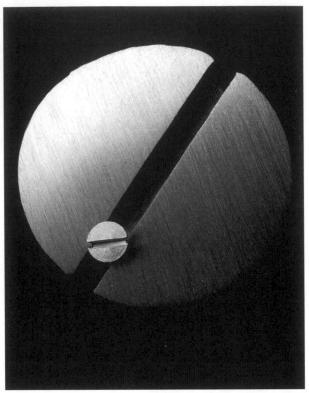

Phil Marco: Blessed Event, 1979

Living Between Two Worlds

Another example of that school of thought is Ryszard Horowitz. Ryszard has known hardships most of us will never imagine, and through it all he has remained true to his artistic vision of creating the work he wanted to create, even in a time when the definition of art itself was being challenged. He explained it like this:

> The first reason why I put aside fine arts wasn't photography. I came to the States in 1959 from a small town in Poland, historically a great cultural center with medieval architecture and art. And I was educated in traditional terms, believing in figurative painting, and drawing from a model and plaster casts. I arrive in New York where abstract expressionism is reigning. Jackson Pollock is the hero. What the hell was I supposed to do?
>
> Nobody at the time paid the slightest attention to figurative painting. I had to reeducate myself to find myself in this totally new art environment; which was fine with me because I had the advantage that I appreciated the old and at the same time I was very much open to new things. And when I went to school here, I realized I was a freak. I was unique because some of

Phil Marco: Torso, 2005

my colleagues who were interested in art, in design, never had any inclination to go to museums or to study traditional art, study art history. It was very painful to me, but it gave me a phenomenal background, a basis, a point of reference.

So now when I want to get excited, I go to a museum, look through slick photo magazines. A lot of people don't understand the perceptual difference, because everything you see now has been done in the past, for better or worse, everything has been done already. So why not go to the source? I keep telling people, go look at Caravaggio, look at Picasso, look at things that really excite you, look at the source, see how it evolved, how different people changed the vision and added to it. Everything is one big visual evolution. That was really very important to me.

Then when I met [Alexey] Brodovitch [legendary creative director at *Harper's Bazaar*], it was also very important, because I found myself in an incredible environment with people like Arnold Newman, and Penn, and Avedon, and Hiro, and all those people, and a lot of photojournalists, also musicians. He had a wonderful way of talking about creativity, about

creative aspects and how important it was for an individual to be able to develop his or her own point of view. To realize that what one does will be appreciated by others—one day you will be a great hero, the other day you will be kicking your butt. You have to believe in yourself, and foremost you have to be able to defend and articulate what you are all about. Don't rely on what's "in," because it will be "in" today and "out" tomorrow. Be able to think what you believe. That was extremely crucial and educational and valuable to me.

Then later on I had a wonderful experience working for a short period of time with Avedon and with Newman. That was also extremely revealing to me, because I dealt with two giants and two people who represented different styles in photography— but certainly they had their own vision and were masters of the media, and they knew what they were doing.

Also, I studied people. I observed how they worked with their models, how they approached them, how they quickly created their vision. How things happened. It was interesting; I always loved to see documentary movies about how movies are made. I loved to see the mechanics, to see the whole thing.

My experience with *Harper's Bazaar* was very important, although it was quite painful at times. It ended my working in Europe and coming here and getting different reaction, understanding early enough that what Brodovitch had told me was so true—that you find a group of people who adore you, and then you turn around and people hate you. You have to build a little shield around yourself and be able to survive through it.

Belief and Trust

In all of the interviews, the three essential elements of talent, timing, and inspirational people recur. You can have one or two, but your chances of moving yourself to the next level requires that all three elements work cooperatively. Barbara Bordnick, whose evocative work I will discuss later, responded to the question, "Who inspired you to change career directions?" in this insightful way: "If not myself, the people who believed in me even more than I." You have to believe in yourself; but sometimes others see something in you that you cannot see until those you trust bolster your spirits. The key ingredient here is that you have to trust their judgment even over your own sometimes.

And a beautiful thing happens when you have an instinct for what you want to do, and someone shares the vision and has the means to help you bring all the elements together. Pete Turner has had many such experiences, as can be seen by the immense body of travel work he has inspired us with over the years. He told of one such experience that elucidates the point about change of directions:

There was an event that sort of changed my thinking about photography. In 1973, on the island of Heimaey, in Iceland, a volcano erupted in the center of town. A lot of photographers photograph volcanoes and logically so, because they are very colorful, but that wasn't what turned me on. I was looking at the *New York Times*—I usually glance through it in the morning—and I saw this little two-column picture of smoke and ash and volcano and all these houses right in front of it. I called up Harold Hayes, who is that fellow who gave me the "sophistication" story [see Pete's interview in chapter 3], and I said, "Harold, I saw the most amazing picture." He had the *Times* too and we were both looking at it, and I said, "I'd love to go over there tonight and shoot this town. To me it's got to be like science fiction." And he said, "Let me see if I can make some calls and can get you an editor over in Iceland." He was that sort of a guy. So he said, "Call me back at lunch time." That was like 10 A.M. I said, "But I want to fly tonight." And he said, "Well, find out what time the flights leave and what not."

So I'm like packing [chuckle] and he called me back and said, "I might be crazy but you've got it." The next thing I know I am out at Kennedy and I land at dawn in Iceland. I had a contact who flew me over to this island. I was only on the island twenty-two hours, I think it was, but the next dawn, this thing spews out this lava, and I knew it was the most incredible picture, and I got it! I didn't even know if the island was going to blow or what, but I said to myself, this is like a Japanese science fiction movie. It's like a Godzilla-type thing. I mean, it was hard to believe this was happening in front of me, this was the ultimate trip. I was talking to myself, you know.

I knew I had all the film and I got off the island. I'm flying back home, and I'm thinking how can you ever top something like that? You can shoot volcanoes, but it's very different when it's in the center of a town. It was a turning point. I had been doing a lot of realistic type photography, and I decided, well, there's got to be a place for more surreal things. It sort of opened my mind a bit to change directions.

There are times when our hand is forced by circumstances, and we have to make the most of what we can. Bob Krist offered a candid view of his career moves, including newspaper photography, each of which turned into a new opportunity:

I first picked up a camera when I got a job to go to Europe with a theater company and my primary impetus was I wanted to take beautiful pictures. The newspaper work was a complete and utter deviance from that, but it did

teach me to do storytelling pictures. The stories I was telling were a lot rougher around the edges than I wanted to tell. The one thing that did it for me with the newspapers was that I just started to get that crust around me that newspaper guys get when you see so much misery day in and day out.

There was a fire down in a Jersey City ghetto. A guy turned the corner and his brownstone was up in flames, and his wife and four children were in there. It was revenge arson, but a bunch of crackheads bombed the wrong house. And this guy just kept trying run into the burning building to get his kids out, and it took, like, six Jersey City firemen to restrain him because it was too late, and I photographed this whole thing, and won all these awards, and I came back and I said to my wife, "I'm out of here. I'm not doing this anymore; this is not what I want to do."

At that point I just wanted out of the news and into something a little softer, and then I kind of segued into corporate work for a while, and I did that and it was very lucrative and a lot of fun for a while. After about seven or eight years, I had just had it shooting laboratories and guys in ties talking to each other, and I knew I wanted to travel. I kind of segued out of that into doing more travel editorial.

Every phase that comes, I usually get sick of what I'm doing, or I just get fed up with it, and I try to play to what I want to do next. And a lot of times it's had a happy coincidence with the market either disappearing or something like that. When I got out of corporate work, I got out about a year or two before the whole bottom fell out of the annual report market. Fortunately I had already jumped over into doing some editorial. It's like you jump from one lily pad to another just as they are going under, and somehow you make it across the pond.

Sometimes you can use a commercial job to push yourself to the next level creatively, even if that doesn't entirely jibe with the client's needs, as long as you stay true to your passion. Pete McArthur gave this insight: "One thing I found to be true was that just doing a good job was one thing, and being passionate about doing a good job takes you to different places. Doing a good job makes it easier to get paid but doesn't necessarily get your photography to any higher level. At the same time, being passionate about your work actually can piss off a client now and then, but over the long haul has a more positive effect on your portfolio. I had a couple of assignments early in my career that had me shooting pictures that were supposed to look as close as possible to paintings. This started to move my portfolio in a fine-art direction even though it was commercial art. How does the saying go? 'You shoot what's in your book.'"

There are lots of reasons why and how an artist changes directions. Some of the reasons are subtle, simple things; some of the reasons are huge flashes of insight. However they happen, they can be life-altering. Therefore if you are considering moving in a new direction, you have to create a portfolio that reflects that vision, and you have to get the attention of the people you want to work for—you have to captivate their imaginations. This has to be a gradual building process, one that will help you "segue," as Bob Krist noted, from one station to the next. This is something we will examine in more detail later in this book.

The initial step of Recognition comes in many forms and at different times for different reasons, but it starts the entire process. We need to be able to realistically see 1) the patterns that we have created, consciously or unconsciously, in our personal growth; and 2) what the circumstances were which led us to choose those patterns. What we need next is a way to honestly assess where we have been, where we are now, and where we need to go.

III

Assessment

Finding Your Passion . . .
Again and Again
and Again

First of all if you have a camera around your neck
that's basically a license to explore.
—Jerry Uelsmann

Change doesn't only occur when we are faced with something catastrophic in our lives. It can happen silently over a period of time, building momentum until it morphs into something totally unexpected. Creative people need to be aware that there must be an element of their passion associated with every type of change they encounter. Without that element of passion, they will find something lacking in their new role, and it will leave them unsure of themselves, unbalanced in the universe, unable to feel complete. Our passion, no matter what form it takes, has to be acknowledged, accepted, nurtured, and shared, over and over again—and with each completion of this cycle it grows more powerful, and more unique. If we

ignore it, it goes into hibernation, waiting for us to give it the respect it deserves. In this chapter we will look at several ways in which you may consider how well you are attending to the call of your passion, and how others have kept their passion alive through challenges not unlike your own.

As was mentioned at the end of the last chapter, it is imperative for us to consider our personal work history in order to gain an understanding of how we have, or have not, dealt effectively with the transitions we have chosen, or have been forced to choose. One of the great joys of writing this book is that I have had the good fortune to interview some of my heroes of photography and ask them to take a look back on their careers, so we might all gain some insights. The following is one such refreshing look back, taken from a conversation I had with Pete Turner. What was most revealing in this interview was that Pete presented the events that changed his career as if they happened because he was lucky enough to be in the right place at the right time, when, in fact, it seems he positioned himself to be in the right place and waited for the right time to express his passion. Louis Pasteur said, "Chance favors the prepared mind." As you will see, Pete prepared himself, always keeping his passion as a main consideration for any decisions he made. Pete had a little chuckle in his voice throughout the entire interview, a chuckle that revealed the joy with which he approaches his work. You can't hear it as you read the printed page, but you can definitely sense the enthusiasm he brings to his work everyday.

I innocently asked Pete this simple question: "What did you do to make a living before you became a photographer?" The following is his amazing story:

> I became a photographer in grade school. I was just very interested in it. I was interested in my formative years. Back then I was very much into chemistry and things like that, and the person across the street had a darkroom and showed me how prints came out in the dark under a red light. That was maybe the beginning, but I guess I really got interested in photography through stamp collecting. I used to love to go to the stamp stores and add to my little collection as a kid. I loved the stamps because they all had these different colors, and they were in different shapes—squares and rectangles and triangles and everything—and they had pictures on them of very exotic places, like the pyramids.
>
> During high school, I got a job on the school newspaper and the yearbook. One thing led to another. People always ask me, "How come you always wanted to be a photographer?" Well, one of the things was that I thought photographers seemed to be in interesting places seeing things happen. Life was not boring if you were a photographer. That excited me. And I was fortunate that my parents lived in Rochester, New York, which

was great because of the Rochester Institute of Technology, where I got my formal education. When I started they only had a two-year course, but in my sophomore year it got extended to four years with a Bachelor's degree. Actually they call our class the "Golden Class" because a lot of very good photographers like Jerry Uelsmann, Carl Chiarenza, Bruce Davidson, Peter Bunnell, Ken Josephson, Paul Caponigro—a whole host of really good, talented people—came out of that class. We're all still friends and Jerry and I talk a lot.

I had wonderful teachers like Ralph Hattersley, Robert Bagby, Les Strobel, and even Minor White. These were all great people. Anyway, we graduated just before summer [of 1956], and I got asked by a postcard company if I'd like to go around different states and shoot different things for their postcards. And I said sure, why not, because I knew I was going to get drafted. The U.S. Army grabbed you after you came out of school. And at the end of that summer, I got my notification for that fall to report to Fort Dix for Basic Training.

I should back up a little bit. When I was in school I used to go out shooting with Professor Robert Bagby a lot, like in my junior year or so, and color was my major, and he really liked my work. He said, "You know, you ought to go down to New York and show your work to these people, the Brackmans, that have an agency down there called FPG." And so I did, and they wanted a lot of my work, and I turned it over to them to market. So here was a teacher who was showing me how to make an income while I was in school. He said, "Pete, it's all good to have these pictures but you need a place to market them." And you know, I loved that guy, he was a wonderful teacher.

So, I'm drafted into the Army. I get lucky and was made a photographer in the Army, and then I was stationed at the Army Finance Center at Indianapolis, Indiana, as one of the photographers on the base. We got this call one day that the general needed a portrait done, and I went over and did his portrait in front of a statue somebody was making of him. Somehow I got the light on him and the light on the statue to match. I never thought much about it. I made some prints that were sent over by messenger, or whatever, and the next thing I know I am called to the general's office, and I go in, and he's having a haircut right in his office. I was very impressed by that. He said, "Son, these pictures are incredible. Have you ever thought of a career in the Army?" because he knew that I was drafted. We started talking and he said, "I know this Major Bryerley in the Army Pictorial Center in New York City, and you really should be working out of the Army Signal Corps."

The next thing I know, they talked officer to officer, and they transferred me to New York City to the Army Pictorial Center. And when I reported for duty, they had just opened a Type C color lab there, and they didn't have anybody to run it. They said, "You wouldn't happen to know how to do any of this stuff," and I said, "Oh, yah, you bet." You know, I really didn't but I knew who to call at RIT to get me in the loop. They gave me some color negatives and they said, "Pete, if you can make prints of these over the weekend, you've got the job." So I worked over the weekend, I made the prints, they were acceptable, and I got the job of running the first Type C lab at the Army Pictorial Center. The sergeant in charge of the lab said, "Look, you can do anything you want, because I don't know this process, and as long as I can take the credit, that's all I care about." And all I cared about was being able to make color prints.

Then I get out of the Army two years later. I have an incredible portfolio of 11" × 14" Type C prints. Awesome things. I brought them around to agencies and record companies and people started to use me because I'd walk in and they'd say, "Gee, look at this guy's color!" Nobody had a portfolio like that. I hit some magazines like *LOOK* and I went off and shot the circus, and they loved it, and they said, "We're going to print it." At the same time I was getting these four figure checks from the stock agency, FPG, which had been doing very well by me. I used to get seventy-eight dollars a month from the Army! The other soldiers around me couldn't wait for me to get one of these checks because they knew I'd take them all out on the town. It was really fun; I had a lot of buddies in the army, at mail call especially. Anyway, Arthur Brackman at FPG was approached by the Airstream trailer company that was getting ready to do an incredible overland trip from Cape Town, South Africa to Cairo, Egypt. They had forty-three trailers that were going to be pulled by four-wheel-drive trucks, and they wanted a photographer who could go to Africa and photograph this expedition, and be able to spend seven months driving across Africa.

Now you're talking about a person who has just gotten out of the Army, and didn't have any roots. This fellow, Pat Terry, comes to New York City and lays this out on the table, and I am drooling. He said he liked my work, I was almost pre-sold, and he said, "We'll supply you with your own RV. You don't have to pull a trailer, so you can get ahead of the group or behind them or go off on your own or whatever." So I accepted and I loaded the thing up with film. I went down to Washington, I met Bob Gilka from the *Geographic*, they said we'd love to come on board and have you shoot Kodachrome. It never did get published in the *Geographic*—there were

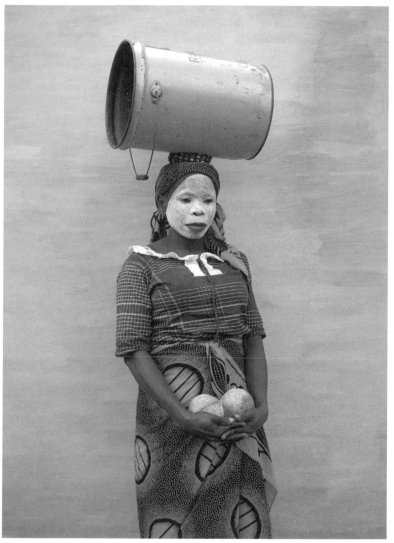

Pete Turner: Coconut Woman

political reasons, or commercial reasons, I don't know—but they did offer me a staff position when I came back.

Anyway, when they offered me staff, it was a big fork in the road for me. But I wanted to go back to Africa for a little bit. I had been there seven months; it was the most incredible experience to be able to photograph this convoy of these aluminum spaceships being pulled through Africa. An incredible trip that ended wagon wheeled in front of the Great Pyramid in Egypt and the Sphinx, with forty-three trailers in a big circle. I shot it from the air. I can remember lying on top of my camper looking up at the

pyramid, it was nighttime and the stars, and thinking, boy, I don't know how I'm ever going to top this. [He chuckles.]

I came back to New York, and I am offered staff at *Geographic*, and I'm thinking about it. But as I'm thinking about it, *LOOK* magazine is publishing my photographs of the Ringling Brothers Circus and I'm thinking, gawd, *LOOK* magazine, look at the size of these pictures. *Geographic* was small and *LOOK* was really big. [He chuckles again.] Meanwhile Harold Hayes had expressed big interest in my work; he was the editor-in-chief of *Esquire*. He started using me. And then *Sports Illustrated* heard about me. So I started making all these contacts, and there were these trade books like Aramco doing corporate things and I got assignments from Esso, which is now ExxonMobil. I didn't know that would happen when I refused the *Geographic*. You asked about decisions in your questions—this was a huge decision. And as a freelancer, if I continued the route I wanted to in New York, with *Holiday* and all these different books as opposed to working for *Geographic*—well *Geographic* was security, and I knew that you had plenty of time to do your stories, it was safe, but I chose to be a freelancer.

And, you know it's wild; I mean I live with change. Change is the biggest part of our life. Just think of the transition from RIT, to the Army, to Africa, to New York City—another type of jungle. And there were times when it was rough, because in between things being published, sometimes things didn't happen. But I'll tell you one thing, when I came back with those African pictures, plus the early pictures I had from the Army, all these big prints, it turned people's heads. And you know, looking back even today I can understand why. I mean, who is this kid who has a truckload of prints and pictures from all over the world?

So, I came back and made that V in the road, and I am now getting assignments from *Holiday* and *Esquire*. Harold Hayes was unique. He would come up and say, "Pete, we're doing an issue on sophistication and I've got ten pages, you interested?" I said, "You bet, but I don't even know what the word means. I'm a photographer." And he said, "Don't you worry. How would you like it if I was to give you a list of places and things I want you to photograph and then that will be it?" So the first picture he wanted me to shoot was the Plaza Hotel, the Edwardian Room. There was a whole list of things. And then when they came out with that issue, it was encased in a golden container, all the greatest authors in the world had contributed to that issue, and everybody got a half-inch credit. I got a half-inch credit in that thing. At that point you can't do much wrong.

Today, there are a million magazines and there are a million outlets and it's pretty hard to make a name for yourself. Back in the early 1960s, those

were the magazines—*Life, LOOK, Holiday, Esquire,* and *Sports Illustrated*—I mean that's it. And to be published in them, you automatically got advertising jobs. One of the real good ones I got was Esso. And that brought me back to Africa quite a few times because of the oil countries. I must have flown through Rome so many times, it was like home plate to me. Because from Rome you go to Beirut, and then from Beirut you'd fly down to Saudi Arabia, or you'd fly from Beirut over to Libya, Cairo, whatever, there's like a whole chain of places. Beirut was quite a hub. So those stamps I looked at as a child, while I was flying, they all started to come to life for me.

Well, my whole career really got supercharged—from school going into those magazines and having my work accepted and published. Once that happens, you become someone that people want. A very good agent, Harvey Kahn, contacted me and brought commercial work in. And then I opened a studio at Carnegie Hall and the whole ball of wax. It sounded great, and it was great, but everything has its time. But you know I hate to talk about the business aspect of it because it is a business and the more you shoot the more you have bookkeepers coming in, and the more you have accountants—you know what I mean, it's an endless stream of things. You have to be careful, because a studio can take the fun out of photography. All of a sudden it's really a business, it's not the stamp collection any more. Every image you make in your life has a potential source of revenue for something or other. Don't ask me what, but it's all part of your work. And it all seems to work out. I don't know how. You said you talked with Douglas Kirkland and he could probably articulate this stuff much better than I.

I countered with, "Well, you know, everybody articulates it differently, but the beauty of what's going on with this inquiry, with these interviews, is to start seeing the similarities. I mean we all approach the world differently, but if we are driven by that passion, that thing that just shakes you awake in the morning, and you say to yourself, 'Wow, am I a lucky son of a gun or what?' Sure there are tough times; but if you are honest to your passion, and you persevere, and you are open to ideas, there's no telling where it can take you." Pete responded: "I don't blame people for the negatives. I've had them myself. Everything is not sugar coated. I can hate digital. Or I can love digital and hate traditional photography. It's always a yin and yang for me, because with traditional photography you are stuck with film that a chemist has decided what the color balance is going to be and how the colors are going to look. With digital you're not and you can throw in a palate that can be anything you want.

Pete Turner: Shapes of Things to Come

"I think that where we started earlier in this discussion is that it is all about change. Whether we like it or not we're going to be yanked by change right through our whole lives. Change is here to stay."

There are a lot of things we can learn from Pete's story. The first thing that jumps out at me is that he managed to keep his passion alive right from the beginning. He loves color, he loves form, he loves travel, he loves exotic places and

things, and he loves being there to record and interpret it all in his unique way. He always seems to be standing on the street corner with his camera at the intersection of desire and opportunity.

Creating the Timeline

At one point in my career, it occurred to me that I could assist people in appreciating the roots of their passion by helping them visualize their past experiences so they could isolate and recognize their periods of creative highs and lows. If they could see their circumstances more clearly, then they could strategize, and possibly avoid—or at least minimize—the ennui of the Plateau of Mediocrity, and maybe even bypass the Valley of Despair altogether. If early on I had created a timeline of my career's progress, I believe I could have been more proactive—and I could have been more productive, more prepared for the inevitable encounters with change. This may seem like pie in the sky thinking, but I'm talking about developing a way in which one is not constantly looking over one's shoulder, but instead is using past experiences as a means for looking ahead, without losing sight of what one cares passionately about. This task requires the combination of a storyteller's talent and a designer's ability to conceptualize visually. The storyteller provides the narrative, and the designer takes all the historical data and fashions a comprehensible chart, map, or representation. One can then stand back and meditate on the choices one has made in one's career.

For example, when starting out on any major new project, I like to spend a little time sketching—first on a notepad and then more formally on a big easel—a visual representation of where I am now and my eventual goal, so I can begin to make lists of things to prioritize. Then I can begin scheduling the times when things have to be accomplished and the milestones that will eventually have to be met.

For this endeavor, I figured anyone who was interested in creating a career map, if you will, would need a representation that would synthesize data from their own past. This, in turn, would allow them to take a hard look at that data in the clear light of the present, and would give them the freedom to consider the feasibility of what they want for their future—the stuff of their dreams.

The Work-History Timeline and the Personal Timeline

When I start working with a client, the first assignment I have them execute is the creation of personal and work-history timelines. This lets us get a perspective on where they have been in their careers, what they consider to be their important accomplishments, and also what distractions and obstacles they have encountered along the way. I tell them they can design it any way they choose, but it must have a baseline, time segments, and anything they consider as significant events in their work history, such as new jobs, promotions, new clients, achievements, problem

times, resigning a client, leaving a job—in short, anything that prompted a change in career direction. We start out with the work-history timeline because it is the easiest to comprehend.

I remind my clients or students they can design their timelines any way they wish. This, in itself, reveals a great deal. Some will do a straight-line continuum that resembles the timelines you would see in a history textbook—Paleolithic, Neolithic, Bronze Age, etc. Others create a tree trunk, which illustrates their main form of expression, along with arabesque branches that show all the little excursions that caught their fancy along the way. And still others create a series of columns and lists, with titles like Education, Professional Experience, Skills, Accomplishments, Interests, as though they had taken their resume categories and turned them 90 degrees on their side. All of these visual expressions are equally relevant, because they help us to see our career experiences in a condensed perspective. We might visualize our lives as goal-oriented on a linear path, or as a series of episodes that have meaning only when looked at in their totality. Or maybe we see our lives as connections between hard work and destiny, somewhere between sweat equity and happenstance. Whatever the form, these work-history timelines give us a picture of a life with dimension, a life with alternatives.

Next, things get a little more complicated: I ask them to create their personal history timeline. Maybe you can, as one of my students did in a workshop, place your work experiences above the timeline, and your personal experiences below the line. The interrelationship was very revealing, as we could see a tug of war that existed between perceived allegiances. At times, work and personal histories could be seen as working cooperatively and in harmony with each other; at other times, there were tensions between work and family, or work and other interests.

Practically speaking, the timeline assignments are a reality check, because they reveal what a person feels is most important in his own shorthand way, because he assigns his personal level of importance to each event. The real significance of the timeline assignment is that it is a tool to get people talking. That talking leads to little self-revelations where priorities surface, and those lead to bigger truths.

List of Skills

Once the timelines are in place, the next thing to consider are the skills that have been acquired along the way. By studying the timelines it is relatively easy to begin listing the obvious and the not-so-obvious skills that came along with each experience. You may have good darkroom skills that helped enhance your digital post-production skills. You might have shot photographs at first, then been asked to write a story to go along with the shots, so now you have journalistic abilities. Maybe you were asked to shoot live action along with stills on several jobs, and have now broadened your image-capturing possibilities to include film or video. Skills don't

have to be exclusively technical in nature. They can include managerial, accounting, production, communication, interpersonal, and other professional skills. And don't forget other skills that are important in our increasingly global economy, such as foreign languages and cultural awareness. Transferable skill sets can make the difference between a mediocre job and an exciting career.

List of Interests—The Roots of Passion

With the timelines and the skills list in place, the next step in our preliminary journey of self-discovery is the development of a list of interests. This is revealing because we voluntarily select our interests; no one forces us to do these things, and we do them because we enjoy doing them, plain and simple. Doing things voluntarily is at the base of passion, so it is important to understand why and how we are drawn to certain things and not to others.

So how do you find your passion? The answer is, you don't find it. You allow it to find you, and you stay open to recognizing it when it comes your way. You can't force it. You can urge it by educating yourself; you can attract it by immersing yourself in it; you can cajole it by practicing it—but you can't order it to do your bidding. You have to prepare yourself for passion and wait for it to introduce itself to you. As a friend once told me, "If you are waiting for your ship to come in, then don't wait at the airport."

This is where the fine art of playing becomes such an important factor. When we first play at something we do so because it is enjoyable. At first we fool around with our newfound toy, and then we find we have lost all sense of time while being immersed in this new adventure. Eventually we can't wait to be interacting with this thing that brings us so much joy. The adrenaline that kicks in gives us extra energy and we find we can keep playing beyond being tired. If we do well at our play, we praise ourselves or we get praise from others. Once we reach one threshold of satisfaction, we want more and we push ourselves harder. It is part of the Creative Ascent, the joy of newness, of discovery, of growth. Play is at the heart of passion because it encourages us to reach beyond our perceived limitations and set new goals. That is why the Plateau of Mediocrity is so discouraging: the newness becomes routine, growth is stunted, there is nothing left to discover. After a while, mediocrity cannibalizes what is left of desire and play becomes joyless hard work with diminishing returns.

You have to get back to the rudiments of play if you want to summon your passion. Many people have to look back to what they enjoyed in their youth to find their passion. Pete Turner instinctively knew that the combination of his fascination for the darkroom and his love of stamps and what they represented (color, design, and exotic travel) were deeply embedded in his creative psyche. From that foundation he nurtured his interests with technical knowledge, and that provided opportunities

for him wherever he went, over a long period of time. Richard Avedon, who contributed so much to our industry, was quoted as saying, "If a day goes by without my doing something related to photography, it's as though I've neglected something essential to my existence, as though I had forgotten to wake up."

There are other simple questions that can open your mind to rediscovering your passion. I ask my students and clients to write down what sections do they instinctively gravitate toward when they go to the bookstore; or what kind of sites on the Internet they seek out; what kind of stations do they have preset on their car radios. They are simple questions, but the answers tell a lot about the person. In the bookstores, do they look for biographies or picture books, children's books, or technical books? When they are online, are they searching out chat rooms or sports Web sites, financial news, entertainment gossip, or the latest fashion styles? Are they addicted to listening to the latest news reports, or political talk shows, or music on the radio (if so, what kind of music)? The deeper we go, the more we find out what is important, even if it seems trivial, because we keep returning to it—not because we have to, but because we want to.

As a kid I used to spend a lot of time during the summer in the city library. I grew large (I've never grown up; I've just grown large) in San Bernardino, California, where the summers are brutal and the library was safe and had the best air conditioning. My sister and I would check out large quantities of books as members of the various vacation book clubs for kids, and pretty soon I had gone through the suggested reading lists for children my age. I remember making up a game where I would slowly walk down the long aisles with my eyes closed, and pretend that I was sending out radar waves that would tell me when to stop. Then I would reach up on a shelf, randomly pull down a book, and read a few pages from the introduction. If the subject matter interested me I would read on; if it didn't, I would put it back and continue with my game. That started me on a long interest in books and the exotic adventures and wide range of knowledge they contained. Eventually I found that there were certain sections that held more interest for me, and I would concentrate on the books those sections contained. In a way, the books spoke to me as long as I was ready to accept their calling.

Another revealing question is where do you like to go on vacation? Again the answers tell us if the person prefers to stay close to home or is adventurous. Does the person strike out alone or with others? To established destinations or to remote, exotic places? As a photographer, you could be earning a livelihood while taking pictures anywhere in the world, even your own backyard.

Another question to ask is, what are your hobbies, pastimes, and interests? Hobbies are a perfect example of something a person would do out of a universe of choices. Interestingly enough, Leonardo da Vinci used to create rebus games for his own entertainment. Imagine, Leonardo da Vinci needed entertainment! He would

write a few words backward and in Latin, then draw little pictures in place of some of the words and create puzzles that needed decryption. That kind of mental exercise kept him nimble in his thoughts and allowed new thoughts to enter his mind— thoughts that were vastly ahead of their time. The brain processes myriad bits of information simultaneously, and from time to time it has to work in another direction, another dimension, then it has to have time for rest before it can come up with a new variation on an old theme or something entirely new.

Jerry Uelsmann, 1982

During an interview with Jerry Uelsmann, I asked him to talk about how he approaches a new project; does he plan what he is going to do or does he instinctively just let the process happen? Here is what he had to say:

I wouldn't use the word planner. I do think that a lot of the more powerful images occur below the threshold of consciousness. You have points of departure in ideas where you start, but you have to be open for a dialogue with that process to see where images can go. Rarely do the images I end up with illustrate the initial idea that I thought might work. So I think there is a lot to be said for keeping a spirit of play, and again, art is one of these things where there is certainly more than one right answer, so it's important to constantly try things.

If you have a camera around your neck, that's basically a license to explore, and when I am out photographing I just respond to things with my camera. I know I don't have to totally conceive the finished image at that point, that something might be an interesting foreground or background or whatever. I never know at that time what it will be a foreground for, but I basically respond to the world and collect material. Then later I sit down with my contact sheets and begin seeing things that may or may not blend together in some meaningful way. And after I get some of those examples to try, then I go in the darkroom. Once I start printing, I constantly see this thing coming up in the developer, and I keep asking what else can I do to this, where else can I go? Sometimes once I try it I reject it initially, other times I stay with it for three or four days in all kinds of directions.

His words caused me to ask a question that had haunted me for some time: "Do you ever have that feeling sometimes, when you are creating things and you look at it the next day, that you don't know where the hell that came from?"

Jerry responded, "That happens a lot. I lecture a lot, and when I talk about the creative process I try to tell people that they've got to learn first of all that uncertainty and self-doubt are essential to the creative process. That as long as you are comfortable with what you are doing, you've been there before and you are simply echoing something that worked for you in the past."

We must not overlook the importance of serendipity in discovering our passion. Serendipity is the ability to make accidental discoveries and that ability is at the heart of rediscovering your passion. If you are too committed to one outcome, you

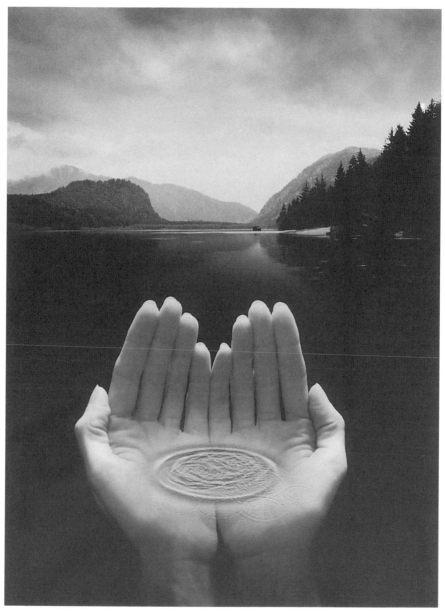

Jerry Uelsmann, 2003

might overlook the alternative that is sitting in front of you. Barbara Bordnick, an internationally renowned portrait and fashion photographer, related this wonderful story of how she came to discover another subject matter and the rewards that "accidental discovery" have given her.

Barbara Bordnick: Delphinium

I was invited to try a digital back on my Hasselblad, and that was my first fascination with digital photography, but it was when I began shooting with Canon's 35mm digital cameras that I really became hooked. And it started me on my latest career change: I was making some photographs for Canon with their D30 camera and there was a mix up with the model booking, so she didn't show up.

In order to deliver something to Canon, I reluctantly photographed some flowers I had sitting on my table. I'm near the Union Square Market, so I usually have flowers. And I entered a world that neither I nor anyone else had theretofore discovered. It was amazing, and the result has been two published books called, *Searchings: Secret Landscapes of Flowers*, Volumes I and II. I am working on the third in this series. In fact, it has resulted in so many different things. Several exhibitions, and most recently a collaboration with the choreographer, Jennifer Muller, to create a dance, *Flowers*, for her company, The Works, which debuted at the Joyce Theatre in New York.

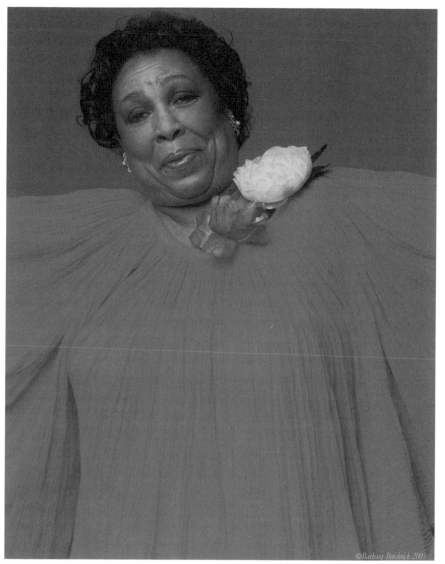

Barbara Bordnick: Helen Humes, jazz singer

This, and many other stories like it, lead me to ask the question, are these discoveries accidental or are they more available than we think they are? Are we just too creatively myopic, or too rushed, to perceive them? Are we so bombarded with stimuli that we can't see the worlds of wonder and possibility that are waiting right next to us? Barbara had the ability to see past the obvious setback of the scheduling mix up with the model and turn the situation into an opportunity, one that has been creatively and professionally rewarding.

Barbara Bordnick: Harpers Bazaar, *1969*

One other very useful method, one of my favorites, for helping someone find the basic elements of their passion is to have them get involved in a mentoring program. I ask my clients, "If you could mentor people in your artistic field, what kind of class would you create for them?" Then I try to find that kind of program for them. The results are always personally and socially fulfilling, and the outcome is predictable. When an artist sees the light that comes into the eyes of a young person he is mentoring, then he relives the joy he himself has lost. Let me illustrate this with a story. I mentioned that I helped start a nonprofit arts program for children after the riots in Los Angeles in 1992. During our first meeting with a group of kids for a photography class, we were ill equipped for the number of kids that showed up and did not have enough cameras. One of the mentors came up with a brilliant idea. The mentor asked the kids to go back home, get some sunglasses, and then return. They all returned with all sorts of sunglasses. We took a grease pencil, drew a rectangle on the inside of one lens on each of the sunglasses and proceeded to deliver a class in one-point perspective. We then marched the kids out onto the street where they walked around until they *saw*, through their sunglasses, an example of one-point perspective. They looked funny crouching down along the sidewalk as they screeched out, "Hey look, the palm trees line up, and the parking meters meet up with them down the street!" The mentor taught a visual lesson but also learned a life lesson about the joy of seeing something new

even in the context of the familiar. That kind of joy can do more for a frustrated artist than anything else in the world. It renews faith in the world and in the purpose of the medium.

One other question that I like to ask of my clients in order to bring out their personal definition of their passion is, "What would you create with your art if you won the lottery?" The reason for the question is obvious. A great obstacle to exercising our passion is the obligations, mostly financial, that make following our heart unsustainable. But if we were not encumbered with money issues, what would we create? I don't know of anyone who has not thought about what they would do if they won the lottery. We have all probably considered how our lives would change if we hit the big one. So if you could create anything, and didn't have to worry about money, what would it be? A gallery showing of your latest portraiture; a visual history of your hometown; a tabletop book of your trip to an exotic island? All of these projects could be financed with some introspection, a vision, a few connections, and some planning—and you would not have to win the lottery to do that.

Lessons Learned

Now here comes the fun part. Find the biggest surface you can write on. Maybe it's an old piece of foam core, or a blackboard, or dry-erase board, or mirror, or sliding glass door—the biggest, least confining surface you can scribble on and not worry about cleaning off later. Now tape, thumb tack, or rewrite the results you developed on the timeline of your work history, the timeline of your personal experiences, the list of your skills, and the list of your interests. Get it out there big as life, because it is about your life. Arrange it any way you want, but put it out there where you can stand back and get a good long look at it.

What do your career and personal timelines tell you about what needs to be addressed first before you can make a career transition? Personal relationships (marriage, family, and friends), health matters (illness or accidents), economic factors, and other aspects of life all have an enormous impact, and it is useful to see how they are perceived and interwoven with your work timeline.

The beauty of this exercise is in the thought processes we bring to it, how we describe our reminiscences, and how we evaluate what we have accomplished. What are the lessons we can learn from putting it all in one place, so that we can look at it as objectively as we can? Do we observe ourselves as victims or masters of our fate? Will Rogers once said, "If you find yourself in a hole, stop digging." Do we see ourselves as shadows of what we wanted to be, or as apparitions of our aspirations? Some of us see changes as the clash of infuriatingly hard choices, while others see change as a flowing river that one just blithely rides upon.

The truth is that life is a mixture of our fanciful expectations and our realized aspirations. The truth lies not in the extremes but somewhere in between. I always laugh when a new talent is described as "an overnight success," because there were probably years of hard work and sacrifice that preceded that so-called overnight success. This, however, is often overlooked in the bright lights of instant fame. In a classic quote, Albert Einstein once wrote to a colleague, "I do know that kind fate allowed me to find a couple of nice ideas after many years of feverish labor."

As you create your timeline in earnest, this dominating question emerges, have you been using the development of your passion as a major determining factor in making your life decisions? If you have been, then you will find it easier in the future to make the transitions that will keep you contributing and productive. If you have not, then you will find hollow satisfaction in other endeavors. Tough but true.

Making Sense of the Inquiries

Obviously what we have just done is to match up your perception of your passion with the realities of living. This has been a short feasibility study to see if you are ready and able to move on to another level of expression. And one thing has become abundantly clear for the person who chooses a life in which creativity plays a major role: your passion has to be continuously monitored; it has to be discovered again and again and again, ad infinitum.

Now that you have it all in front of you, what do you see? What emerges from these fragments when they are woven together? My guess is that there is a tapestry more intricate than you anticipated. Is there too much information, or too many circumstances that make the image hard to comprehend? Then maybe you have to find a way to make it all simpler. Is there a hole where something meaningful should be? Then maybe you have to bring together the elements around the hole and mend the emptiness. What continuously got in the way of your growth as an artist? What did you allow to distract you from pursuing your abilities and possibilities? Are those things, those habits, those excuses still playing a role in your life? Have you been treating your passion as a hobby, or is it time to take it more seriously and raise it to the next level? If it is a passion, you will find the time.

Once you recognize that there is a problem, and you accept the reality that you must do something about it, the next stage in the creative process is logical. You have to determine what you have going for yourself, and you have to get your assets together in a focused way. You have to honestly reacquaint yourself with your strengths and your weaknesses, and address how you will use that knowledge to

achieve your goals. Do you have what it takes to be competitive in the new market-place? How do you capitalize on your skill sets and apply them to the new technologies? Next we will take a look at various ways others have taken their passion and enhanced their knowledge, so they could devote their time to what they desired most: visually capturing the moment.

The Education of
a Photographer

I have been a photographer all of my life. It has been
my life and will continue to be that way until the day
I leave this earth. I am a photographer through and through.
—Douglas Kirkland

Let's say that after much soulful assessment about your skills, experiences, and interests, you have come to a decision that there is something so intriguing about photography that still keeps calling you, and you know in your heart of hearts that you must heed its call. It could be the travel involved in photography, or the technology that interests you. Or maybe it is the lure of meeting the important people who make up our world that piques your interest. But you also realize that you will have to learn new techniques, new ways of doing things, things that will take you out of your comfort zone. The prospect of doing all that work seems daunting, and you don't know where to begin.

Education, in any field, is an ongoing endeavor, and photography is no exception. I have met photographers who, figuratively speaking, have never put down a

camera since they were first introduced to one, and I have met people with widely divergent backgrounds who took up photography after attaining degrees in other fields but didn't feel complete until they brought the camera into their lives. And that is what is beautiful about the photography field: you can enter it at any time; you can change directions within it; and you can be anything you want in the photography arena—because photography is not one thing, it is a language that unifies us all. We live in a visually hungry world, and photography provides us with a window on every aspect of our world. On top of that, photography as a field of endeavor is very egalitarian. All anyone cares about is, does the image communicate, does it motivate, does it instruct, does it make us laugh, does make our blood boil, does it magnify our humanity?

I have had the honor of being involved in showing portfolios and reels thousands of times, and there is one thing I can categorically say about those presentations: no one ever asked me to show them a diploma of the talent I was representing. The creative directors, art directors, art buyers, producers, and photo editors I have met over the years have never asked where the talent I represented ranked in their graduating class. They just wanted to know if that talented person could produce the work on time and on budget and infuse it with unique vision. Of course, if the talent had a solid, formal education in photography, the work should display a high level of professionalism, right from the start. I happen to be an instructor at the Art Center College of Design, which has very rigorous requirements for entrance and insists on a high standard of professionalism in its graduates. I always write the following on the chalkboard the first night of each semester: "Paying your tuition is not the same as paying your dues." We want our students, who will be the next generation of professional photographers, to know that there is no free ride in our industry. You are always gauged by the caliber of your most recent work.

The Importance of Reeducation

We are now going through one of the most dynamic times in the history of photography as an industry. Technology has changed everything, and we are not turning back. Whatever you learned in the photography classes you took way back when has been an important foundation, but it is no longer enough. Traditional, film-based photography will continue to dwindle, and digital photography will continue to grow in the hands of amateur and professional photographers alike. I remember looking over the floor of the PhotoPlus Expo at the Jacob Javits Convention Center in New York City not that many years ago and seeing small booths for digital products in the shadow of the big names of photographic film and equipment. It has been a relatively short time, but the marquees of new digital equipment manufactures have gotten bigger and caused the floor plan to change. Digital products have taken

over the marketplace. Those small one-hour photo shops in strip malls are now turning into passport photo shops and are selling frames and scented candles.

Here is what Ryszard Horowitz, who has been in the advance guard of digital discovery since the beginning, had to say about the impact of new technologies on photographers' sensibility, sensitivity, and craftsmanship: "I am one of the first photographers who went digital. I got started in digital technology years before it became fashionable. I remember when I went to Germany, I met the people who had the first so-called *paint box*, which was interactive. I met somebody in Hamburg, Germany who had it. [I wanted to see what my images would look like if I used it.] I started working with some programmers and instantly knew this was it. When I brought some samples with me back to New York, I faced tremendous opposition from my colleagues, other photographers and most of my clients, and nobody wanted to hear about it. And now we sort of take things for granted.

I interjected: "You may appreciate this but I remember sitting on a panel discussion about twelve or fifteen years ago in which photographers were saying, 'Oh, my god, the digital world is going to take us and swallow us all up and nobody will want us any more, and it will be the end of the world!' I listened to this for quite a while until I was dizzy and then I said, 'Gentlemen, I am sorry, but why do I have the distinct feeling that a similar conversation to this may have been going on in Paris in 1836 among the fine artists, saying, 'Mon Dieu! Daguerre has made the machine that takes the picture and nobody will want us to paint anymore!' We had to be reminded that this is a tool and there was nothing to fear."

Ryszard continued: "There were painters, Degas and many others, who immediately got a camera and started photographing their models, looking for unusual angles and painting from them. When I was an art student, I sensed the camera was a fabulous tool to make notes for perspective, things that had been in existence for ages, using the camera obscura and using all these optical devices to see perspective from different points of view. My teachers were very traditional people who did not like the fact that I attempted to draw from my photographs. They wanted me to study from the painters by copying great works of art and painting, but not from photography. And now everything has become interwoven, and there really is no distinction between photographic and nonphotographic optical manipulation. Everything goes, but it is very difficult for people to change, and so few of them have any vision to see the possibilities of new technologies being introduced."

I followed up with: "Do you shoot mostly traditional film or digitally?"

Ryszard explained: "I stopped shooting film quite some time ago. Ever since they introduced cameras that offer high enough resolution so my eye could not distinguish the difference, they made me totally satisfied. The same is true about ink-jet printers as opposed to working in a darkroom. I've spent years in darkrooms. I built a fabulous darkroom with all kinds of special tools and gadgets. I invented all

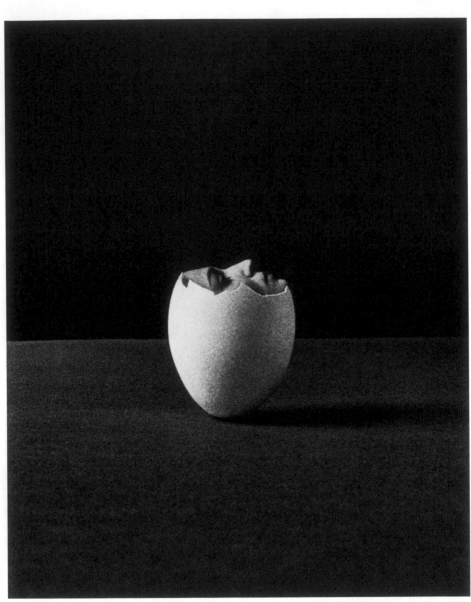

Ryszard Horowitz: Nedda, 1969

kinds of things for myself. And as things progress in digital, I realize there is no need to go back. I mean obviously you draw from the experience, and I am happy to have the experience. But I worked for years in a field called photocomposition, which involved making little masks, multiple exposures, working on the enlarger creating all kinds of images. Now people are convinced they were done digitally. They look at the date, like at a published book right now, and they look at some

pictures that were done in the 1950s and 1960s, and they don't believe, you know. And I am happy in a sense, because my point was that it is one's vision—not what tools or technique one uses—that really makes the difference. It's the ability to communicate what you have to say, and you have to have something to say. So, how you do it, I don't care, I really couldn't care less. You have to master whatever technique you need, and it has to come like a second nature to you—like you learn a language, or play an instrument, and you don't have to think about how to do it, you just do it. You think more in conceptual terms, not in technical."

Ryszard Horowitz: Peeling Desert, 2003

A Willingness to Learn

All the photographers I interviewed for this book had one more thing in common. Right from the onset, when they became committed to photography, everything they had done in their past was somehow worked into their becoming a better, more well-rounded photographer. Their beginnings may have been humble but they successfully parlayed their experiences into broadening their photographic skills.

One pro who has never shied away from an opportunity to learn is Phil Marco. Look his work up on the Internet and you see him listed as a highly respected editorial and commercial photographer, a winner of the most prestigious awards for his photography as well as motion film work. Phil recently formed a company to execute

computer-generated visuals. His work has always intrigued me, and it was a treat to interview him and dig into his willingness to transform creatively. I asked Phil about his background:

Well that's both very simple and a bit complex. I was born into a musical family. My father was an opera singer, and my mom was quite an accomplished pianist who would accompany him when he rehearsed his arias. At an early age I was a bit of a prodigy in music. I played Bach and Beethoven when I was four, and I gave a concert as a boy soprano when I was eleven. My father had moved from opera into show business, to choirmaster and organist of a parish church in Bensonhurst, Brooklyn. Most of my early life I sang in the choir as a soloist. Around the same time, I became interested in art and began to paint and draw. To skip ahead quickly, what I really wound up doing was a little bit of each, but I was very passionate about being a painter. I also used the camera on occasion just to record ideas. But no other focus other than that. So in need of money I hustled and I did a number of things.

To earn money, I could always go back and sing weddings or funerals. I also made pizzas for Joe the Boxer in Brooklyn. And sang club dates in some of the fancier mob run restaurants in Bayridge, and at a few places in Manhattan, like the Limelight in Greenwich Village. I reached the point where I was getting tired of hustling, and felt that I was spinning my wheels. Maybe I'd try getting something steady, painting after work, and snagging some additional gigs on the weekend. I came across an ad for a photo assistant. I had a very light knowledge of photography, having used a camera only as a sketching pad to record ideas for future paintings. I really didn't have too much to offer in the way of experience. But I had a lot of nerve and confidence that I could to do anything I needed to do if I put my mind to it.

So with that motivation I answered the ad. I walked up the steps, which were dripping with water, and I came to a door gushing water from beneath, flooding the hall. The photographer answered the door. He had been photographing people showering, for a series of ads for Dial soap. I told him that I knew very little about photography but I was willing to learn and do whatever was necessary. I guess it was my directness and the fact that he was flooded and he needed somebody to help him at the time. He handed me a mop and said, "The job's yours kid." So I started there part-time because the whole objective was to secure more time and funds to pursue painting. The job paid $37 a week to start.

My job was to get there in the morning, wake up the photographer, walk the dog, and some very basic studio needs. In time I picked up on

loading cameras, mixing chemicals, printing, and what ever else he needed as we went along. The photographer's name was Lou Long. He was a brilliant illustrator with a wonderful sense for casting and people. We still keep in touch, and he's as excited about photography today as he was then.

As I became more involved in photography and was compelled to use it more on the job, I realized that I was in awe of its ability to capture and convey ideas so rapidly and directly. The excitement I began to feel about photography as a medium totally sublimated my need to paint. And what initially had just been a means to an end became an end unto itself, and film became my canvas.

When a little studio on the outskirts of the Village became available, I made my move. It was on Eleventh Street off University Place, around the corner from the Cedar Bar, where Jackson Pollack, Franz Kline, together with a number of other Abstract Expressionists, would gather. And one of the former occupants of the studio, I learned at a later date, was Robert Frank. Things were looking up. I still painted occasionally, but it was becoming obvious that my interest in photography was taking over and growing stronger. My first professional camera was an old 1000 F Hasselblad that I picked up in a pawnshop. I began experimenting with color by flooding a small restaurant sink with water and immersing some stainless-steel canisters I picked up in the Bowery filled with various solutions of color chemistry. The process was crude, but the results were very exciting and genuinely inspired me to move on.

With no clients or layouts to follow, I just began to photograph simple images that inspired me; similar to the way I approached painting. My vision and concepts were strong, but my photographic technique left a lot to be desired. So I continued to reference and apply the lighting and compositional skills I used in painting to photography. I would take a simple circular form like an orange and photograph it in every conceivable light and point of view for days. Most of my first subjects were from the grocery store, and friends. Primarily because they were readily available, inexpensive, and without an hourly rate. Concentrating on still lifes, however, gave me the opportunity to learn how to apply light to a wide range of textures and shapes. It also satiated my interests in science and mechanical problem solving. As I became more proficient with my technique and began to learn how to create dramatic lighting for my concepts, the excitement I felt about photography as a medium of expression began to grow exponentially.

When I was in my early twenties, I created a few dozen images that I was pleased with, and I thought that it was time to go out and get some feedback. I came across a Milanese projector called a Farrania, which was

totally self-contained in a thin, black-matte case. It had a pull-up arm with a lens that projected an image onto the inside cover of the case, which served as a screen. The 2¼" × 2¼" slides were then slid one at a time by hand into the gate. It also had a built-in storage space for thirty slides. I opted to use this method of showing my work, because I couldn't afford quality color prints, and I didn't have any of the lush 8" × 10" transparencies that would eventually become my format of choice. However the 2¼ format at the time served beautifully. It offered quality reproduction and a fast and economical way to capture and present visual ideas. I read all the trade magazines and award books I could get my hands on, looking for designers, art directors, and ad agencies whose work caught my eye. So I compiled a short list and began making phone calls. After numerous hang-ups and rejections, I finally began to get through. Armed with twenty slides and the confidence I gained from the positive feedback I was receiving, I would do whatever was necessary to provide the best lighting conditions for the slide show. Because if they weren't shown in a fairly darkened room, it would be a total wash out, and any semblance of quality and color saturation would be lost. At times I'm sure that it strained the patience of my curious but confused audience. I would think nothing of walking into a room, and after a brief and polite introduction quickly start running around closing doors and drawing blinds or drapes over windows to achieve the right light level for the show. So if the conditions weren't right, I just wouldn't show them. However that was rarely the case, as I was always determined—possessed is probably a better word—to find or create the right light level no mater what convolutions it would take. After a number of successful showings, rumors began to abound about this young Italian kid who was going around the ad agencies with a little black box, and a bit of an attitude about not showing his work if the light in the room wasn't just right. The general consensus was, however, that the images were so fresh and exciting that it was well worth the initial minor annoyance.

I remember going to Doyle Dane Bernbach for the first time in the mid-1960s having made an appointment with a young art director named Len Sirowitz. The light in his room was terrible, and I was just about to pack it in, when I spotted a janitor's closet across the hall that he reluctantly climbed into with me. After a few uneasy moments in the dark, when I began to show my slides, he was so excited about the work that he called in Bill Bernbach, who in turn called out the entire floor to line up outside the janitor's closet. As a result, all of DDB opened up for me, and Len and I worked together on the multi-award winning campaign for "Better Vision" that became part of advertising history.

I observed, "But the emphasis is that you are self-educated."

"Yes, in reference to photography I'm totally self-educated. My education at Pratt Institute and the Art Student's League was in fine art. I learned photography through books, experimentation, and practice."

To me Phil is the spirit of the complex, eclectic visual artist who has not let technology or definitions get in the way of his passion to create. The world provides him with his artist's palette, and he works without the restraints that hold so many back. He is self-educated because he learns from everything.

The Relevance of Every Experience

Usually, we think of our heroes of photography as always having the vocation of photography. But they are surprisingly like the rest of us, and they inspire us with their single-minded devotion to following their passion. One interview that I think may interest you, and at the same time inspire you because of his breadth of experience, is from Jay Maisel. As you look back at Jay's work and you think of his use of light, gesture, and color, you can see how he has drawn from his fine-art training (mentioned earlier), and his appreciation for the variety of life. I asked, "Jay, what did you do for a living before you became a photographer?"

"I worked in a bakery up in New Haven. I mean a big, freaking bakery, not a little bakery, in a factory baking bread. I worked in a rubber plant making gloves. I worked in a delicatessen behind a counter. I sold sodas in an entrepreneurial way. I did sign painting because I knew lettering. I was a soda jerk."

Jay Maisel: Chinese Policeman

I continued, "Did any of these things feed into what you do today, such as skills that you learned, like how to deal with people?"

"Of course. Everything feeds into it."

I then asked, "I know you went to art school at Cooper Union School for Art and Engineering, but where did you get your education to become a photographer?"

"Out of Andreas Feininger's books. Andreas Feininger did a book called *Introduction to Photography,* and that's really where I studied photography."

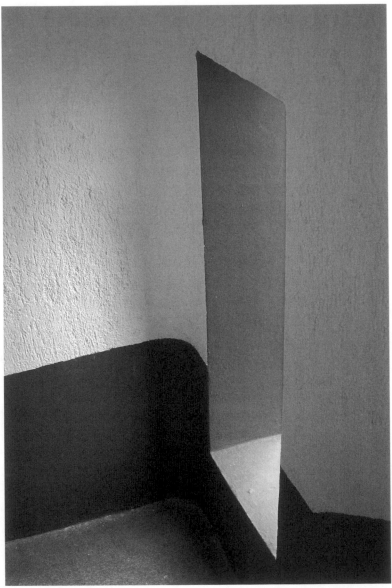

Jay Maisel: Akumal window

Imagine that. Jay Maisel taught himself how to use a camera by reading the popular Andreas Feininger book, and using his skills and personal experiences to bring forward a body of visual art that has touched us all for the past several decades. His recent portraits of a wide array of people looking at the destruction after the World Trade Center disaster on 9/11 is a hauntingly powerful testimony to his ability to capture the infinite variety of pain that coursed though the minds and hearts of the onlookers. Only a person who understands the complexity of our diversity could have captured those moving images that will live on beyond our time.

From One World to Another

As we read earlier, Ryszard Horowitz understands the healing forces of creativity. He has given us images that allow us to transcend our everyday experiences and raise our spirits. As a child Ryszard was separated from his family when the Germans invaded Poland, and his family endured the horrors of the concentration camps. He has never stopped learning, never stopped showing us an alternative world of wonder, and his story is an inspiration to us all. I asked about his education:

> I started taking photographs when I was a teenager. I was about thirteen or fourteen when I got my first camera from my father. My interest in photography happened rather early in my life.
>
> I was born in Krakow in Poland. I went to the High School of Fine Arts, and then to the Academy of Fine Arts, and I never finished because I came here. Here I went to Pratt Institute, where I studied design, advertising design, graphic design, etc. So when I was at Pratt, I had the great fortune of meeting a number of great American designers and photographers. People like Herb Lubalin, and Lou Dorfsman, graphic director of CBS Network, and other designers. Then I met Alexey Brodovitch. Through him I met Avedon, and then I became an assistant to Avedon and then I met a bunch of other photographers. And so, needless to say, slowly, I started working for some of those people and working for a number of film studios and advertising agencies. I also worked as an art director for Grey Advertising. I decided that I really wanted to devote myself full-time to photography. I was in a position to assign photography to others, but frequently I thought I could do it myself, and sometimes I did it better. I wanted to do what I always loved, photography. Photography became my full-time love and interest.

I asked, "At what point did you chose to be a photographer? Was there a specific event or time that you remember?"

I was an art director and group head at Grey Advertising with a secretary and a big window, you know, and money, and I knew it was time to go. I met some people who were very helpful in lending me a little bit of cash to get my own business started. They were friends, but they were also directors with Grey Advertising, and they believed in me. And they said, "Look, you know we'll lend you some money to set you up in your own business." I took the money that they offered, and I found a great place on Fifth Avenue and Eighteenth Street—a place I couldn't afford now—and I stayed there for ten years, with my rent going from $250 to $5,000 a month. And the beginning was rather fascinating.

Work started coming from different places; also right away I began traveling to Europe and working in Paris and in London. I found that my work was received there with greater understanding. Even then, and I am talking about mid-1960s, I already began to experiment with photography. Very early in my life I realized that I am not interested in using photography in a straightforward way; I wanted to capture what's in front of me whether it is set up or I just happened to [catch it while] traveling . I wanted really to *make* pictures. My art background was very helpful, because I was able to make little sketches to memorize some ideas and also to be able to share them with other people. Remember, Polaroid then didn't really exist. There wasn't too much you could share with people, and I started playing with experimenting in the darkroom, playing with the optics, doing all kinds of things people told me not to do. And I began slowly developing a unique style of my own that enabled me to position myself in a little niche within the advertising business and within the editorial business here in New York. Through Avedon and some other people, I became acquainted with *Harper's Bazaar*, which, at the time, was the greatest showcase for photography. And I began doing editorial work for them that only now is beginning to be truly recognized.

Lifelong Education

Education sometimes becomes more of a way of life than a means to an end. One of the most influential photographers who has had an impact on commercial and fine art photographers alike is Jerry Uelsmann. Through his evocative imagery he has always pushed the limits of what can be done with the medium. His story gives an inside look at how our medium has evolved, and is a metaphor for our own evolution. I inquired how he started in photography:

I got involved in photography in high school. And then after high school I went to Rochester Institute of Technology, and from there I went to

graduate school. From graduate school at Indiana University, after I got my Masters of Fine Arts degree, my first job was at the University of Florida. I taught for thirty-seven years, and now I am retired. I taught photography in the Fine Arts.

When I first started teaching, back in 1960, there were very few places that recognized the potential of photography as a serious art form. You had to teach the basic craft, but at the same time you had to teach the history—as much as was available, because the art historians were not familiar with it. And you presented an aesthetic stance of what the potential was. I mean there were a lot of issues to address. It was a very dramatic time because you served all roles. There was not a lot of critical writing about photography other than *Aperture*, and I constantly made slides to introduce photography to my class. I gave them possibilities in terms of things they might be interested in trying.

All the art students took a variety of courses. I was the only photographer for many years, and so all the students I had were painters, or printer makers, or sculptors, or potters. They were fine-art students, so they had all these other disciplines in addition to photography. It was many years before they could actually have their main emphasis be photography. And we didn't really have studio facilities.

I asked, "Would you consider yourself more of a teacher than a practitioner?"

Jerry responded, "Well, you are both actually. The big difference between my life [and those of] other photographers was that no one was buying fine-art photographs, I assure you. There weren't any galleries, even in the 1960s. So your main support system was the university. I worked hard at being a teacher; and it was, in a way, a wonderful time, because you really had a cause—photography was an underdog."

When I interviewed Douglas Kirkland, it was a few months after I had listened to a lecture he had given. The lecture was titled, "Douglas Kirkland—A Fifty-Year Love Affair with Photography." Douglas had that single-mindedness right from the start, when he wrote letter after letter requesting an internship with Irving Penn. That perseverance turned into an opportunity to work for Penn, and set him on a course to photograph some of the world's most recognizable people—people whose personalities were enhanced by his indelible images.

I started out the interview with, "What did you do before your involvement in photography?"

High school. In other words, I have been a photographer all of my life. It has been my life and will continue to be that way until the day I leave this earth. I am a photographer through and through.

Douglas Kirkland: Audrey Hepburn

I grew up in a small town in Canada, Southern Ontario, near Niagara Falls, and the most exciting people in the world, those in the midst of the things that were happening, were the photographers. I was made aware of them through *Life* and *LOOK*, and comparable publications, even daily newspapers in our area. That was a very, very exciting world, and that's what drew me to it. The excitement of travel, the excitement of being in the middle of things, in the middle of Hollywood, in the middle of China, in the middle of Europe, in New York City—all these things that a young kid dreams about in a small town."

Sometimes you have to find your way as you create your career, but when it all falls into place there is a sense of well being that can only be described as coming home. Ken Merfeld has had a lot of formal and informal education, and his story is compelling because nothing is wasted, every experience is utilized in the art that is unique to this extraordinary artist. I asked Ken how he got started in photography:

I was a student, two college degrees worth, and then I dropped out and was a ski bum for a while. A girlfriend gave me a camera and I started to get interested in photography.

I first decided to be a photographer when I was in the mountains. I took a photograph of a very special dog, an animal that was my buddy. Every spring the porcupines would come out, and my dogs would chase the porcupines and would get zapped in their face with the quills. And I did a portrait of this wonderful part-collie/part-wolf dog that I had up in the mountains, and when I looked at that portrait I decided that meant more to me than both the college degrees that I had spent years working on. So I thought, when I rejoin civilization, I would check into the art side of the coin and photography.

I came back down to Los Angeles and heard about a couple of art schools. To put myself through art school, I was a bartender. It was flexible hours, late hours, and I could work part of the night and then tend bar till the middle of the night, stay up and keep on working. That's literally how I put myself through the Art Center College of Design, where I graduated.

[I also have] a degree in psychology and another in marketing management. The degree in marketing management always told me not to go into business, that I wasn't a business person. I went into psychology because I do love people, and psychology is an amazing help. I don't use it on a day-to-day basis, but I would have to say that having a background in it, and being highly observant of people, and looking at people on a variety of levels has helped me tremendously. A little bit of psychology goes a long way.

New Opportunities

Who knows where the inspiration will come from? Just be assured that the inspiration will come if you invite it into your life. One thing about a camera: if you are good with it, it can help you gain entry to places you never dreamed of; it can even start you in a new direction which becomes a new industry, which becomes a world of opportunities for others. One such case is the story of how fine-art photography gallery owner David Fahey began his career. When I asked David what he did for a living before he got into his line of work, he said:

I worked as a photographer actually before I got into the photography business. I had a series of part-time jobs through college. But I dropped out for a semester and got drafted to Vietnam, to the infantry. When I got out of the Army in 1970, I went back to college and I continued my studies in photography. Along the way I actually taught photography studio classes at a junior college while going to college.

The way I got into photography was that I was a musician, and I wanted to get in to hear music for free. *The* club in Los Angeles in the late 1960s was the Troubadour. Every major act that came West usually opened at the Troubadour. So I went up to Doug Weston, who owned the Troubadour, and I said, "If I can get in free, I will take pictures for you." And he said fine, and he introduced me to the doorman, the ticket people, the waiters, and the manger, and he said, "This guy gets in free." So I would show up every week, sometimes twice a week, and get in there before they opened the doors, get the best seat, and I photographed all these great musicians on stage. That's kind of what got me into photography.

[I got my formal education in photography] at Cal State Fullerton. I have an undergraduate degree in photo communication, and a graduate degree in art with an emphasis in creative photography. Outside of UCLA, it was one of the first fine-art photography programs in Southern California.

It was a very close community back in those days. We all knew each other. Quite quickly the students became very friendly in a social way with the teachers, and so we all used to socialize—Darryl Curran, Robert Heineken, Edmund Tuskee, and Eileen Cowin. We all belonged to an organization called SPE, the Society for Photographic Education. That's kind of where all the early photographers met and got together and exchanged ideas and hung out. That's where photographers had conferences. Every year it would be a different location, and people would do slide lectures, that's kind of where it happened. They would use the conference facility up in Carmel at Asilomar, for example. That was open to not only the teachers but some of the graduate students, too.

When I was going to graduate school, I was teaching photography, and I taught at Compton Junior College. That was a job so I could finish college. Then close to when I was finishing, I went into a gallery in L.A., and they had been open only a month. I got the impression they could use some help, so I offered my services. That was the G. Ray Hawkins Gallery. I went in and said "Can I work here?" and G. Ray Hawkins said sure, and after a few months I began to direct the contemporary art part of the gallery.

Because I knew a lot of photographers, it was natural for me to be in charge of that area. So that's how I got in the gallery business. That was in 1975.

I wondered out loud, "How did you recognize the fact that there was a future for fine-art photography? I mean 'fine-art photography' was not necessarily the buzz word of the day."

David offered, "I remember when we sold our first Cartier-Bresson piece for $700. I think we sold four or five of them one month, and that was a big deal. And then we sold an Ansel Adams for $1,000 and that was huge, unheard of. Then, three years later, we sold one for $40,000. Then we began to exhibit and sell Paul Outerbridge's work and that was when everything was changing."

So apparently timing has a lot to do with success—timing, and serendipity, and passion, and on and on.

The Value of Tenacity

Education—scripted or by total immersion—sets the patterns for work ethic and discipline. Acclaimed cinematographer and director Dean Cundey is a special effects maven, a man whose film credits reads like a list of your favorite block-busters. But to hear the story of how he got into the business, it sounds like an un-believable script for an adventure comedy with a protagonist who never takes no for an answer and is always driven by the next creative challenge. His story will give hope to anyone who is fighting the good fight in the film industry. I started the inter-view by asking Dean how he got into filmmaking:

I went to UCLA Film School, and I started studying a broad course of study. There they make you take editing, film writing—all the stuff, so you can understand the whole rather than a certain area. When I was at UCLA Film School, I was taking film, and I was minoring in architecture and graphic design.

Then they announced there was going to be a special class that was going to be taught by James Wong Howe. Howe was one of the preeminent cinematographers in Hollywood—he started in the 1920s—and he went all the way up into probably the 1970s. He was a famous Academy Award–nominee, a very distinguished fellow.

To me it was the most fascinating class because it was unlike the others that were so much theory. He made us all be the crew, and he would show us how to light a set. We had a small, three-wall set on one of the stages at UCLA. Each meeting he would say, "Okay, now we're going to make a seedy hotel room," and we would have to do it with just the lighting—

thinking about the mood and style of the lighting. "Perhaps there's a neon sign outside the window blinking," someone would say. We learned what the actual, practical work was of cinematography, not just hard shadows and soft shadows.

And there was crew group dynamics, like who was in charge. He would say, "No, no, no. You don't come and talk to me, you talk to the gaffer. He is the guy who is in charge of the lights." It was a great class, because he was very deliberately immersing us in the politics and protocols, as well as the practical use of light—all of the stuff that is part of the job. I got completely swept up by how a cinematographer was the dynamic creator of the image. I got fascinated by the fact that cinematography was where you got to work with the director and the actors, and it was the responsibility of the cinematographer to take the production designers work and make it look as good as possible; to enhance it by lighting the strong areas of the set to add really interesting shadows and textures. So I immediately got fascinated by that, and I focused, as it were—no pun intended—to work in cinematography. I spent the rest of that year taking cinematography classes and learning about that, so when I graduated I said, "That's what I want to do. How do I do it?"

Now, I hate to do this to you, but you will have to go on to chapter 8 (on Networking and Preparation) to see how Dean's story turned out. The rest of his story gives us a glimpse of how important it is to keep the chain of associations intact and never to burn any bridges behind you. But I want to get back to education and its role in establishing a career and then redefining it as you progress. What we have seen expressed by the interviewees is that education comes from every quarter of our existence.

We have also seen all of the interviewees express their willingness to learn. To them, a new technique or technology is not a roadblock but a new adventure that gives them more chances to express themselves. And since many of them see themselves as works in progress, learning a new idiom frees them from the indulgence of boredom. Actually "boredom" is not in their vocabularies.

Answers to the Question, "Who Are Your Photography and Art Heroes?"

We read that several of them talked about their teachers, and that encouraged me to ask them who their heroes of photography were. The list is revealing in itself, because it reminds us of the great artists whose works we must go back and review

from time to time, and from whom we receive inspiration. Because the spiral of creative evolution allows us to build on the past and create our future. I am going to give you the extensive list of names the interviewees mentioned, so you can cruise through the list and envision in your own mind those luminaries who have given so much to our profession. I encourage you to use the list as a reference and go back and visit the work of those mentioned. Maybe it will shake something free in you as you create your personal path to rediscovery.

Jay Maisel: I would have to say my heroes were everybody's heroes—Robert Frank, Irving Penn, Ernst Haas.

Eric Meola: Ernst Haas, Irving Penn, Ernest C. Withers.

Douglas Kirkland: Besides Irving Penn and Gordon Parks, a friend of mine is Pete Turner. He's a great guy. I could go on to others, but those are the ones that have influenced me the most.

Barbara Bordnick: Sarah Moon for the exquisite work she does; Richard Avedon for the miraculous energy and power in his work; Edward Steichen, Baron de Meyer, Josef Koudelka.

Bob Krist: I've always been a great admirer of the *National Geographic* guys—Jim Stanfield, Bill Allard, Dave Harvey, Chuck O'Rear, those guys. The classic *Geographic* photographer type has kind of been my ideal all the way along.

Pete McArthur: Landscape photographer John Pfahl.

Phil Marco: My heroes first and foremost are the painters. For lighting: Caravaggio. Joseph Wright of Darby, Rembrandt, and Vermeer to name a few; and for concept and imagery, all the Surrealists—Magritte and Dali in particular.

Ken Merfeld: The people that just struck me from the get-go are people like the reclusive photographer Michael Disfarmer, and August Sander and his plight, what he tried to do with his photographs of the Germans, I think that was amazing. Diane Arbus, just what she did to open the world of photography, to push the limits of what was accepted. That probably hit me strongest of anything, because I understand where that comes from: I've spent twenty-five years exploring that same journey. I appreciate the finesse of someone like Irving Penn, his compositional brilliance and his way with people. I am an old soul, so I also look at some of the older people. Julia Margaret Cameron, back in the 1860s, was an absolutely incredible image-maker and the process that she used is something that I have stumbled into and found absolutely amazing. And I appreciate people like Edward Curtis, someone who will spend thirty-five years working on his passion without any kind of acknowledgment.

Ryszard Horowitz: I love all kinds of photography. I love Henri Cartier-Bresson, his work. As for contemporary photographers, I love James Nachtwey, a friend of mine, I would love to death to do what he does; I can see his passion and his sensibility, and intelligence and sense of composition. I love Irving Penn, his intelligence and style. I love Arnold Newman's portraits, especially the portraits from the 1950s and 1960s, which mean a great deal to me. I hate to mention names, because it becomes almost too personal, but I'd like to get it across that I don't look for inspiration to people who think the way I do, or attempt to see things the way I do. I'd rather go to the opposite. I'd rather go to extremes, and I'd much rather get influenced and excited by artwork in general—you know, painting—and also cinema.

Jerry Uelsmann: I was raised in a classic tradition, so I had the normal historical figures, although I was a big fan of the manipulation of people like Rejlander. But in today's world I think there's such a wonderful broad span of stuff happening in the world of photography with all the crossover digital stuff, and it's hard for me to name individuals. I've always been a fan of Duane Michals, who added a sort of narrative to his work. And I still have tremendous respect for what Ansel did, his accomplishments with the vision and the craft.

David Fahey: Gee, that's a long one. I like a lot of people for a lot of different reasons. I think as it relates to being a gallarist, you have to genuinely like a lot of different things, because you have to be enthusiastic about a lot of different things. In photojournalism there is Jim Nachtwey. Of course Bravo and Weston, and people like Peter Beard. William Claxton I think is one of the top two or three jazz photographers. Melvin Sokolsky is very underrated and I think is a great photographer. There's Penn—can't get much better than Penn, he could do just about anything. But then I like the documentary style of Robert Frank and Allen Ginsberg in particular; he photographed the whole Beat Generation. I mean, go down the list. Herb Ritts, who is Los Angeles born and raised, totally unique photographer—who, as big as he is, is yet to be recognized for how great he is. And then in Hollywood photography, George Hurrell just stands apart from everyone. Then you have someone like a Phil Stern who is kind of like the Cartier-Bresson of Hollywood, he made a different kind of environmental portrait that was more of a reportage style. I love young contemporary work that is being done. It's like I said, I genuinely couldn't sell anything I didn't feel excited about. I have been showing pictures for thirty years and I've generally been excited about everything we've shown. I like all of them equally well. Some are favorites you know, Kertesz is great, Brassai is terrific, it just kind of goes on and on.

Obviously, learning and relearning the tools of our trade are imperatives, and they are an outward expression of how we interpret the world. Now let's examine the value of having a focus and why, out of a universe of options, we chose to shoot certain subjects. This leads us to the next step on our journey of rediscovery.

Personal Knowledge

How do you adapt yourself to change?
You have to constantly be living it, questioning it,
asking yourself, what is interesting to explore?
—Douglas Kirkland

So far you have recognized that a challenge exists, created a timeline to visualize and take stock of your personal history, and rediscovered your passion. These are the first steps of Assessment. That was followed by another element of Assessment—education—in which you considered how successful photographers have learned to reeducate themselves when they were faced with challenges to their creative expression.

By getting an overall picture of your past accomplishments, and seeing how others have successfully dealt with similar issues, you now can start to see patterns of your own behavior emerge that highlight the choices you have made and how you have reacted to them. It's not just the choices themselves but also the reasons why you made, or didn't make, those choices in the first place that expose the most revealing answers. For example, you can now ask yourself some important

questions that will take you deeper into your self assessment: What has been your main motivation for making changes? What are your creative strengths and weaknesses? Have you come to a point where you feel creatively burned out, and what can be done about it? These are just some of the interesting questions that leap out once you open up the treasure chest of personal knowledge. Let's start out by asking the most basic of all questions, which is, what do you really care about?

Your Personal Vision Statement

To start off with, it is important to define what is most important to you and how that works into your career choice. In other words, what is your personal Vision Statement? By that I mean, what is it that you aspire to? When you start your day, what do you dedicate yourself to, or do you just jump out of bed and charge ahead? Do you want to contribute to world peace? Do you want to end world hunger? Do you want to have the world's largest collection of Manolo Blahnik and Dolce & Gabbana shoes? What is it that motivates you? And, very importantly, does that motivation have anything to do with your creativity and how you express it?

You may remember that I mentioned in an earlier chapter that a question I sometimes ask my clients to answer is, what would you create with your art if you won the lottery? Notice I did not say, what would you do if you won the lottery? I asked that once and a client said he would jump in a boat and sail away. He didn't even bring up the topic of how he would enhance his creativity—he just wanted to get away. He had bigger issues than I was capable of helping him with. Now I ask each client what he would create if he won the lottery, and together we try to get to the heart of the matter as quickly as possible. So let me ask you, what are you passionate about?

Passion gives us power. It is made up of vision and energy. It also gives us the justification to strike out on our own and explore uncharted territory. It gives us the courage to challenge convention and open up opportunities for ourselves and others. A vision statement has a personal component ("I want") and a goal component ("to make people confront the human condition" or what ever you feel is worthy of your talent). Vision statements challenge us to reach outside of ourselves. They are the first step in a checklist of factors that will take us outside of our comfort zone and, in so doing, will give us a peek into what we are capable of doing. Essentially, you must first have a vision, and then you have to start figuring out what steps you will need to reach your goal.

Your Personal Mission Statement

That is where the next step, the Mission Statement, comes in. The Mission Statement lays out how we intend to achieve our Vision Statement. "I want to make people confront the human condition by using my camera to capture the face of

poverty." The Mission Statement gives us the authority to bring together core values with our talents. A well-formed Mission Statement infuses a goal orientation into your every action because you now have a sense that you are working on a cause and nothing can stand in your way.

Now you have taken two small but important steps on a journey of thousands of miles, or years, and a myriad of experiences captured on hundreds of rolls of film, or digital media. It all starts with a few words that keep rolling around in your head, and you can't rest until you fill in the blanks. The key to the Vision and Mission statements is that they have to appear to be just a little bit out of reach, but attainable the more organization and effort you put into them. Corporations are famous for having lofty sounding but corny Vision and Mission statements. They then fall short of their goals because they try to be all things to all people for all the wrong reasons. But personal statements of vision and mission have to be concise and meaningful.

You are well served to start out each day saying your Vision and Mission statements out loud, so you can hear them and you can form the words clearly. You can write them on a card, slip them into your pocket, and glance at them throughout the day so you can stay focused on what is important. Before long your eyes will see things that relate to them, your ears will pick out words and sounds that connect with them, you will find people who have the same interests, and you will become aware of them in places you never noticed before.

Creative Strengths and Weaknesses

Once you have a focus in mind you will want to concentrate your energies on what is necessary to achieve your goals. You don't want to spend all this precious energy doing things that will sap your vigor. What are you good at? What are you not so good at? The best way to do this is to start out by asking: what are my creative strengths and weaknesses?

When I ask this question of my clients, it is usually relatively easy for them to come up with their creative strengths; the weaknesses are a little harder to discover. On a personal note, when I was first confronted with this question, I answered that I was known for being a pretty good communicator. Hooray for me. But when I dug around for a weakness, I found that my weakness was actually a mirror image of my strength. The fact of the matter is I hate to be misunderstood, so I go to great lengths to make myself clear. Unfortunately, sometimes I overdo my explanations and end up confusing people. Does that make sense? These two personal qualities are actually tied together in a convoluted way, a symbiotic way, feeding off of each other and keeping both alive. At first I thought this insight was a little perverse, but then I realized that many of our strengths and weaknesses are correlated. It is nothing to be ashamed of, and there is something empowering once you accept the fact and learn how to use it to your advantage.

Here are a few more examples. See if you can relate to any of them:

I · **Strength: organized. Weakness: micromanagement.** Some people think you are very organized, because when you do a job you have everything buttoned up and ready to go with backup in case anything goes wrong. The reality is that you hate to have anything go wrong on a shoot. You need a Plan B—backup pieces of equipment, an alternative location, or whatever. You live in fear that you would get caught not anticipating a problem, so you overcompensate, or micromanage, and have as many contingency plans as the budget will allow.

2 · **Strength: perfectionist. Weakness: perfectionist.** We can all relate to this one. You work your tail-end off striving for perfection in your artwork because that's the way you were taught, and anything less than perfection is not your best effort. You toil away noodling the props, or chasing reflections, or getting the right angle and light, or (here's my favorite) fixing it in postproduction, only to find you are running out of time (or light, or disk space, or budget, etc.) and you have to settle for something less than perfect.

I hate it when that happens. So you realize that being perfect is not all it's cracked up to be, and you have to recalibrate your idea of what can actually be done.

3 · **Strength: no fear. Weakness: no fear.** You accept every job that comes your way with no thought of failure. This "Bring it on!" attitude is envied by those who do not have it; no obstacle is too great and no challenge is left unaccepted. Of course, the downside is that sometimes you get in over your head and you end up spending more time and money trying to make everything right, when a little calculated caution in the beginning could have saved a lot of grief.

I've known many an entrepreneur who had this way of doing business, and they were either considered great visionaries or great failures.

4 · **Strength: Experience, knowledge, and time invested. Weakness: Too much experience, outdated skills, and past your prime.** Ouch. This one's for the mid-career folk. You, the over-qualified worker, find yourself in an employment no-man's land, when instead you should be sought after for the wealth of knowledge you bring with you. The new technologies have brought us seemingly unlimited resources for knowledge, but they have failed miserably to bring the wisdom concerning

how to use that knowledge effectively. There is no substitute for experience, but a lot of clients and employers are not willing to pay the price. Which is wrongheaded, when you think of it, because the older worker has the wisdom to control costs and work around problems.

No doubt you can see something of yourself in some or all of these cases. Knowing your own creative strengths and weaknesses is an important step in appreciating the extremes and understanding how far you are willing to put yourself on the line.

The obvious outcome of knowing our creative strengths and weaknesses is that, once we have identified them, we can either educate ourselves to overcome the weaknesses, or we can look for people who can help us make up for our deficiencies. But we have to be very careful here and not become complacent, expecting that the person or persons we hire to make up for our creative weaknesses are the answer to all our ills. They may just add another layer of complication if their vision and our vision are not compatible.

Compatibility of vision and shared agendas all depend on shared goals. When the stress caused by conflicting goals reaches a certain point, we get distracted from our passion. For whatever reasons, we find we are spending more time taking care of things other than our passion. We lose time, then energy, then the will to attend to our form of expression. The downward portion of the cycle begins. We are headed to that dreaded Valley of Despair again, where we are tired of it all. There is even a name for it—we say we are "burned out."

Creative Burn-out

I have given a considerable amount of thought to the phenomenon of being "burned-out." Burn-out manifests itself in a multitude of ways. It may occur when we become frustrated because we cannot create. Burn-out may occur when we have been repeating the same act over and over again and it offers no challenge to our psyches. Once we fall into burn-out's clutches, we feel we will never be able to unleash ourselves from its grip. There is a physical component (you have to be healthy to climb out of it), a psychological component (you have to get your mind in a positive framework to overcome it), and a metaphysical component (you have to have a high sense of duty necessary to snap yourself out of the doldrums). In my interviews with successful photographers I saw glimpses of these physical, psychological, and metaphysical aspects of creative burn-out in their responses, which were as diverse as their personalities:

Eric Meola was direct in his response: "Sink or swim. Just do it."

Jay Maisel, as usual, had this straight-ahead advice: "I hear that a lot, and I just think you need to get rid of all the bullshit around it and get back to the basics of

photography. Just go out and take some pictures without having somebody telling you what to do. Go out and take pictures of what interests you rather than what makes money for you. And if you are still burnt out after that, then maybe you shouldn't be in this business."

Pete McArthur's response because it was just like him—candid, self-deprecating, and funny: "Take a class or just grow up, quit whining, and shoot something like you would have done twenty years ago. This goes for me too."

Pete Turner had this to offer, based on his own experiences, in which each opportunity has the potential of leading to another option you may not have initially considered. When Pete started to feel burned out, he would remember the stamp collection, and how the brightly colored stamps spoke to him about the exciting world out there: "I'd say, I've had enough studio shooting or commercial stuff. I'm going to go off some place on my own and just shoot to clear my head out. Interestingly enough, some of my better pictures were made on trips like that where you just go and follow your instincts completely."

Douglas Kirkland gave this advice based on how he handles the subject: "Explore the latest technology. What I do is the following; I keep looking at pictures all the time, everywhere. I keep trying to extract from them. I don't want to copy them but I want to get some nourishment from them. And I keep getting input from them all the time and occasionally I see something I really like, and I say, 'I wish I'd done that picture myself. That is really cool.' Now, what can I learn from that? What elements are there in this that I could use? Again, this is not copying; this is just nourishment and understanding. Correspondingly, you see something really bad, that's really been messed up, and you say, 'What did they do so wrong?' It's all part of the process of continuing to learn."

I believe that we all internally know what we have to do, but sometimes we need the support of those we trust to help us along. **Barbara Bordnick** touched on the importance of relying on the honesty of friends: "I was very burnt out and unhappy until that model didn't show up. [See anecdote in chapter 3.] My friend, Sarah Moon, advised me to just take one photograph everyday and not worry about what it is. Just shoot everyday. It was great advice."

Bob Krist had this great insight to offer based on a recent experience: "I can only say, try something different. Believe it or not, you get burned out no matter what you are doing. I don't like to say this out loud because it sounds so ungrateful, but I was in Italy for six weeks shooting a big stock thing, and I was just trying to get a handle on shooting in Rome. I called my wife and said, 'I'm burned out on travel. I can't do this any more. I just don't want to do it any more.' And she kind of talked me down off the ledge. You can get burned out on anything. Too much chocolate cake and you'll get burned out on chocolate cake."

Bob Kirst: TelCenter

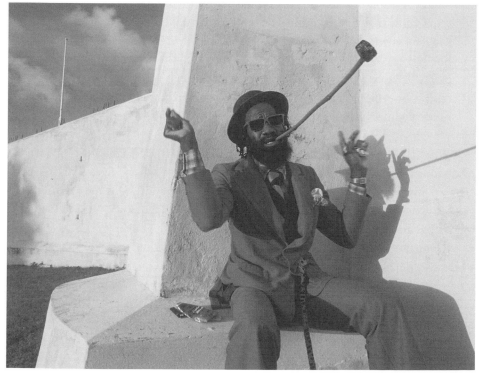

Bob Krist: Pipeman

When I posed the question about creative burn-out to CLIO and Ace Award winning travel/documentary photographer Mark Edward Harris he reflected on himself and other photographers giving us a glimpse as to how common the problem is. Mark has traveled the world producing remarkable photography and film as well as publishing three books, *Faces of the Twentieth Century: Master Photographers and Their Work*, *The Way of the Japanese Bath*, and *Mark Edward Harris: Wanderlust*. He offered this unique perspective:

I don't think you can force anything or be too conscious about something like that. You can't say, "Oh, what's the latest trend?" and go running around after that. I think the thing to do is just go out and do personal work.

In fact, Eve Arnold had a great effect on me. I had interviewed her years ago. But even before that, I was doing some research on her as a student, and in one of her books, I think it was *Flashback! The 50s*, she said she was either sitting around panicked waiting for the phone to ring or overwhelmed by work. So to smooth out her life, she started developing personal projects. And I think when people have personal projects, they never get burned out on those. And it actually makes the commercial work less of a burn out possibility, because you are thinking, oh, this is how I am making money to support these personal projects.

I know that Annie Leibovitz every once in a while gets on the road and shoots something, like she went to Bosnia with a camera and some film. She was tired of all these twenty-people productions, and she wanted to get down to the basics again. She's actually an excellent documentary photographer. So when I get that type of feeling, or when things start to get repetitive, it's like, okay, now I am becoming almost a caricature of myself.

What an incredible statement: "a caricature of myself." That is probably the most comprehensive phrase I have heard on the topic of what it feels like to experience creative burn-out. You don't even feel you are yourself. You are standing outside of yourself. You are acting the way others expect you to act, but in a way that makes you uncomfortable in your own skin. You are not your own self.

If you are not being yourself, then you need to find that self that is you again. **Phil Marco** had this straightforward answer: "Sometimes it's a matter of just getting away from it all. Maybe go to galleries and do nothing, but observe. Put everything aside and let your mind become a blotter, and then just give it a rest. Literally take a break. Sometimes you have to get out of what you are doing in order to come back in with a fresh point of view."

Ken Merfeld offered this deeply considered response: "I think all photographers need to build in a little bit of a preventative balance within themselves so that

doesn't happen. I believe that a photographer has to have a release within their medium other than just the type of work they are earning a living from. Whether it's picking up a toy camera or walking around weekends shooting snapshots with a point-and-shoot, or using a pinhole camera, or just playing with your art instead of always having the pressure attached to it. We all began as photographers because we loved the process of image-making. We loved the surprises. We loved the magic. That gets bled out because of all the pressures, and because of the deadlines, and because of the competition. That's why people get stressed out and lose their love for the medium. So if you have a way that you can protect that love of the medium, you can survive."

Ryszard Horowitz's thoughts reflect his philosophy but goes well beyond it: "Well, the concept of being 'burned out' is hard for me to identify with. I understand it very clearly, and as I mentioned before, most of my friends burned out or moved on to other things. But if you really have passion for photography, and you really do it because you love it, how can it burn you out? You can be burned out by a nasty client, or by circumstances, but not by photography as such. Of course we all go through stages when we stumble—nothing comes out and there are only difficulties, and nothing works—but that is something that we have to overcome. It's hard for me to make too much sense out of it, except that if somebody feels burned out, take off, change the environment, go to the other side of the world, do something else for a while and then go back. I love moving myself away from it. I have a place in upstate New York in the woods where I can totally escape the madness of business. Also, I love to travel, I love to meet people in different parts of the world and show my work, look at their work. I love meeting with young people, it's like a two-way street: I learn from them, they learn from me. I see their enthusiasm, sometimes I see their talent, sometimes I see no talent, but it's very exciting because you see yourself in the past. Watch your own children kind of growing. Relive your life and see how they stumble, or they don't."

Jerry Uelsmann revealed how his perspective on invoking the creative process has mellowed over time: "Everybody has to deal with that individually. A lot of people ask me about 'blocking' and all that. We all have blocking systems, but as you get older you learn to cope with that and I basically work through them. It's like we have this twenty minutes to talk [during the interview], let's just be profound. You can't do that. You can't say I am going into the darkroom to make these wonderful images, but at least I try to create conditions that are conducive for things to happen."

David Fahey gave a practical response as to how those in the world of fine art photography might deal with creative burn-out:

Add to your photo library. Buy more books, look at more pictures. Look at what other people have done. For a fine art photographer, it's all about making something that someone hasn't seen before, or making it in a way that hasn't been done before. If you are aware, it helps you to more quickly get to where you want to go.

And as far as shaking it up, I think fine-art photographers should think about making work toward an objective, with the objective being an exhibition or a book. Do your own book. Make your own book dummy. Find your own writer, create a package that is appealing, and then show it to people and show it to yourself and ask yourself, 'Would I pay $50 for this?' And if the answer is no, then it's not working.

When you show it to other people, you want to show it to diverse groups of people, not just your friends and family. Show it to outsiders who don't have any axe to grind or any affiliation with you, and try to get some honest feedback. Get answers, because you just can't wake up and decide to be an artist one day; you have to spend time at it.

So there it is. Being "burned out" from time to time is a common enough occurrence. It happens periodically and apparently to almost everybody. It may even be a key ingredient in helping us recognize that we have to make a change; a warning shot that we need to do some self-assessment. It involves the body, the brain, and the spirit, all of which need to take a break occasionally to relax, to rejuvenate, to reinvent themselves as well. There is a story that Einstein was daydreaming at his job as a patent-office clerk when he came up with his general relativity theory.

Of course some people may claim they are suffering from chronic creative burn out, but I suspect they are only covering their lack of motivation in fancy terminology. For those living in that exotic region of denial there is no hope, no energy big enough to move them to the next step. I have met a few people who have never gotten past the "what if" hurdle. I am sure you have too. Thank goodness you are not one of them. The fact you are reading this book is proof that you are willing to ask the necessary questions that will help you take control of your future. So what holds us back? What diminishes our abilities to accept the possibilities? One obstacle is obvious, but it can also be obscured by misperceptions. Many times that barrier is risk. The next chapter will allow us to consider risk and how to gain control over its power.

Barriers to Entry

Whether we like it or not we're going to be yanked by change right through our whole lives. Change is here to stay.
—Pete Turner

One of the most powerful reasons for stopping short of taking a chance when change offers an opportunity is the perception of risk. Just to be clear here, by "perception" I mean possibility, and by "risk" I mean the chance of loss or injury. In other words there is a fear of losing or being hurt by something, which may be real or imagined. From your overall assessment of the previous chapters, have you noticed that you have often gone with the safer decision? What kind of creative career risks have you taken and what were the outcomes? What has been more important when considering your creativity, choosing security or picking the unknown? In order to overcome our fears, we will have to have a clear vision of what we want, and we will need to understand our strengths and weaknesses, as was explained in the last chapter. In this chapter we will look at the concept of embracing risk rather than using it as an excuse for inaction.

Don't get me wrong. I am not implying that all your choices have to be totally selfish and foolhardy in order for you to have a fulfilled life. Of course you have to

make decisions that are going to involve and impact your loved ones, and their needs must be honored; but you must not forget to give due consideration to using your gifts, your talents, your passion, when making those decisions. It's the responsible thing to do.

And I am not suggesting that the only truly free people are those who have no bosses. It's just the opposite, in that you will never be so bossed around as when you are in charge. You are not selling out when you punch a time clock, or pick up a regular paycheck, as long as the work you do is fueling your desire to make a contribution and filling that need inside of you to be part of something greater.

Job security is nothing more than a construct. As a friend of mine says, job security exists between the ears. My generation, the baby boomers, had parents who suffered through the Great Depression. To them the most important thing was to make sure they had job security so that their children would have financial security. But when I entered the workforce, I could not conform to the structure of the eight-hour day. I could not understand that I had to sit around for eight hours even if my work was finished, or that I had to go home even if there was more to be done. How could I be secure in my job if I felt I was wasting my time at it? Going out to make a living on my own was considered risky, but it was something that I had to do because the alternative was unbearable for me.

The days of graduating from school, getting a job, staying there for thirty years and then retiring are pretty much over. By some estimates, today's worker will have five or six job changes during his career. And as medical science improves our ability to live longer, we will have even more chances to—that's right—have more jobs. The rug can be pulled out from under you at any moment, and you can find yourself in totally unknown territory. So why not prepare yourself with a little knowledge of your abilities and how to go about using them to their best potential?

I am not advocating that you change jobs just for the sake of change. Running off to join the circus is not the answer to all the ills of job disenchantment. Maybe the job you have now can be improved with some restructuring or communication skills, some fine tuning of attitudes. It could be that you and your clients or co-workers just got away from the core values (Vision and Mission statements) you started out with. The topics we are about to consider might 1) help you to ask the right questions; 2) start the right discussion; and 3) possibly create the dialogue that will build a more productive atmosphere.

I am proposing that we approach risk in a calculated way, weighing our options carefully, and thoughtfully acknowledging what we have going for ourselves. In that manner we can minimize the odds of failure and enhance our likelihood of success.

Risk Assessment

Risk is an essential part of the artistic tradition; it is part of every story of growth. Even though we can go back to ancient times and find examples as to why we

should not take chances, we still tempt the fates in hopes that we might succeed where others have failed. One classic example we all know from Greek mythology involves the archetypal artist Daedalus, who was directed by King Minos to create the labyrinth to confine the dreaded Minotaur on the island of Crete. In his attempt to leave the island and also save his son, Icarus, Daedalus designed wings of feathers held together with twine and wax, so they could escape by flying over the Aegean Sea. But young Icarus, who was warned to fly a middle course, gets carried away with the exuberance of flying and strays too close to the sun, thereby melting his wings and crashing to his death. Icarus's legacy is that he is now nothing more than a symbol of bad judgment for future generations. Had he listened to his father, he would have been saved. But no, he had to get cocky and push beyond the limits of reasonability. The part of the story that is fascinating to me is that presumably Daedalus made a successful flight because he understood the limits of his invention and he steered a measured course.

For some, just the thought of risk turns them to stone. They never take chances, because the outcome might be more terrifying than the ordeal itself. Fear of risk can come in three forms:

1 · Fear of failure (self doubt). It is easier to do nothing and know where you stand than take a chance and not have any certainty of the outcome. This is also sometimes known as an excuse for laziness.

2 · Fear of not being able to live up to your own expectations, or not being able to live up to the expectations of others. But if those expectations stand in the way of your passion, how valid are they anyway?

3 · Fear of fraud. The chance that someone will find out you don't know what you are talking about, you will be revealed as an imposter, and you will be ostracized.

Fears are grounded in the *anticipation* of pain. Therefore the best way to overcome fear is to take command before you find yourself immersed in a threatening situation. How do you do that? You do it by becoming knowledgeable of the threat by doing research, educating yourself, gaining information, visualization of the situation with yourself in control, and then proving to yourself that you are well armed with the information you have gathered, and that you will gain from the experience no matter what the outcome. When you have knowledge of the obstacle, you can weigh your reactions, calculate your means to succeed, create alternate plans in case things go awry, embrace the challenge, and grow from the experience.

Some people seem to have the risk-taking gene woven into their DNA; others have to cultivate it. I remember reading a story of how Steven Spielberg gained entrance to the Hollywood. Apparently he discovered his passion for filmmaking at an early age when he used his dad's camera to make family movies. Then, when he was a teenager, he took a tour of Universal Studios and managed to leave the group tour to explore on his own. When he was asked what he was doing by a studio official, he said he wanted to learn about films so he had ventured off on his own. The official was so impressed he gave young Steven a pass, which allowed him onto the lot for a week. Each time he walked through the gate, he made his presence known to the guards and they got used to letting the young man pass. He turned that week-long pass into an ongoing one. He managed to get on the lot for three months. He even placed his name on one of the empty offices. He visualized himself right onto his career path. He literally saw himself in the role of studio executive, and he took the small steps that led to the larger steps necessary for him to create his dream. That kind of chutzpah has given us one of the finest filmmakers of our time.

The Artist as Risk Taker

So what is it that lets photographers who have successfully recreated their careers know when to test their limits, but also know when to step back? What internal mechanism allows them to go further than most are willing to go, yet alerts them to stop short of self-destruction? I asked a number of professionals how they dealt with the topic of risk as it applied to their careers and the reinventions of those careers. Read between the lines of their answers and you will find that something special about each one, which will tell you about the depth of that person's character and breadth of judgment.

Some, like **Phil Marco**, accepted the title of risk taker as a badge of honor: "I think that part of the excitement in life is going over the edge and trying something new. Although some sensibilities remain the same, I've never been afraid to move into new areas. I find that it's not only very challenging but necessary."

Douglas Kirkland took a long-range view of risk: "I suppose that's a very interesting word, 'risk.' Freelancing is a risky business, but there isn't any work today that does not have its risk. My grandfather was born in Scotland, came to Canada, and got a job as a teenager in a foundry and spent his entire life working one job. Essentially nobody can say that anymore. Because things change, jobs change. If you are looking for security you are probably more vulnerable than ever if that's all you're thinking about, because you will not take enough risks to satisfy your curiosity. The most secure person is the one who is adaptable."

Bob Krist reinforced these views: "Funny, we talked about that the other night. We, Peggy and I, took some enormous risks when we were younger, when we were going freelance. And now that we are both in our fifties we're not such risk takers

anymore, although this thing with self-publishing is a big financial risk. I think we're taking more calculated risks. But I am not a daredevil in any manner or sort of way. But if we need to risk something for a new outlet or something, we will try it."

Mark Edward Harris took a pragmatic approach. What some people might think is a risky lifestyle, he sees as a normal part of his job: "I'd like to think that I am always ready for an opportunity. In other words, if I get a call this evening saying,

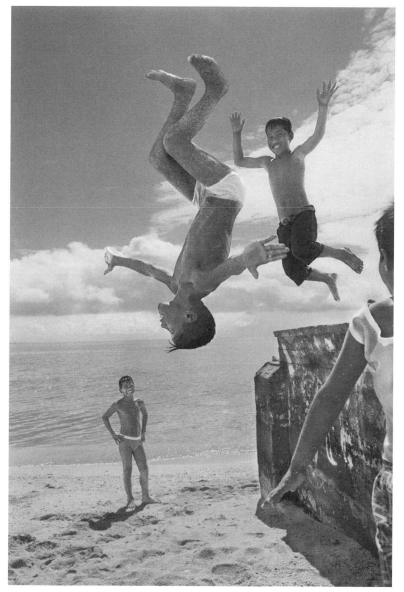

Mark Edward Harris: Children Playing

'Can you get on a plane tomorrow to Tunisia to do something on this earthquake?' I'll do it. In other words I am ready to go. Just like the shoot to do the Special Olympics came up, I think, two days before they were starting, so I was ready to make a move. It was the last thing on my mind when I was invited to this dinner, but the person there said, 'Boy, we'd really love to have you there.' I don't know if that is risk taking so much as it's just juggling. For some people, change is tough.

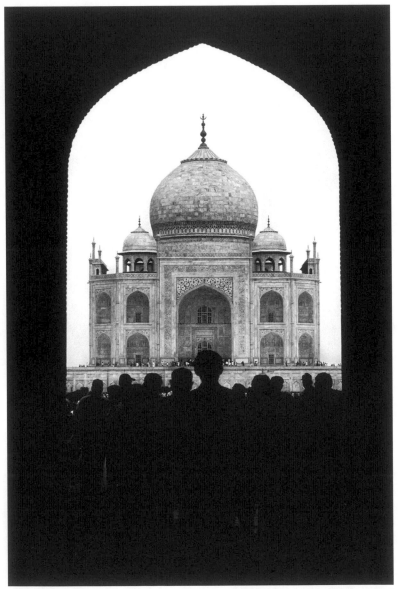

Mark Edward Harris: Taj Mahal

That type of change means nothing to me. If there's a flight this evening to anywhere in the world and there's a good assignment, then I am ready to go, simple as that. It's hard to say which part is the risk. To me I think just that ability to adapt very quickly to a situation—like all of a sudden I have to be in Japan tomorrow—I could do it and I feel very much like I am at home wherever I am. That type of personality is vital for what I do. You don't have two or three days to sit around. You just do it."

Ken Merfeld had this to say about taking risks: "I've always been one to push the envelope as far as the type of work that I do, the variety of work that I do. I just have never been satisfied doing one genre, so I've explored a lot of different levels of commercial photography. The personal project is very important to my heart and I've risked many times going out and changing the subject matter of that project. Whether I'd spent a year or two working with bikers, or transvestites, or people with their pets, whether I feel I've exhausted or explored an area for long enough to understand it and have a viable body of work and make a decision to go to another area. And that's always a risk, because if I was starting over with new subject matter and new people, reasserting who I am and what I do with these people, no matter what the type of person I am dealing with, can I still do consistently what I do, across the board, as far as getting underneath someone's skin or into their heart and soul? If I can do it with a gang member, can I do it with a difficult CEO?"

Few people take as many chances as Pulitzer Prize–winning photojournalist Nick Ut. Nick has been a photojournalist since the Vietnam War. Nick received his award for his unforgettable photograph of a young Vietnamese woman running through the streets, her clothes burned after a napalm bombing—a photograph so powerful that it helped to change the way the American public viewed the war and thus changed the course of history.

During our conversation I asked him about the circumstances of the famous photograph, how he got started in photography, how the profession has changed over the course of his many decades as a photographer, and his work process:

> One of the aircraft dropped napalm and the bomb killed a couple of her family members and her clothes were all burning. Her back was burned very badly. They had many photographers and TV cameras there, CBS, ABC, NBC. In the old days they shot film, and some had to rewind their film because they [had taken] pictures of a grandmother carrying her one-year-old grandson who died in her arms, and they were out of film. And that's why when the girl was running, nobody had any film left. I had three or four cameras. I saw a lot of black smoke and the girl running, and so I ran and took a picture of her.

[I am Vietnamese. I was a teenager during the Vietnam War.] My brother was an Associated Press photographer. Like me, he was a combat photographer. He died in 1965. I asked AP if they would give me a job, and they said, "Nicky, you are too young, you are only sixteen." I wanted to learn something about photography, and they gave me a darkroom job. I loved it there. After that I said that I wanted to become a photographer, and they saw my pictures and said, "Nicky, you're a good photographer," and I said, "Okay, I'll go out and shoot the war," and I became a photographer after that.

Things are different now. When I first started, we shot black-and-white film, and you had to develop your film yourself. But today it is easy because of digital cameras. When you take a picture you put it on your computer and send it in right away. Back then you had to set up a darkroom everywhere when you wanted your picture right away. Today you can set up a computer anywhere you want to go. You go to a Starbucks Coffee house, sit down, eat, and send the pictures. . . .

[In terms of planning versus instinct], if you go to do a feature, you have time to think about the story; but when you are on the news you don't have time, you have to have action and act right away. But like I told you, you make this your business and you do the assignment right away.

Then I said "I am going to ask you a question that is going to sound stupid but I have to ask it because I have asked everyone else. Do you think of yourself as a risk-taker?

He said, "No. AP has been like a family. When my brother died, I loved the company so much because I had so many friends with the company. I enjoy the job all the time. When I told them I was leaving the company they said, 'No, Nicky you better stay because the company is like your family.' That's why I enjoy working. They love me so much and I love them, too."

Nick certainly takes what most of us would consider all the risks in the world, because he's out there where people are getting hurt, and he is our eyewitness to it all. But he sees it differently. The people he works for are his family, and he would do anything for them. But he's not foolhardy either. He's been in harm's way for forty years, but he has had the good sense to protect himself, so he could photograph another story, another day. Like he said, he knows his business. So, I suppose, our perception of risk is related to what we think is at stake.

And so it goes—risk is what you make it. Making sense of things is what our minds are all about. Could it be that many of the things we initially consider as barriers to entering some new area of enterprise are really illusions, mirages, and chimeras? With knowledge we can assess how much risk actually exists and calculate the margin of success. Maybe we only need a new way of seeing things to look past the prejudices and excuses we have assimilated into our field of perception. Maybe we need to broaden our knowledge to give ourselves more patterns to recognize and visualize more options for success.

Planning

Marketability

And in short, according to a variety of cases, I can contrive
various and endless means of offense and defense. . . . In time of
peace I believe I can give perfect satisfaction and to the equal
of any other in architecture and the composition of buildings,
public and private; and in guiding water from one place
to another. . . . I can carry out sculpture in marble, bronze, or clay,
and also I can do in painting whatever may be done,
as well as any other, be he whom he may.
—Leonardo da Vinci (from a résumé he sent to the Duke of Milan)

I love this quote. We all share a huge admiration for the great Leonardo da Vinci, partly because his work resonates so well with each one of us individually, and partly because his work is so universal. He appeals to our sense of beauty, and he challenges our highest aspirations. He is the epitome of the artist/engineer, two worlds coming together. He is the operational definition of the Renaissance Man. He is right brain and left brain working together to explain and expand our consciousness. To many of us, he is the ideal intersection of design and technology, so far ahead of his time that he helps to define our own.

It is unimaginable to think of him having to explain himself and his work, let alone conceive of him sending a curriculum vitae to the Duke of Milan in order to get a job. But the truth of the matter is that all of us, no matter how brilliant or ahead of our times, have to effectively market ourselves if we want to keep doing what we want to do. It's a fact of life now, as it was in da Vinci's time. Leonardo was not only a genius at creating great works of art and visionary technologies; he was able to put together one heck of a résumé letter. Let's take a closer look at the composition of the letter.

First of all, he understood what was relevant to his potential benefactor. He did his homework and discerned that power and the display of that power were the things the Duke sought most dearly. Regardless of what Leonardo thought about his own talents, he fashioned a letter that appealed to the Duke's self-perception. "I can contrive various and endless means of offense and defense" was a great way to get the attention of a man with a powerful military force at the crossroads of the known world. If Leonardo could gain access to the Duke's military budget by creating not merely the latest but "various and endless" contraptions of war, he could tap into a great reservoir of wealth.

Next, Leonardo introduced the idea that he could also create architecture in time of peace, thereby ensuring the Duke's legacy of financing great edifices of lasting importance—buildings, bridges, and aqueducts that would stand as memorials to his generosity for generations to come.

But Leonardo didn't stop there. He moved on to the most basic of motivators, the Duke's ego, by proposing that, if hired, he could sculpt glorious statues, which ("Can ya see it now?") would powerfully grace the piazzas in front of the magnificent buildings, a testimony to the Duke's mighty and benevolent nature.

And, almost as an afterthought, Leonardo pitches in that last casual line, as if to say, "Oh, by the way, Duke, old boy, I can also paint as well as any other painter." It is added as a little portion of humility just to temper the tone of the letter. It speaks to Leonardo's willingness to be a principal participant in the Duke's plans; he is self-assured but not arrogant, and he understands the expectations of his potential patron.

It is a beautifully engineered piece of prose, and one which I use in my classes to point out that it doesn't matter how talented you are, you still have to let people know about your work to have it become known and ultimately accepted. We all have to promote ourselves. We cannot wait around to be discovered. We have to allow others the opportunity to think they discovered us—even if your name is Leonardo da Vinci.

The Conventional Approach to Promotion

What is the best way to go about the process of marketing ourselves and our work? This is probably one of the questions I am asked most frequently by artists who are eager to uplift their careers. Unfortunately, somewhere along the way, many of those

artists learned—or rather acquired—a method for promoting themselves that has proven to be more detrimental than helpful to expanding their opportunities. For the sake of discussion, let's call this method the "conventional" promotion approach.

It involves the artist doing an extensive review of what is currently referred to as *the style* of the day, the thing that is currently *in* and apparently selling. This could be some technologically driven method, an approach to color (remember infrared, and cross-processing?), or even a mood (how about the vacant stare of disenchanted youth as a favorite subject matter?). Each style starts out as innovative—somebody took a chance—and is eventually embraced as the "new thing," until it inevitably becomes ubiquitous, cliché, and saturates the visual marketplace. A friend and fellow instructor of mine, creative director Mel Sant, recently said, "Just think of it. It wasn't that long ago that we were all smudging Polaroids."

Once photographers adopt that style, they then save up their money, or mortgage all they have to buy the largest mailing list known to mankind, along with a massive amount of stamps and envelopes, and eventually they send out examples of their "new" work to anyone with an address. The hope is for a possible shooting assignment to come from this expensive and labor-intensive mass-marketing approach. Then, finally, the photographers sit and wait by the phone for that special someone to call. And, they sit, and they sit, and sit.

The "Passion First" Marketing Approach

Now contrast that method with what I believe to be at the heart and soul of marketing as it applies to creative entrepreneurs. I call it the "Passion First" marketing approach. The first thing you have to remember is that the conventional marketing approach may be relevant for generic consumer commodities like toothpaste and laundry detergent, but it is hardly appropriate for products which are the manifestations of a unique and personal vision. What makes your vision one that clients want is its individuality, its ability to call attention to itself, to cause a potential customer to take notice of it and ultimately consider buying the product. First and foremost, your "Passion First" marketing approach must express your one-of-a-kind passion, your personal vision, your singular interpretation and execution, not your ability to replicate.

Here's Step One. We start by asking the fundamental question, "What do you LOVE to shoot?" I don't mean, what do you *like* to shoot, I mean LOVE to shoot. For example, when you wake up in the morning, and you say, "Today is a great day because today I get to shoot _____!" What is it that you fill in the blank with? (We will get more deeply into this later on.) That's what I am talking about. By fantasizing that you don't have anything holding you back, what would be the greatest possible shooting day you could imagine? If you are having a hard time imagining it, close your eyes and visualize yourself waking up tomorrow morning and asking yourself that question. That is where our process begins. As always it starts with

passion. Once you have defined that thing that is uniquely motivating to you, passion opens the door for you. And it does not have to be one thing; that would lead to "pigeon holing," a horrible condition. You can have several things you are passionate about, but you must focus on one thing at a time. By focusing, you can identify your potential clientele much more easily.

Step Two is "Who NEEDS what I LOVE to shoot?" This is an important step because it begins the process of identifying those who share your passion. If they share your passion, it will be easier to get their attention and hold it until the right job comes along. There are so many things that have to come together at the right time for you to be picked. Why not make it easy on yourself and your potential client to see each other as mutually beneficial?

Narrowing the Field

Step Three is "What is the SMALLEST NUMBER OF PEOPLE who NEED what I LOVE to shoot?" You may be asking, the smallest? Why the smallest? The answer is that in the creative arts, you are dealing with a unique set of circumstances: 1) you have to penetrate the market where your work will be best received; 2) establish yourself in that market; and 3) have your name passed around as an important part of that market's needs, i.e. word-of-mouth advertising. Then, as you build on your reputation, you will be asked to do more extensive work by people who trust you and can recommend you to other potential clients. While everyone else is looking to make an immediate big splash in an already oversaturated marketplace, you are steadily building your reputation, giving yourself a solid foundation reinforced by your ability to perform. That builds staying power. That builds a circle of like-minded individuals who believe in you. That builds a career.

The beauty of this three-step approach is that it is simple, it is elegant, and, best of all, it works. I have seen very talented people who did not enjoy or want to deal with the complexities of marketing fall by the wayside and go on to other fields. It was tragic to see, but they felt that the marketplace was a place they did not feel comfortable in, and they did not want to compete in it. I have found others who did not like it but were fortunate enough to find someone they trusted and who shared their passion and could deal with it in their place. And then there are the artists who love the competition and the thrill of making it all come together. Like it or not, the marketplace is something you have to deal with. You always have to promote yourself and your work. And you have to do it all the time. In short, as a client once said, "Life's a pitch."

One thing you will see in this book is that the professionals I spoke with all approached the issues of marketing in their own unique way. Some hate it, some love it, some put up with it, many feel they don't do enough, or aren't very good at it—but they have all dealt with it in their own way.

Ryszard Horowitz reinforced this when he said, "On marketing, I believe in PR. I don't believe that you should kill yourself for it, but it's important to get your work out. I have been lucky, having lots and lots of my work published. In the past I paid for it, I bought advertising here and there, but again if somebody asked me what works, I say I don't know. It adds up; it's accumulative. You can buy yourself into particular situations but it is never long lasting."

Nowadays, among other media, a Web site is a necessity. A veteran like **Jay Maisel** realizes the importance of getting the word out. "It doesn't matter how well known you are or what you have to literally sell something, you have to go out and sell it. So, I am trying the Internet."

Generally speaking, I advise my clients to specialize, especially those who are looking to reinvigorate their careers. That way, they will be seen as the artist that can provide a specific solution and get hired for an assignment. Once they get in the door with a client, they can expand on that specialty and prove that they can do more. If you start out as a generalist, it is harder to separate yourself from the crowd.

Eric Meola had a different approach to this topic. He had this to say: "I used to send out a lot of self promotion. I still believe in that very much, but now I send out a few very specific pieces to fewer people. I've never specialized in one area of photography—I like portraiture as much as I like landscapes. Everyone says you have to specialize, to find a niche; to me that's the best way to limit your exposure to clients, to cut out 90 percent of your market. A lot of projects involve many different areas of photography, but essentially people come to you for your way of looking at things, and that's what I always tried to deliver." Eric has proved that he is able to shoot anything over a period of many years. Perhaps that, along with his strong classic imagery, are his niche in the marketplace.

Photographers need to find the promotion medium that best matches their interest, and then use that medium as a mechanism to promote their work. **Barbara Bordnick** had this insight to share when I asked how she marketed herself, and how her methods of promotion have changed: "It's always been according to what I've been doing. Most of my promotion has come from editorial work. I have spent way too much money on sourcebooks and mailers, and the best advertising is editorial work or publishing books."

Whereas Barbara utilizes editorial and book publishing, **Bob Krist** uses other traditional routes. "We do the old-fashioned things. We do a lot of direct-mail post-cards. We do calendars every year. At this point, when you've been in business for about twenty-five years, with stock and stuff, we're not doing so much outreach to new business as much as maintaining the old business. Enough new business comes along that we seem to be doing okay."

One challenge to always having an ad in the sourcebooks and then suddenly not running ads at all is that some clients might think you have left the business

Eric Meola: Fire Eater

altogether. Obviously this is detrimental in an industry where staying power is para-
mount. If you do decide to run an ad in one of those hefty books, make sure your
work stands out from the rest. Art directors are always telling me that the books have
a disturbing sameness to them, which seems to indicate that no one is doing any-
thing innovative and daring. Of course, that is a double-edged sword, because the
clients of those art directors may not allow them to use any innovative and daring
work in their ads anyway.

Eric Meola: Promised Land

Another double-edged sword is the fact that the new technologies we employ to promote ourselves may be expedient and efficient, but they remove the human element. **Ken Merfeld** agreed and had this to say when I asked how he marketed himself: "Promo pieces, e-mails, and Web site referral. I think promotion methods are changing, or have changed. I think we are into the electronic world, and a few years ago I don't think people had the time or the desire to look at a Web site or a CD that you would send them. And I still think there are a lot of people who would rather have something in their hand to look at or to show to people. But it seems more and more people ask you 'Where's your Web site?' or 'Can I look at your Web site?' So I think the biggest change in marketing these days is to embrace the electronic way of sending images around."

This aspect on Step Three of the "Passion First" marketing approach—What is the smallest number of customers I can have and still run a viable business?—is especially important for those who choose to be fine-art photographers. **Ryszard Horowitz** has managed to carve out a special place for himself and he shared this: "I found out that I was always the best source to get work. I am the last person really to suggest what works and what doesn't work. I've been asked to participate in endless seminars about how to advertise, how to promote, what's good, what's bad. A lot of people give you formulas that work for them, and I never found any understanding of what makes things tick. I opened my studio in 1967, and I still don't know anything about it." [He chuckles.]

I countered with, "Well you must be doing something right. I mean how do people see your work? Do you show in galleries?"

Ryszard explained, "For the last number of years, I have been traveling all over the world. I've been exhibiting. My work hangs in many great museums throughout the world, virtually every place except in the States. I never had any museum work here, because you have this schism—advertising versus fine art."

Jerry Uelsmann has long been recognized and respected by the fine-art photography world, and this was his contribution on the topic of marketing as it applied to his work: "At this point in my life, I've had enough publications and museum exhibits and things like that, and I have a profile so that people will occasionally track me down. But I still have galleries: I have a gallery in New York, and New Orleans, and Carmel, and Denver. As long as I have several galleries selling one or two prints a year, that's helpful."

I do not normally move in the fine-art photography world, so I decided to ask gallery owner David Fahey for his inside views on marketing:

> Marketing kind of defines itself. Marketing is determined by the subject matter of what you are showing. And photography, because it is a visual medium, it is a natural kind of thing to market, because if it's great photographs, all the magazines want to reproduce it. And they get to reproduce it for free because it is promoting our exhibition, and we're not selling it as a photographic image for a magazine per se—it's promoting the show. So the artist will go along with doing it for free, and it helps the artist, it helps us, and it helps the magazine because they get great visual images for nothing. Photography is very easy to market in that sense. And then if you pick the great artists, there is already an audience built in for these people. People follow their careers and know them. And we have found that direct mail is very effective.
>
> The Web site has been great. The feedback we get from many, many people, if not all, is that ours is one of the easiest sites to maneuver, that it is very user friendly. We had 1.6 million hits in one month. That filters down to a small percentage who actually buy, but that's perfectly okay. For example, if you go on today and you click on exhibitions, current exhibitions come up. But you can also scroll down and see the last five years of exhibitions.

One Marketing Goal: Many Ways to Achieve it

Again, there is no "one size fits all" answer to the question of how you market yourself and your work. What works for one person may be a waste of time and money to another. But there are some principals that you can employ that will help

you to stay focused on your target market, and those principals must be passion driven. It all comes down to what do you truly love to create, who needs that type of work, and how do you get your work in front of the people who need what you love to do? The process is simple; the execution has to be uniquely yours.

Now more and more of the art directors and art buyers I talk to are relying on e-mail with hyperlinks to Web sites that have thumbnails of an artist's work. Sure, they may see something they like on your mailer, but they may be wondering what else you are capable of doing. If you are fortunate enough to get a hold of an approved e-mail list, make sure you are respectful of the recipients and make your introduction short and to the point. Include one embedded image that you feel best shows your talent, and have a link to your Web page where you can have separate headings for the various types of work you shoot. This will give you the chance to show the commercial side of your work, as well as the fine art, or conceptual, or personal, or whatever other sides you wish to show.

Once your presentation is together, and your promotional materials are sent, and your Web site is up and running and full of current photographs that show the dimensions of your work, and you have your best smile on, then you are ready to take your show on the road. But how do you get started with your next career opportunity? What are some recommendations on getting in the door? In the next chapter we will take a look at making the connections that lead to new job opportunities that will enhance your new career choice.

Networking
and Preparation

A friend of mine said that if there were
no computers someone would have to have invented
them for me. It has nothing to do with my plans,
my smarts, whatever, it just happened naturally
because it is just who I am.
—Ryszard Horowitz

One thing that is true of any journey is that it will be easier to start and main-
tain your momentum if you do a little planning. Sure, we want to allow for
the joys of the unexpected, but the role of planning is to set us on a course
and to keep us focused on our goals. When we start off to build on our careers, it is
essential to research what we are getting into, so we can be flexible and change
according to the ways the winds of change blow.

I remember reading that when Captain William Clark's contingent of the Corps
of Discovery left on the historic journey to find the Northwest Passage, they

departed Camp River Dubois in the middle of the day. It seemed odd to me that such a momentous trip would start so late. I imagined that, given the enormity of the event, they would all want to leave as early as possible to get off to a rousing start and cover as much territory as possible. But then I read on. The reason they left midday was that, if they had forgotten anything, they would know it when they pitched their camp that evening, and they would not have to travel far to go back and pick up the necessary supplies. In addition, Captain Lewis met up with the rest of the party in St. Charles, Missouri, after gathering information from fur traders and acquiring maps. In other words, they recognized the importance of their adventure, they assessed what they would need to succeed, and they planned for the unexpected.

And equally important to the planning for the trip was the trust captains Lewis and Clark had to have in the unique talents of the individuals that made up the Corps. On top of that, they had to have faith in the members of their party who would introduce them to the indigenous people along the way, people who would allow them to get up the rivers, across the plains, over the mountains to the far Western ocean, and back again safely.

To some of us, starting or reshaping a career seems no less formidable. We have heard tales of others who have carved out an existence that allows them to enjoy the richness of their lives, but we are not sure we can follow in their footsteps. Could it be that those stories are just myths? Could it all just be some cruel joke that something better is out there for us?

Prospecting

We have already studied a little about ourselves and the dynamics of risk. And we have established that risk can be minimized by transforming it into calculated risk. In this chapter we will dig a little deeper. There is a term in the sales and marketing worlds that describes the process of looking for the perfect customers or, in our case, the perfect clients. The term is "prospecting" and it implies just what you would imagine. In prospecting for gold or other precious metals and stones, you go out to some lonely place and dig around for your treasure. You could just walk out into the wilderness and start digging, but your chances for finding anything worthwhile are heightened by studying the terrain and its geological makeup, having a map, having the right equipment, familiarizing yourself with the problems you may encounter, and teaming up with an experienced crew with expertise in areas you lack. And so it is when we go out looking for the golden clients—the ones who *need* what we *love* to create. Finding the golden client can be accomplished two ways, through referrals and research.

Referral

Referral is by far the best way to find clients because when someone refers you, there is a built-in level of trust. If you can present yourself by saying, "So-and-so suggested I call you," then the other party automatically gives you more credence than someone she doesn't know. That kind of introduction can shave several degrees off the proverbial "six degrees of separation." It can warm up an otherwise "cold call." When you introduce yourself that way, the other person will probably say, "How is that old so-and-so?" and you have already broken the ice.

As my co-instructor Jean Mitsunaga says, more than 80 percent of job referrals come from "the hidden job market," which includes those unadvertised jobs that are offered through a network of people who have something in common. That sure beats picking up the phone, calling a receptionist at an anonymous company, trying to explain that you want to show your work to any creative-department person, and ultimately getting transferred to a voicemail that will be ignored. In that case, you are just another one of countless requests that have no direct connection to answering what the company's professional needs are. You may have the good fortune to talk to someone, only to find that the company has a policy of seeing unsolicited portfolios only on a drop-off basis—you leave your book on a Tuesday and pick it up on a Thursday, and you have no idea if anyone looked at it on Wednesday.

You quickly find that you have to be as creative with your marketing as you are with your own work. But don't try to get too tricky or you may be blacklisted from showing your book at the company. I have heard stories of artists and reps who have gone beyond protocols and done something so egregious they are no longer allowed on the premises. You don't have to claim to be a long-lost cousin to get in the door; you only need to have a lot of perseverance and the right work to show.

Research

Good old hard-core research will not only get you to the right people, it will help you familiarize yourself with who is doing what kind of work and who are the best prospects. I tell my clients to go to a newsstand, sit in front of it for a while, and just look at the variety of magazines that are on the shelves. None of those magazines can exist without photography. Recently, while at a local Barnes & Noble, I noticed three monthly magazines on ferrets, those weasely little creatures that are actually outlawed as pets in my state. And there was a monthly magazine dedicated entirely to pizzas! They had stories about pizza dough, pizza sauce, pizza ovens, pizza-oven mitts, pizza history, the future of pizza—if it had anything to do

with pizza, that magazine had it covered. Photography drives people to pick up the latest issues. Someone has to supply the photography and that someone could be you.

Now, once you become part of the pizza, or weasel, or fashion, or automotive fraternity/sorority through your remarkable photography, your name will be passed around as someone who can be trusted, and your research will turn into referral. Is it easy? No. Will it take time? Yes. But research and its positive effects will get you recognized by the peer group to which you wish to belong. Your career will become your lifestyle and visa versa.

Networking

You must never overlook the importance of becoming involved with your trade organizations and the trade organizations your clients belong to. One thing that happens when you work alone is that you lose a sense of community. That community can offer support, and information that can lead to job assignments. Every trade organization has an annual event where you can showcase your work to other people who are interested in what interests you. I had a student who offered to shoot the portraits for the local advertising club's annual event. He ended up doing portraits of the top creative directors and art directors, and did such a good job many of them invited him to their agencies to show his book to the other personnel, which led to job assignments.

Building Bridges

It's all about preparation, research, proving yourself, putting yourself in a position to get referrals, and staying visible. This is a lifelong endeavor; from the time you first enter the field through every career reincarnation. A very good example of this is the following story from Dean Cundey on how he got into the film business. I teased you by giving you some of his story earlier, and now I am fulfilling my promise to give you the rest of his interview:

> I was determined that somehow I was going to [get into the cinematographers union]. Determination is the main thing, because there are so many creative jobs, but certainly in the Hollywood film industry there are constant roadblocks to getting somewhere. A couple of my buddies from UCLA had talked Roger Corman into producing a low budget feature. They had already assigned the camera job, but I had done makeup before [so I took the makeup job] because it was a chance to work on a real feature, and once again observe the whole thing.

My first actual paying job, my first professional job, was a result of the networking. When the job was over I sat down and said, "I wonder what I do next; how do I get a job?" The phone rang and it was Roger Corman, and he said, "So you did makeup on that film and it actually looked pretty good. I'm directing a movie; do you want to do makeup on it?" I thought, this is pretty cool. I don't even have to go and look for work. They call you up and there it is.

So I said sure and I did makeup on *Gas-s-s-s* and I did makeup on Cindy Williams, Ben Vereen, Talia Shire, and all of these young actors who were being given their first opportunity by Roger. I did well enough on the job that I got noticed, and I got a recommendation and Roger noticed.

When *Gas-s-s-s* was over, it seemed like it would be easy for me to continue with hair and makeup but that really wasn't what I wanted to do. I didn't actively pursue other makeup jobs. I probably could have, but I remember turning down the next job. I had an opportunity to work on a short film and to shoot it, and that was important because now I started networking in the area of my real choice.

It was probably one of my most conscious efforts. I had worked on five or six low-budget films, and I was always struck by the fact that a cinematographer was at a loss because a low-budget film didn't have money and would not send out a complete package of equipment that would allow you to do the job properly. You had to scramble. I decided that I would create a grip/camera van that had all the things you would need for a basic shoot. It would be this efficient package of equipment that would go anywhere and they could shoot anything. There was the trick. Not just a big van that you would load equipment in. I called it the "Movivan," knowing that it would become part of the image. It would become more than a device; it would perhaps become a symbol of me.

So I worked with three other guys and we built the van in my driveway. I gutted the van, put extra doors in it, and I completely modified it. It wasn't just a van that pulled up and you unloaded a bunch of cases. I had a vision of an efficient tool to work with. And this is where some of my background in architecture and drafting came in handy.

We built this truck and each guy who was involved had a skill. One guy was a gaffer, one was the sound recorder, and so on. We built the truck, and then I leased a package of equipment and my father co-signed the lease. I leased cameras and lights, and sound equipment, and grip equipment. It became a great door opener, because I would get a phone call about a

project and they would say, "We want to rent your truck for a show we are doing. Do you have to come along with it?" and I would say "Yeah." Then they would say, 'Well, we've got a guy now but. . . .' A couple of times they went away, but other times they would call back and say, "We've decided to hire you." So I had a value-added aspect to my talent.

You get a reputation of being competent at your job but you have to also do what the job requires. So you have to be willing to take the risk and take the hit. Maybe you have to be willing to accept half the income for the year to do what your want to do. Will the people around you be willing to support you and say, "Well, we're willing to tighten up our belts to help you"? It's a major issue. It's all toward the building of the résumé or reel or whatever it is you are going to need to validate yourself as the person you want to be. It's all part of the plan.

I wanted a little more on career changes, so I asked, "You've touched on so many things. You did the work with Roger Corman, and then you somehow linked up with John Carpenter on the *Halloween* movies, *The Fog*, and *Escape from New York*. How did that happen?"

Dean went on, "Well, again that was sort of networking. I had done probably twenty films and worked with various people. I instantly realized that John appealed to my creative side. When you get the creative satisfaction it is also an inducement to perform better. You look for the opportunities for personal creative satisfaction."

I dug a little more: "Obviously you been able to move your career along by working with Roger Corman to John Carpenter, to Robert Zemeckis, to Steven Spielberg, to Ron Howard. Did they look back on your body of work and see something to indicate you had the talent and the attitude to be able to do something that they needed?"

Dean offered, "A lot of that comes from people looking at my work and realizing that I had particular talents and aptitudes. I was doing an ensemble comedy when I got a call from Robert, and he said, 'I loved *Escape from New York*; I loved the look of that.' The studio was taking a risk with Bob, because he had had some movies that did not make money. But I liked him because he was a visual storyteller too, and it became evident that we would be collaborators. A lot of the success of *Romancing the Stone* was that it had fun in a romantic comedy. And it became a case of how do you deliver 110 percent?"

I had to say, "I get the sense that you are very optimistic. I have the impression that whatever you do, you look at it as an opportunity to advance your career, whereas a lot of other people might be hesitant."

Dean agreed: "I think optimism is essential. You have to look way down the road. You have to look for creative satisfaction. You have to be very optimistic that you will succeed; optimistic about your entire life."

Then I had to inquire, "I would be remiss if I did not bring up *Apollo 13*, *Roger Rabbit*, and *Jurassic Park*. How did those films come your way?"

Dean explained, "Well, I've always looked for projects that I could learn from and somehow enrich the lives of people. Early on, I worked on *The Witch Who Came from the Sea*, a far cry from the films you mentioned, but it is all part of the steps to making those other films. The key is that each film was a link that allowed me to move from one film to the next. I was working on a film and I was told, 'There's a call for you. Steve Spielberg wants to talk to you.' And I said, 'Oh?' thinking, 'Yeah, sure.' So Steven said, 'Hi, how are you doing?' And I said, 'Fine, how are you?' I had never talked to him before. He said, 'Listen, I'm doing this movie called *Hook,* and I'd like to see if you are interested in shooting it. It would be perfect for you,' and so forth and so forth. So I said, 'Oh sure, I'd be glad to.' And then he went on to say, 'Oh, and I'm doing this movie called *Jurassic Park*.'

"Each job has to be evaluated on its own merits. There are a lot of factors that go into choosing which project to take on."

Dean touched on it all. Whether you are a beginning artist or a seasoned veteran, you have to be vigilant and never take anything for granted in your career. It takes eagerness to do the best job you can, commitment to the profession, an enormous amount of self-confidence, preparedness, availability—and it helps to be opportunistic. The lessons Dean spelled out were enormous: he parlayed every job into another opportunity, continually advancing himself along the way. His story provides us with a map to career reinvention, because he utilized every element of his experience, background, education, and networking to keep working and to keep creating films that continue to entertain and inspire us.

Inspiration is Everywhere

Ryszard Horowitz is another one of those tremendously inspiring individuals. I simply asked, "Who inspired you to change directions?":

If you find somebody, whether it's a friend or a teacher or whoever, to open your eyes, who can put you on the right track and encourage you, that is really priceless. I should also mention that a very important moment for me was when I met a guy by the name of Bob Greenberg. Bob has a very renowned production company in New York, RGA. In the early 1990s he

was already heavily involved with digital technology for film, for editing, and for creating special effects. He was designing film titles, and he came across my work. He approached me asking if I would be interested in helping him set up a film photography department at his company that would revolve around digital technology. I had this incredible opportunity of meeting some of the greatest programmers and also having access to some of the best digital-equipment software and hardware. He was doing beta for all these great companies like Silicon Graphics. So I started working with his people and learning about the technological possibilities, and for many years I was directing in the digital environment. This gave me tremendous insight into the technology and also the ability to work on different platforms, not simply becoming a Mac man or a PC man. Again I managed to transcend the whole bullshit and I went for, "what can this thing do for me?"

And eventually, after years, I began to feel frustration, because I had a head full of pictures, of ideas, and I didn't want to produce them for other people. The moment that I became articulate, so to speak, with computers I just felt like a newborn. This was one of the greatest revelations of my life. To be able to sit down and just do it. That's where I am right now. I am totally independent. I have tremendous support from Apple, from Adobe, from Epson, from Canon, etc. And I've been doing a lot of poster design, a lot of exhibitions in different parts of the world. As soon as I got my Epson printer, I started printing my own shows. I wouldn't say I am a one-man operation, but I can do a lot of things that in the past would involve a whole staff. And when I travel, I travel with my laptop and a digital camera, and all I have to do is rent a studio and some lights and I can go into business. And that's the greatest advantage.

I know what you are driving at, and I know what is the core idea of your book and believe to be inspired by everything, by life, whether it is a concert or a movie, or any type of emotional experience, a book. It could be visual; it could be a description; it could be a sentence; it could be words; anything. As far as talking about change, we are living in this moment in history when we are going rapidly from analog to digital— analog is almost dead. To me it was a natural course of events. A friend of mine said that if there were no computers, someone would have to have invented them for me. It has nothing to do with my plans, my smarts, whatever—it just happened naturally because it is just who I am.

When you are inspired by everything, you inspire everyone around you. Ryszard continues to reinforce the point that anything is possible for those who follow their passion and are willing to commit to the work needed to sustain that passion.

Again those intersections of opportunity and action come into play. When you are given a chance, you have to size them up, and, if they address the stuff of your dreams, you have to give them some serious considerations. And it helps to have a pipeline to people you trust, and people who trust you. If there is anything I have had reinforced so far, it is that, generally speaking, people want you to succeed. Maybe it is because they see a little of themselves in you. Those people will introduce you to opportunities, but you have to be willing to accept what that opportunity has to offer. Indeed, it would be a horrible thing to look back at your life and feel as though there was a path of creativity left untaken.

Financial Considerations

Don't think that if you make a dollar you have to spend it.
What you need to do is always keep a financial cushion.
—Douglas Kirkland

A very important component of career transition is figuring out how you are going to follow your passion and, at the same time, make enough money to fuel the fires of that passion. One of the greatest barriers to change is thinking that the financial considerations are going to be too big a hurdle to overcome. So some people dismiss the idea of transition and give up before they even try. It is better to take a good hard look at your options and develop a plan you can stick to than it is to defer your dream. Remember, an underlying theme of this book is to help you take advantage of the opportunities that lie before you, so you won't have to look back ten, fifteen, or more years from now and say, "I should have done something back then to live my life the way I always wanted."

So what are some of those options? If we take a look at the lessons of our own past and the lessons of others who have gone on to be successful artisans, we notice one common theme: if you really want the change, you will find a way. Different

people take different routes to achieve what they want, but they all manage to accept the fact that what they are embarking upon is so important that they will not let anything stand in their way, not even something as monumental as money.

On Financing Your New Venture

Starting over doesn't have to mean *starting* out all over again. Just the word "over" in the phrase starting over indicates to some degree that you already have some experience, contacts, technical skills, and most importantly, life skills that will help you make the jump to the next level much more easily. You are wiser now, so you won't spend time making certain mistakes; and you are more clued in to how the system works and what will be expected of you, so you won't have to stress about the small stuff. You can detect what works for you and what doesn't, and you can have more confidence in your instincts. You know that rejection is not the end of the line; it is just another opportunity to prove something to yourself. If you sense that you are being lulled onto that Plateau of Mediocrity, you can take action, launch into the next round of Creative Ascent, and not fall down the slippery slope of the Valley of Despair.

A lot of would-be new ventures never get off the ground because many people think they will have to acquire enormous sums of money before they can get moving—and they don't have the kind of capital to start with. While it is true that many, if not most, new businesses fall flat because they are under-funded, it is also true that it probably does not cost as much as you might think to get things moving in the right direction.

You can choose one of three options. First, you can choose No Change. In this scenario, the future is too uncertain; you can put up with the disenchantment and abuse for a while longer. It will take too much effort to make a move. The second option is Change in Small Steps. This option allows you to keep the job you have now, but earnestly dedicate increasing amounts of time to your new venture. I say "earnestly," because it is easy at this level to put off taking action if you are too comfortable; you get lulled into putting off your goals. So you have to commit to short-, mid-, and long-term goals and monitor your progress or else you will kill your dream with procrastination. The third is Complete Change. You've had it. You can't put up with the rut you are in anymore, and you must take action because you can't bear another day of mindlessness. You are convinced that you must leave what you are doing now, and you need a completely fresh start. You know that this option is adventurous and you could fall on your face, but once you start down this road there is no turning back. You may be adverse to risk, but you must will yourself into going out there because an unknown future is better than the known unpleasant present.

If you chose option one, No Change, then you will only be allowed to *fantasize* about what the future will hold. However, if you chose options two or three, you will

first need to figure out what your startup costs will be. What kind of equipment will you need to get started? Where and how will you live? How will your lifestyle change? How much will your fixed monthly costs (rent, utilities, food, transportation, insurance, etc.) be? And, after you have figured out your fixed costs, you will have to calculate what your variable costs will be, i.e. the prices you pay for things that change from month to month. For example, your entertainment costs will probably have to be minimal. But look at it this way—you will be working so hard at what you love to do, your life will be your entertainment.

Once you have figured out your startup costs, you will have to determine how to acquire the money. If you chose option two, you have between six months to a year to obtain the funds. If you want to jump right in, you need the money now. Some people are savers, some are not. Some want instant gratification; some are willing to impose self-discipline to get what they want. You will have to ask yourself: what price are you willing to pay?

When I asked Douglas Kirkland how he had financed any of his new directions, he reflected on what was most important to him: "Well to begin with, don't spend everything you make. One of my friends from New York, Arnold Newman, used to remind me, 'Save it, save it.' He exaggerates a little, but you have to be very, very careful. Don't think that if you make a dollar you have to spend it. What you need to do is always keep a cushion."

Mark Edward Harris had this to say on how he financed a new career direction:

That's the tough thing about these two new books that I did. The first book, Abbeville Press came in and gave me a fairly good advance and all that, but after my first experience with Abbeville, I thought I'd try to do this a different way. So I got a great distributor, Ram Publications; I had a designer make a mock-up of my book idea on Japanese hot springs. Well, first of all I went to the American Book Association; they have conventions, one in L.A., one in Chicago. I saw who was doing what and I collected catalogues. I also saw a couple of different distributors. I approached a couple of people, and I sent this mock-up around and got some great feedback. Ram said they'd love to do it, but why don't I produce and they would distribute it? It was an investment, but it was something I really wanted to do and it had an amazing design. I did it that way—just using the money I had from commercial work. And it has definitely paid off in a million ways. I mean not just in terms of money.

Perpignan is the photo festival for photojournalism that takes place every September in Perpignan, France, near the Spanish border. And to go to those international festivals has been very good as well. I would say that to get your face and your work seen at places like that is extremely impor-

tant. Because we all live in such a vacuum that when you can network and go for the camaraderie, it's always great to hear what other people are doing, but there are a lot of agents and things. Just like when APA was doing those portfolio reviews. I think those things are incredibly important. The in-flight magazines saw my first book a long time ago at the Perpignan photo festival. That was really a kick-start to getting work out on a more international basis.

We live from assignment to assignment, from one inconsistent payday to another, and it is hard to think of saving money. We may go for long spells without income, and when the check does comes in we may go a little wild and think we are rewarding ourselves by making expensive purchases—only to find ourselves quickly in the hole again. It pays to take a long-range view, as Bob Krist related: "Building the stock files has been good to us over the years, and we've built a residual income that generates money in and of itself once you get a collection big enough. Plus my wife is really, really smart with investments. When we were doing a lot of annual-report work in the 1980s and making disgustingly great money, and I wanted to buy BMWs and speedboats; she set up little trust funds for the kids' education and invested in all this other kind of stuff. So now when I am faced with these college tuitions that bring you to your knees, it's not so shocking, because she invested wisely back in the early 1980s when you could do that kind of thing."

You could be extremely fortunate to have some of your startup costs gifted to you by people who believe in you and your venture. That gift could be a tax write-off for them and a financial blessing for you—a true win-win. You may find through such a gift that other people believe in you more than you do in yourself, and that knowledge can give you the confidence to take steps you previously only dreamed about.

Some of the photographers I have spoken to, like Ken Merfeld, found money through other means, but they never give up finding ways to finance their vision: "Like any artist, we beg, borrow, or steal, or find scholarships, or if you get involved in the fine-art world, explore grants, etc. So money is always an issue with artists, and you have to get pretty creative as to how to maintain your cash flow."

Ken touches upon a very important point when he says you have to get pretty creative with how to maintain your cash flow. It takes a special breed of person to be an artist/entrepreneur and to make a living from the things he or she creates. We are all so close to the things we create, and sometimes it is hard to part with them. You have to take the attitude that what you are doing is important work that has to be shared, and in our present-day society you have to be as creative with your business as you are with your artwork.

Another way to fund your new work would be to find a business partner and split the startup costs. But that also means you will have to split the profits.

Partnerships in business are tricky. You have to share the same vision, mission, and commitment to make it work. There must be clear definitions as to how things are going to be done, where the money comes from, where the money goes—in other words, total disclosure, so there are no false expectations that will breed distrust. The best thing about partnerships is that two people working together, with equal energy and respect, can create more than they could individually, and they both reap greater benefits.

You could also get money from a venture capital (VC) group, but it will want a portion of your company and will want fast results. And, generally speaking, VCs want to invest in larger, moneymaking opportunities, instead of one-off products such as photographs. They go through a great deal of due diligence before they write the big check, because they have investors who want a significant return on investment. So unless you have a high-volume enterprise, a VC group probably would not find your art enterprise lucrative enough.

You could also wait until you win the lottery and use the winnings to fund your future project, but if this is your business plan, with a million-to-one odds, then you are not taking this whole idea seriously—you may as well settle down to enjoying your hobby and take the pressure off of yourself for starting a new career.

You can also barter or trade out your services, but you will have to have very carefully spelled-out definitions of the value of the goods and services traded, so neither party feels as though it has been taken advantage of. One person's idea of the value of a product (especially an art product) can be quite different from another's, and it is very easy to get burned. As one of my students said, in a barter situation, you want to be on the "money end."

So let's review. You can do the following to raise money to finance your career's reinvention: other work (i.e., non-photographic); save, reinvest, or have money gifted to you; get scholarships and grants; get a partner; gamble; find venture capital; or barter. Or you could go the route that most entrepreneurs go, which is to borrow money. You can borrow from family and friends. You can use credit cards or get a business line of credit from a bank or credit union. You can borrow on the equity in your home. And you can get a loan from the Small Business Administration. If you have collateral you can borrow against it. In his book *The Entrepreneurial Age*, author, lecturer, and entrepreneurial consultant Larry C. Farrell states: "The fact is, the average cost of a business startup in America is only around $14,000, and the two biggest sources of 'entrepreneurial funding' are available to anyone: personal savings and credit cards." The challenge here is to be constantly aware of what you are spending, and not get so far in debt that your all your talent is doing is servicing your debt. Getting out of debt should not be the reason why you create; it will quickly spoil the reasons why you create.

On Pricing the Assignment

Knowing the value of things is at the basis of what we create. Many people think that since we are doing what we are passionate about, we would do the work even if we were not being paid for it, simply because we enjoy it that much. Of course the problem with this line of thinking is that if we do not set a reasonable price, the work will be viewed as being without value. In our contemporary economic climate, the value of anything is judged by how much someone is willing to pay for it. That value of a photograph is determined by a long list of factors, which include the background of the artist, the history of the piece, supply and demand, and its intrinsic aesthetic.

At first, you create your work, people like it, and you give away a few pieces to those who really admire the work. Then someone, perhaps not that close to you, offers to pay you for a piece they find interesting. You come up with a price, they immediately buy it, and then you kick yourself because you probably could have gotten more. Does this sound familiar? That is when you wish you had some pricing guidelines to help you, but the more you look into this the more you realize that it's a wide-open market, and you will probably have to make it up as you go along.

I was fortunate enough some years ago to attend a lecture sponsored by the Advertising Photographers of America/Los Angeles and given by world-class negotiator, Herb Cohen. He is the author of *You Can Negotiate Anything* and *Negotiate This, By Caring But Not T-H-A-T Much*. Cohen negotiates on behalf of governments, multinational corporations, and travels anywhere his skills will open up deadlocked negotiations. He worked on the release of the American hostages during the Iranian hostage crisis, the release of the hostages on the Achille Lauro cruise ship, and a number of other headline-capturing world events. After hearing of his accomplishments, you expect Moses to walk in the room. But Cohen is a surprisingly average-looking man who has taken the time to understand how human beings perceive situations and negotiate—and his investigations are monumentally important to us. As impressive as his résumé reads, his guidelines for negotiation are, as I understand them, deceptively simple. Basically, you must be well informed and you must be patient. That's it. Of course, you never want to make the first move in a negotiation and paint yourself into corner; you always want to give your opponent a place to go that will be in your favor. You want to ask as many questions about the item as possible because then the value of the item becomes clearer; you want to be willing to go the extra mile in reaching a fair settlement. But ultimately, you want to do your homework and not panic. Keep in mind that when a client says, "Money is no object," it invariably becomes the subject. As my good friend photographer Harry Liles always says, "Keep your lips moving." As long as you are talking there is hope.

Herb Cohen's information and insights were extremely helpful for me as I set off to find a simple method I could use when talking to a potential client about a fee

for an assignment. I knew to ask the right questions, and I knew I could supply the patience as long as I kept the client talking about what the job meant to him in terms of increased sales and return on investment. That's the key: you have to help the potential client see lots of money coming back to him if he utilizes your talent to promote his product.

Now, before you enter into negotiations with your would-be client, think of a vertical scale with a base point (a price you cannot go below), and a high point (a fee above which you will price yourself out of the market). These two arbitrary points become your range. You may decide your range is $500 to $1,000, or $10,000 to $20,000. It doesn't matter, as long as you develop a range that is reasonable and one within which your interests and your client's interests can operate. Start off by looking at your layouts and shot lists and ask, "How complex is the assignment?" Then mark a line between the two points—is it towards the bottom, middle, or top?

Something else is important to mention here. Before you talk with potential clients, it is necessary to have a little talk with yourself. Once you have settled on a fair price, it would be wise to ask yourself if there is a lower price you could live with. If there is, then hold that as a fallback position, but don't go any lower. So, you are talking; you ask all the right questions. If they ask you for a figure—and they haven't offered any amount to start with—tell them you have determined that such and such, say $5,000, is a fair price. Now, they can say okay—in which case you will think, Darn, that was too easy. I probably could have gotten more. Or they can say no—in which you can ask them what they feel is a fair price. If they come up with a price that is not lower than your fallback position, you can say you would like to think about it and get back to them. Never rush negotiations. When the time is right, you may call them back and accept their lower price, and say that in the future you would like to encourage them to pay the higher fee because they will find out that the images are worth more to them in increased sales.

If, however, they come up with a price that is lower than your fallback position, you can just say, in a very professional tone: "I will have to respectfully decline this opportunity. It would be a disservice to my other clients if I accepted it at this price." This implies that there are other people who see the value of your product, and they are willing to pay the price because it helps them immensely to promote their product. Also, this prospective client will now know what price you and others put on your work. So, if they decide to call you in the future, you will have established a starting point for future negotiations.

Phil Marco had this insight when I asked him about how he determined prices for his work: "It depends on the client, usage, and what's involved. On average, I would say ten to twenty grand an image, but depending on the logistics and complexity of the photograph it could be fifty to one hundred thousand per shot. But having said that, if there is something really exciting editorially, or an important

public service announcement, or a friend or an art director I respect who has a great idea and no money, I'll waive my fee. So it always comes down to the work—for me that's always the most important consideration."

Not often, but once in a while you may meet a potential client who will go ballistic when you quote him a fee. Most people are reasonable if you give them room to negotiate, but, every once in a blue moon, you will run into a manipulator who wants to trim the budget or to look good to his boss. I have encountered this only a few times in thirty-plus years of negotiating, but it is still worth mentioning. I suppose this tactic is used to intimidate the photographer into lowering the fees on the spot. First of all, you have to ask yourself if it's worth working with someone who, before you have even started the job, is treating you so poorly. The answer is obviously no. If this is how he is before the job, imagine how he will be during the shoot, let alone what it will be like trying to get paid by him. One of the greatest attributes of going through the negotiating process is that you will get an instinctive read about how clients treat you, how they communicate, and whether or not you want to be stuck on a job with a person (or group) you would rather not be around—especially for an extended amount of time on a stressful shoot. There is nothing worse than being on a job you hate, knowing that you picked up a bad vibe early on and refused to acknowledge it.

But say they do go bonkers on you and scream out, "Who do you think you are, Michelangelo? Why I've never paid that much to anyone! This is highway robbery!" You can just calmly say, "Well then, what did you have in mind?" Don't lose your cool. Just stay calm and ask the question very professionally. That usually defuses the situation, and I've had potential clients get downright apologetic after I respond to their tirade this way. I know they are under pressure. My job is to help them solve a creative problem, not make it worse, and to preserve my integrity and the integrity of the people I represent. And there are plenty of other people I'd rather work for out there who are respectful and willing to pay the price, because they know it will benefit them.

Here is what Douglas Kirkland had to say on negotiating: "You have to have some notion of what the field is. If you have friends in it you can discuss it. That's become more of a problem today than what it once was. There used to be a gentleman's agreement type of thing. For example, when I started, I never asked how much money there would be for something, because I always knew there would be enough, that I would be well looked after. And if there was any disagreement or problems, I could say something and they would respond. That was quite a different time. Today, if somebody says, 'How much will this be?' you have to protect your rights as much as you possibly can, number one; number two, set your fees high— 'This will be $20,000'—you can always reduce it. If they fall off the chair, and you feel you're going to lose it, you can be clever and counter with, 'We can work some-

thing out. What will work for you? What were you thinking about?' And then that way you get them speaking. You can see if it can be worked out. On the other hand, don't go so low you lose money."

This brings up another interesting observation. If you look at the way people respond to questions, you will find that there are four basic responses. In most interpersonal exchanges, you have the ability with your response to Accept, Reject, Ignore, or Negotiate. That is a powerful thought, because it puts the power in your hands. Just realizing that you have options gives you a sense of control of the situation. That simple acknowledgment is empowering. For example, if someone says something to you and they expect a response, you can say yes and agree with it; or you can say no and flat out reject it; or you can chose to not acknowledge it and ignore it; or you can debate and negotiate the statement. It is surprising to me that so many people think that their options are limited because someone else has taken control over them by virtue of status, or rank, or money position, or whatever. In actuality, we give them control by the caliber of *our* responses. Therefore, if we conduct ourselves professionally and respectfully, we will know how to clear the way to stay focused on doing the best possible job and not fall into the wake of someone else's agenda.

I noticed that all the professional photographers I interviewed for this book had slightly different *styles* in the way they negotiated, but there were a lot of similarities in the *content*. We all essentially encounter the same issues, and we all have had to find ways to coax a price out of a client. Ken Merfeld has this well-thought-out approach to pricing: "My pricing is determined on the usage, the duration [the amount of time is it going to be used], where it is going to be seen, and what the original ad-placement budget is for commercial work."

A sense of fairness obviously plays a big part in negotiations, because it strengthens mutual respect. Another attribute I noticed among those interviewed was that they had proven to their clients that their prices were commensurate with their professionalism. Every day we go out on a job, we have to prove ourselves, and every day we fortify our reputations by performing to the level of expectation we have promised. Eric Meola put it this way when I asked how he determined the prices for his work: "By who the client is—and a combination of fairness and realizing that many clients return based on that first experience."

As was stated earlier, information is one of the important keys to pricing. You have to ask questions of industry professionals you trust, and it is informative to study pricing surveys put out by trade organizations. There is no proportion wheel on which you can dial in to find the exact amount you should charge. Also there are laws regarding price fixing. But you can ask, read, and do your homework. These, together with an understanding of what the customer is willing to pay, will give you a starting point to determine your price. Bob Krist had this to say when I brought up

the subject of determining a price for his work: "We use Cradoc Bagshaw's fotoBiz [business-management software] to quote for stock. For assignments it's just whatever the going rate is. You know what rates are by osmosis, by talking with other guys in the business."

The area of fine-art photography is its own unique universe. Once it was looked at as an anomaly, but it has become a respectable part of the fine-art world. I wanted to understand how pricing fine-art photography works, so I asked Jerry Uelsmann, and this is what he had to say: "It's what the market will allow. My New York gallery constantly wants me to raise my price. But I have discovered that when I have a show in Kansas, they think my prices are incredibly high, whereas they may be a bargain for New York. You just try to strike some middle ground. For years I would raise prices very slowly. Now the phenomenon of people doing limited editions has occurred, where they raise their prices as they go along."

Then I turned to gallery owner David Fahey to get the art dealer's point of view:

Pricing is determined by the artist in consultation with the dealer. We base that on what their peers are selling their work for, auction prices, the fluctuations of the market, adjustment for cost of living, and so forth. It's not so complicated; it's just being on a par or compatible to what a comparable artist would be selling their work for. What the market will bear to a degree as well.

The economy doesn't relate and affect [fine art] photography as much. In other words, the people who can afford to buy seem less affected. The photography market has continually grown and gotten much more expensive and broadened and increased from the beginning—from 1975, when I first started. I don't know if you follow the auctions and what is going on with the prices—people would be shocked out of their pants to know what's been going on. It's just phenomenal what is happening. Photographs I sold for $3,500 three years ago are selling for over $100,000.

We're always selling other people's work out of the back room even if there is a show on we're selling from the show, but we are doing other deals. Right now we're selling a lot of collections that we sold to people five and ten years ago, and fifteen to twenty years ago. We are now buying back those pictures and selling them. That's quite a time-consuming project, but it's a moneymaking project as well.

So the general advice is to have enough things going on to be able to sustain what you love to do, and by the same token you may have to make some concessions along the way, or you may have to diversify in some other way.

David Fahey in his office. © Tony Luna

On Getting Paid

In the next chapter, you will find out that almost everyone believes that the billing step begins when the job is shot, but actually it should begin way back when you have been awarded the job. At that point you have the most leverage with your client, because everyone is excited about the upcoming job, and they want it to get off to a good start. That is the time to ask your client who will be paying the bills. That way, you can establish a working relationship with the person or people who will actually cutting the check. By introducing yourself to them early on and finding out *how* they want the bill submitted—this is important—you can cut weeks, months maybe, off the billing process. Because if you wait until after the job to send the bill to the art director, he may be on another job and your bill will sit on his desk for weeks. When he returns, he will send it along to somebody else (who may be on vacation), and your bill will sit on her desk for another two weeks. When she returns, she will want to check through it, maybe call you for some clarification (send original receipts or redo it in triplicate), and that will hold up payment. Then your payment will have to wait for the next billing cycle before it is finally sent out through the postal service, which may take even more time.

Conversely, if you call the bookkeeping department at the time you are awarded the job, you can learn who to contact and what are their procedures. Then, if you give them what they want, in the manner they wish, in a timely fashion, chances are you will get paid much more quickly than you ever have in the past. Most accounting departments only get calls from suppliers when the suppliers are demanding money. So, if you call them to introduce yourself and ask them how you can make their lives easier, they will love you. You would be surprised at the number of calls I get from photographers who are trying to get a payment, and when I ask them how long it has been since they sent their bill out, they tell me sixty, ninety, or even one hundred and twenty days ago! My first question of course is, "Why did you wait so long to call me?"

How to Become Wealthy

I would be remiss if I didn't include the following observation. We were on a job many years ago when I asked a wealthy designer friend of mine, Erick Erickson, how he had managed to do so well financially being an entrepreneur in an artistic occupation. Instead of dismissing my request, he said straight out, "You will never get wealthy in a service-oriented occupation." He paused long enough for me to repeat the words in my head, and then he said, "You have to figure out a way to make money while you are asleep." Lord knows, I've spent many a sleepless night pondering what he meant. And what he meant was that, in order to become wealthy, you have to find a way to generate income beyond the obvious and without having to be present.

He went on to tell me that, as an independent contractor, there are only two ways to make money directly from working. I could raise my fees, but eventually I would reach a ceiling, because the market could only allow me to go to a certain price level, after which I would be too expensive and not be called for any work. The second way I could make money was to work more hours, but that too had a limit, because there are only so many hours a person can physically work. At some point, no matter how good I was at what I did, nor how much stamina I had, I would tap out in both areas. I would have to create something that has a life of its own and let it make money while I was off doing what I loved to do, such as:

1 · License your photographs as stock. They are equity in a box (or sleeve, or drawer).

2 · Take the equipment you bought for past jobs that you don't use anymore and pool it together with equipment from other photographers and start an equipment-rental company.

3 · Rent out your studio space when it is otherwise not being used and convert that into a revenue stream.

4 · Make a book of your work.

5 · Invest a portion of your money in companies you shoot or have shot for. You have the distinct advantage of observing the behind-the-scenes workings of those companies. Choose businesses that you like and feel have potential.

In other words, it is in your best interests to look for ways to create revenue streams that are not directly dependent on what you are presently shooting.

One of the great benefits of our occupation is that it allows us to see what is new in the world. We get to meet the movers and shakers, the people who are creating new products and services. These people need our talents to present their work to a waiting world. We are in the envious position of being right there when things hit the marketplace, and we can take advantage of those opportunities. Who knows, you could be present when the next great breakthrough happens, and you can turn that in to a cash flow that will open other doors for you. The key is to recognize a good thing when it is in your presence, to assess its potential, to create a plan to take advantage of it, to implement that plan, and to verify that the plan was the right course of action. Sound familiar? I though you would think so.

Speaking of movers and shakers, let's take a look at how companies are managed in the next chapter and measure our own managerial attributes so we can do our jobs more effectively.

Time Management and Management Style

The best business sense is common sense.
—Dan Wolfe

There are all kinds of horror stories of how a good product was run into the ground because the person in charge was overwhelmed with managing (and micromanaging) and had to walk away, or was carried away kicking and screaming. You and I both know people who have been so consumed by the managerial demands of their work that they lost the love they once had for their profession, some even paying a high physical price for the stress they were dealing with on a day-to-day basis. There's only so much the body and the spirit can take before they pay consequences for such a situation. The question that always arises after a physical or emotional breakdown is, "Was it worth it?" And the answer is always the same. In this chapter, we will look into several ways we can take control and become more vigilant, more knowledgeable, and more effective in managing ourselves and others.

Creative entrepreneurs who make the decision to reinvent their careers have to determine what kind of management style they will bring to the workplace. Will the business operate as a democracy or a dictatorship? Will the entrepreneur have a laissez-faire approach or use some other method to run the business? Knowing what your most efficient management approach will be, and more importantly, getting yourself and/or your team to buy into it, will significantly ease your transition into a new career orientation. And even if you chose to be a one-person shop, you still need to have some sense of order, some kind of organization, to help you stay on top of things before they overwhelm you and send you back to that dreaded Valley of Despair.

We are aware of all kinds of bizarre management styles—and apparently they work, as long as people are dumb enough to perpetuate them. I know of a photographer who used the Management by Chaos method. He would stand in the middle of the studio and scream out, "I can't find the Polaroid back!" and everyone would run around frantically and look for the Polaroid back. When someone found it they were given an "attaboy," and things were calm again until the photographer would yell out, "I can't find the loupe!" and everyone would rush around to be the salvation for the next half hour. Apparently it worked, because everyone said, "Oh, he's an artist, and artists are temperamental, so that's okay." And apparently he surrounded himself with a studio of codependents.

There is a story around Hollywood that a well-known director once defined "teamwork" as (I am paraphrasing here) "a whole bunch of people running around doing what I say." This is another management model based on the chaos paradigm. To pull this one off, people have to be afraid that they will lose their jobs, so they will do anything as long as they appear to be moving and acting busy. The way to do this is to look like you are doing something (even if you aren't) and stay out of the way. Meanwhile the boss thinks things are getting accomplished when, in fact, everything stays the same. This is not teamwork: it is just an exercise in mindless self-deception that ensures mediocre performance.

And I have known the most insidious method of managing, which I call Management by Deceit and Manipulation. This takes a very intelligent person who can keep straight all the lies he has told different clients and subordinates in order to get his way. That person puts a new level of complication on every aspect of his relationships and manages to keep things bumbling along only because everyone else is missing an important piece of information, which they need to do their job.

I am sure that you have experienced scores of other management styles, including intimidation, ignorance, incompetence, management by whim, misguided vision, puppet leadership, arrogance, and of course, greed. But, by far, the most useful method I have encountered is management based on discussion and consent. This form of management has the magic ingredient: all participants feel they have

had an opportunity to be heard and have their contributions taken seriously. Of course there has to be a decision maker, a team leader who ultimately selects the course of action, but that decision must be accepted as the result of each voice being valued.

I believe that every successful relationship, no matter whether it is business or personal, is built on *communication, cooperation*, and *mutual respect*, with *trust* as the foundation. Keep in mind that all four factors are interrelated and have equal value. First there has to be free and open communication among all the participants. Whenever communication is not allowed to be free and open, the stifled voices will resent the fact that the final decision was made without their input. If they resent the decision, they will be less willing to cooperate with the other members. If that lack of cooperation spreads, then the members of the team lose respect for the leadership and those who align themselves with the leadership. As factions fragment the team and individual agendas grow, the members increasingly distrust each other and each others' motives, and that lack of trust spreads like a cancer throughout the group.

The important thing to keep in mind is that trust is at the foundation of it all. A lack of trust can erode communication and then, in turn, cooperation, and mutual respect. Once trust is lost, everything is lost. How do you build trust? For one thing, if you say you are going to do something, you do it. That is why you have to be very careful about what you say. You have to do your homework to know that your decision is well considered, not just a reaction to a problem or an action based on faulty or incomplete information. In other words, you have to perform your due diligence. Once an atmosphere of trust is fostered, it has to be maintained through even more diligence by the management. It is amazing how far a team will go once a two-way system of trust, open communication, cooperation, and respect is created.

Here's a personal story to demonstrate this point: The studio I work at had a sizeable crew made up of full-time and part-time employees. I kept noticing that people would leave after a typical shooting day was over, but I was still working and they could have helped me with some of that work. I would go around picking things up and resenting that I could have left by now if they had done their work better. Finally one day, I had had it. I called everyone together at the studio and said, "Listen up! There will be a studio meeting in five minutes in the conference room!"

I told everyone of my disenchantment and how it was unfair for them to just leave the studio with so many things left undone, and that I was regularly staying late just to complete their duties. After I finished my tirade they all looked at each other incredulously, and one by one they said something along the lines of, "You never seem pleased enough with the way I do things, so I figured, why should I work so hard? I decided I would do what I have to do to a point, and then leave the rest of it for you to finish up." Needless to say I was a little amazed at their candor and the similarity of their responses. Was it true that I was sending out a message that was undermining my efforts?

Apparently I had fallen into a trap of my own making. Either I was dealing with some very clever operatives who had read the same reverse psychology book, or I was subverting my own objectives by picking up their slack and robbing them of the joy of completing their job. Also, I had apparently set standards they felt they were incapable of attaining. Furthermore—and this was particularly distressing—I was guilty of not allowing them to find their own way of doing things. Sure they may have wanted to take an alternate approach, but I had stolen the initiative from them by implying that my way was the only correct way. And (gulp) sometimes I was going to have to let them fail in order for them to find their own style. This was a turning point in my education as a manager.

The Life Cycle of a Freelance Job

I struggled to communicate my willingness to create a better team atmosphere. In the process, I decided to dissect a generic job into its component parts and then work out with each team member the expectations we shared about their role. This had several interesting outcomes. One was the development of "nine steps" each assignment goes through from beginning to end. The other was the concept of expectation versus observation. First we will explore the nine steps.

Presentation

The first step of any freelance job is Presentation. You must put together and update a portfolio that conveys your passion and you must show it to those who need the vision and caliber of execution you demonstrate in your work. Presentation is the first step, because it sets up the level of excellence your client will expect, and they will see this in terms of how much money your imagery of their product will bring into their coffers. Your job is to leave the best impression of your capabilities and that starts with your portfolio. It puts a positive light on your talents. That has to be followed up by your personal presence, your verbal and written presentation skills, the way you communicate your enthusiasm to work on their project, and the value you will bring to the table. Presentation sets the stage. If you don't get their attention, you will not get the job. Your portfolio must contain the work you want to do, and keeping it up to date requires a lot of work.

Client Contact

The second step is Client Contact. You remember I stated in chapter 7 (Marketability) that first you have to define what you LOVE to shoot, then you have to find those people/companies who NEED what you LOVE to shoot. By using the Passion

First marketing approach, you will be able to target your market and create a program to stay in touch with prospective clients, so they will have all the ammunition in place when the right job comes along.

You can buy extensive lists from mailing services, but you will not know how to target those lists effectively unless you make some inquiries about those potential clients yourself. You may have to go to the library and look up annual reports, or spend some time on a search engine, or go through reference books such as the Standard Directory of Advertising Agencies (*The Redbook*), or the Adweek Agency Directory, or other information services, but you must familiarize yourself with who is doing what and understand how your work fits their needs. Your client contact list has to contain current entries with specific information, and it must be updated regularly. That requires a lot of research work, but the more thorough your research, the bigger the rewards.

Self-Promotion

Step number three is Self-promotion, which we also addressed in chapter 7. Virtually all art directors, art buyers, and photo editors I know have a system in place to hold onto reference material, with headings that relate to the type of jobs they normally encounter. When their boss runs into their office with her hair on fire and yells, "Quick, I need ten portfolios of someone who can shoot chrome and glass, now!" you can bet those art directors or art buyers are going to look in their hanging file folder or manila folder titled, "Chrome and Glass Photographers." If they don't have one, they will look for the closest title, or reach for their resource books, or check their Web-site bookmarks, or call a colleague—but their job is to give their boss some alternatives, which they can take to the client with recommendations. That's your shot at getting considered. Your self-promotion and advertising has to be updated and distributed regularly, and that requires a lot of work.

Estimating

Now, if the presentation did its job, and the client was the right match, and your self-promotional items were retained, you just might get a call that you are being considered for a job and are now being asked to submit an Estimate on how much the job will cost. The back story is that the clients already have an idea of how much they are willing to spend, but they want you to commit to a figure, just in case it might be *less* than what they have in mind. You, on the other hand, are trying to get the *most* you can for the job, so you ask them "What's your budget?" and they say "What will

it cost? And the dance goes on and on until someone blurts out a figure and the other person responds in any one of a number of ways (see chapter 9).

But for our purposes here, let's just think about the responsibility of developing a workable estimate. You will, first and foremost, need to know what the market will bear. You will have to know your competition and their standards. You will have to know how to read the clients and their motives. You will also have to know how to read your own instincts and when to accept the job or bail out. And, very importantly, you will have to know that you have a lot of leverage at this point. You are setting a standard of professionalism that will be maintained for the rest of this job (and any possible jobs to come). Sometimes a client will just say, here is X amount of dollars to execute the job, and you will have to run some numbers to see if there is any profit to be made on the job. In any event, this takes some business savvy, some people skills, and, oh yes, some intense work.

Coordination

If the talent is appropriate, the numbers are right, and the schedule works out for all concerned, then you are awarded the job! Congratulations! But your job has just begun, because the next step is Coordination. First you get your estimate signed, and then you get a purchase order (PO) signed by your client. You go through the channels to get an advance on expenses (and find out who will be signing the check), and then you begin to make arrangements for personnel, equipment, film and/or capture media, travel and/or studio rental, props, permits, and a whole host of other elements to make the job run smoothly. Your ability to get the job done to your client's specifications and to the demands of your own talent depends greatly on how well the job is coordinated and whether it gets off on the right foot. Surprise! A lot of work goes into this.

Execution

Finally you move on to Execution. This is where you actually get to do what you were trained to do. All the budgeting and scheduling have set the stage for you to spread your wings and execute the best interpretation of your client's intentions.

But wait. What if the client wants some shot variations, or shots that go beyond the definitions on the estimate? How do you handle that? What if your client benignly asks, "Could you just shoot a few frames as a horizontal shot?" Does that mean he is considering also running the ad as a double-page spread or billboard, which goes beyond the limitations of the original agreement? You don't want to flatly turn him down; by the same token you don't want to be a pushover. This is where you have to use your interpersonal skills, along with your artistic skills, to find out what the client is intending so you can make whatever adjustments necessary to the artistic product and the budget. This takes experience, communication skills, and some additional work.

Expense Accountability

The Execution phase overlaps the next step, Expense Accountability. Someone has to make sure the job is not going over budget or over time. It is very easy to start spending money lavishly, thinking there must be some room in the budget to cover incidentals. Someone has to be in charge of making sure the money is not getting out of hand and providing some controls. This takes business skills and people skills, and some energy has to be put out here.

Billing

The next step, Billing, is particularly important. As I discussed in chapter 9, there are a number of preemptive steps you can take to ensure you get paid in a timely manner. Although billing is so monumentally important, a lot of photographers put it off because they are on to another job, or too busy doing other stuff, or just hate sitting down and doing it. All of this is crazy to me, because it can be relatively painless if a few procedures are put in order. Billing is a fact of entrepreneurial life, and it takes some work to get your bills out as quickly and accurately as possible—but the advantages are obvious.

Payment

And the final step is Payment. Whoop-dee-doo! You finally get the check. It's a beautiful thing. But remember, you have to pay your suppliers, your expenses, your personnel, your facility, the government, the insurance, and yourself (your salary). Whatever is left over is yours to reinvest in your business, but you have to learn to discipline your pocketbook so you can build a career and have a secure future. This requires knowledge of your goals and how to attain them, and a lot of intestinal fortitude, along with (you saw it coming), more hard work.

The interesting thing about the Lifecycle of a Freelance Job is that it is a pattern we play out everyday without giving it much consideration. But if you look at it as a cycle, it breaks down into three distinct parts:

1 · **Sales:** Presentation, Client Contact, and Self-Promotion

2 · **Production:** Estimating, Coordination, and Execution

3 · **Management:** Expense Accountability, Billing, and Payment

Any small-business course will mention at some point that the three pillars of commerce—Sales, Production, and Management—support all successful businesses. Freelance photography is no different from any other business.

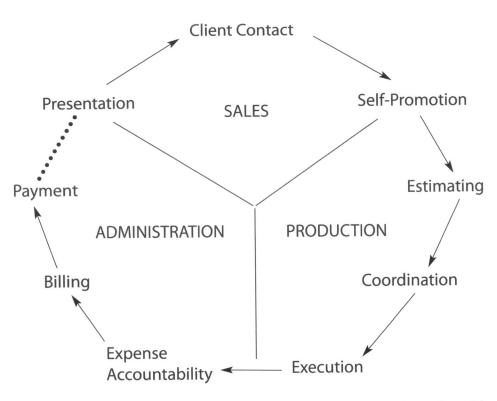

The Life Cycle of a Freelance Job

On any given day we walk into the studio, we spend some portion of our day on any or all of the following: portfolios, figuring out who to contact for work, working on our self-promos, bidding a job, pulling another one together, and/or shooting another. And at some point we have to give a little time to justifying the budget on a job, or billing one, or either finding out why we haven't been paid or allocating the funds from a payment. The disposition of those hours may differ from day to day, but we all put in the hours, the hard work.

I should note here that the vast majority of successful photographers I have spoken to say they spend about 80 percent of their time doing things that relate to their business other than taking pictures. Some even say the amount of time devoted to business is higher. All of them have told me that, back in the day, these business realities were seldom discussed in school, and that more emphasis should be placed on these topics to create a generation of photographers who understand that what we do is a business, and that there are certain expectations if you want to be competitive. I am happy to report that more and more schools and trade organizations are implementing business classes and workshops, and I believe the industry will greatly benefit from those efforts.

Expectations Versus Observations

That brings us to the topic of *expectations* versus *observations*. The basis for most interpersonal disputes (i.e., arguments) is that one or both parties have not received what they expected from an initial agreement and so distrust grows and anger erupts. Think about it: when was the last time you had an argument? Chances are it had something to do with unmet expectations. Someone did not do something you thought they were going to do, or, vise versa; you did not do something someone thought you were going to do.

I am not psychic: I am just an observer of behavior and a chronicler of the obvious. So, if we spend more time up front explaining our expectations, and listening and understanding the expectations of our counterparts, we will have a greater chance of arriving at a place where both sets of expectations are met. That's why there are contracts, and covenants, and purchase orders, and prenuptial agreements, and directional signals—well, you get my drift. In short, we could be more efficient and lead more nonsense-free lives if we took the time in the beginning to understand what we are expected to give and, in turn, what we are expecting to receive.

The Business Partner

It is important to have someone you trust whom you can discuss your ideas with. Those people are not easy to find. There are a lot of opportunists out there calling themselves partners but let you do all the work. Earlier in this chapter, we looked at the four things that are necessary for a successful relationship. And, you will remember, if any one of them falls away the entire relationship is in jeopardy.

Business relationships are not unlike a marriage. With that thought in mind I asked **Douglas Kirkland** if he had a business partner: "My wife Françoise. And she is a very good one, by the way. I have the best of business partners and she truly is a business partner. She's good at everything she does. She's multilingual—French, Italian, English, of course, and German. She went to the Sorbonne. I met her when she was just graduating. We've traveled all over the world together. She worked for Sygma Agency in Los Angeles for a number of years. She worked for *Life*. Her background is quite diverse. She also worked in the movie business briefly. And she enjoys working with me. We enjoy working together. It's not me and her, it's us. It's a mutual enterprise."

On a similar note, I asked **Bob Krist** whether he ever had a business partner and he answered: "Outside of my wife, no. You know when I left the newspaper I was chief photographer of a department of four other photographers. And just dealing with four other photographers and their work habits, or lack thereof, was enough to

tell me that I never wanted to deal with managing or being responsible for anyone else's business ethics or work ethics. So we've studiously avoided any kind of partnership or anything, it's just Peggy and me. We have some part-time help, but it's just the two of us, and that's the way we like it."

I asked **Pete Turner** about his business partner: "My wife. Her name is Reine. Reine Turner. She does the stuff that I hate doing. She's the cement that holds everything together. And she's the hardest critic I have on my work. And she is also good friends with Francoise [Kirkland] by the way. The Kirklands are good friends of ours. They are great people. [My wife] studied art at the University of Michigan; she has a master's degree from there. For estimating I usually call a producer, you know freelance people who do that, because it's tricky and frankly I don't like to get too much into that."

And **Phil Marco** spontaneously offered the following without my asking: "My greatest asset is my wife. My wife is my partner in business as in life. She's is my muse, my confidant. She is an amazing person. She is very much a part of everything I do. To a great extent she keeps me grounded. Pat is really a world-class producer, basically. She will bring in the coordinators, and the line producers, etc., but she's done it all herself. She's a very brilliant, sensitive, and intuitive person. I am prejudiced because she is my wife, but that's genuinely the impression she makes on every one who meets her. I am very lucky."

When I spoke to **Pete McArthur** he said: "Friends, assistants, and studio managers through the years have offered help and advice, but my closest partner with sound advice has been my wife."

And **David Fahey** showed the value of continuity when I asked if he had a business partner: "In 1986 I opened my own gallery with my partner Randee Klein, and we started showing paintings, sculpture, and photography. And then, after a year or two we reverted back to photography only. I should point out that as of about the year 2000, Randee gave her shares of the gallery to her husband Ken Devlin who now is my formal day-to-day partner. He handles the gallery business, financial affairs, also has designed and maintained the Web site and oversees that aspect of our business. Ken's a perfect partner, we are very well matched. I deal with artist relations, and he does all the stuff I don't want to do, and I probably do stuff he doesn't want to do. It's a perfect partnership and he's a smart guy."

David noted that his partner and he are "very well matched" because they share the load. Each of us has to honestly assess 1) what we are good at doing, and 2) what we either don't do well, or don't care to do. You can look at the Lifecycle

of a Freelance Job and quickly determine which issues you are best suited to deal with, and then look for someone who shares your vision as to what the business should be to do the other things. If it turns out, as is the case with most of the photographers I counsel, that you would rather not deal with money and money issues, then you have to find someone who can accept those challenges—someone you can trust. It isn't easy to find that other person or persons, but if you do, it can make a big difference in how your business reacts to change, and whether it grows and prospers.

Implementation

Getting It All Together

**I think of my career more like a jazz musician rather
than a rock star. I'm in it for the long haul and will adapt.
—Pete McArthur**

Let's review. Up to this point you have acknowledged that a problem exists
and a challenge must be met in order for you to live a more fulfilling life
(Recognition). You have examined what you have going for yourself in
terms of your skills, education, personal experience, and interests (Assessment).
And you have received some very practical insights on how others have successfully
made the leap of faith in transforming themselves and their careers (Planning). Now
it is time for you to finally get in the assembly-and-action mode and do some work;
now it is time to move into the Implementation phase of Transition Analysis.

As I pointed out back in chapter 1, "The fourth phase is the physically hardest
because it is the sweat-equity phase . . ." This is where your sense of commitment
becomes real as you devote yourself to the hard work of making your plan a reality.
This is also where the most important factor of implementation, perseverance, kicks
in. Your first task is to use the lessons you have derived from your first three stages

of transition and organize them into your strategic plan. This chapter has three components that will help you to 1) identify what you need to create your new business; 2) define your work; and 3) provide a method to help you stay focused on your goals.

Probably the most effective tool for defining your business is the business plan, which will provide you with tangible milestones to mark your progress.

The business plan for a creative venture is not all that much different than one for any other business, except for the fact that your product is generally a unique expression of your creativity sold or licensed in limited quantity, and not usually mass-produced. Your business is a service-oriented occupation, where your service is measured by the fee you charge for your unique interpretation of the world. In order to convince banks and other bureaucracies that you have the elements in place to make a viable company out of your concepts, you will need to provide proof that you have a career itinerary plotted out and a plan to execute it.

Career Itinerary: Your Goals and Perceptions

Let's take the information you have collected from the previous chapters and use it to formulate your plan. One more thing: when creating your business plan for your new creative enterprise, do not rely on software or downloadable templates. They are too restrictive and don't have the latitude to tell your story. Just follow the points I provide, and you will have a comprehensive outline to explain where you have been, and where you want to go with your concept. This plan will not only help the "suits" understand your purpose, but it will help you stay the course and achieve the goals you have set for yourself.

Your Professional Point of View

A good business plan states up front, in clear, concise language, what the Professional Point of View is for the proposed business. As we pointed out earlier, this is the chance you have to state your Vision (why you want to do this important work) and Mission (how you intend to execute your Vision). The clearer you are the better. I have seen Vision and Mission statements that are so wide ranging no one could take them seriously. The more quixotic your statements are, the less chance you have of anyone taking you seriously. It is better to be focused and specific (and then later grow more generalized) than it is to present yourself as a generalist and not get anyone's attention.

Begin by keeping your Vision and Mission statements to one sentence each if at all possible. That way others will be able to clearly see and remember your goals. After the introduction, you can go into more detail, with each paragraph building on the last, so they can see you have given the idea a great deal of thought—this not just some whimsical idea you dreamt up. This should not be a problem for you, since this concept is something you live for and you can't wait to tell everyone about

it. All great entrepreneurs have a sense of mission and evangelistic spirit about their products. You can describe the influences that caused you to create your new direction (keep it positive), your creative strengths, and the unique perspective you bring to the marketplace. Remember the Vision Statement contains your loftiest goals, while the Mission Statement describes your means to achieve them.

Your Market

Even the best idea is doomed to failure if there is no market to embrace it. I am sure you can think of some examples of products or artwork that never made it because the time was not right. You have to demonstrate that you have researched your market and you know its ins and outs. And the more targeted the market the better. You will have a better chance of catching on if you satisfy a core constituency. Those people then convince their friends to buy into your work.

When describing the size of your market don't make pie-in-the-sky predictions that bend logic. Be realistic about the size of the market and the percentage you plan to capture, and how this knowledge will lead to meaningful market penetration and achievable milestones; otherwise you are setting yourself up for unnecessary frustration, stress, and possible failure. Once you have captured the imagination of the market, you can predict growth and expand your base. Keep in mind that your goal is to build a new career that won't fall into the old familiar format of flash-in-the pan success followed by repetition and predictable, eventual extinction.

Do your homework and price your work respectably: neither too high, making your work unapproachable, nor too low, undermining the caliber of your work and the pricing benchmarks for others in the profession. If it is priced too low, then people won't trust it. If it is priced to high, then people won't even consider it. Do your homework and ask people you trust in the profession what a reasonable price is; then factor in whatever values you add to the product.

How do you intend to promote your services? Have a clear idea as to the most effective way of marketing and selling your work. Once you have clearly identified your target audience, do the research necessary to know what media they respond to, what outlets they pay attention to, and strive to get the most for your marketing dollar. Put yourself and your work where it can get noticed and appreciated. Build an awareness around it that matches the needs of your audience. The concept of branding comes into play here: you build a culture around your work that becomes a part of the lifestyle of your customers and eventually creates a lifelong following.

Your Competition

You should have a keen understanding of who your closest competitors are. How do you do that? When you are asked to bid a job, ask your prospective clients whom you are bidding against. They just may tell you. Many of your clients are

required to triple bid estimates so they can have a range of options to choose from (and they can prove to their boss that they were diligently doing their jobs). If you find you are continually bidding against the same people, you will have a better idea of how your clients see you, and where they see you in the marketplace. As you research your competitors, you can determine what advantages you hold over them. Are you more knowledgeable, more experienced, more accessible, more flexible? Having a nicer studio and a better craft services table available are pluses, but there better be something more substantive that your client can use when talking to his or her boss to tilt the decision in your favor.

Knowing your competition is not just a matter of compiling a list of names you commonly are asked to bid against. You have to find out how they advertise and how to make your advertising more effective. You will have to track the performance of your advertising and self-promotion, so you will have to build this into your business plan and explain the costs involved.

Your Location

The location of your business may be an important factor, but this has become increasingly less relevant as the world becomes smaller due to air travel and the Internet. Still, being reachable, so you can quickly respond to your client's needs, is a reality we all have to deal with. If your business is not convenient for your clients, you may have to go the extra distance to make yourself available to them.

When putting together your business plan, make sure you mention the other businesses in your area that provide support for your prospective business. The more support services available, the less time you will have to spend running around getting the right equipment, supplies, and facilities. And make sure to include that you have taken into consideration any zoning laws and permits that apply to your business. These kinds of details will strengthen your plan and demonstrate that you are a serious businessperson who has thought through all the elements necessary to work efficiently.

Your Management and Your Team

Another thing you will be required to address in your business plan is the structure of your company. Are you planning on being a sole proprietor, a corporation, or a partnership? You will have to define your role, the responsibilities of your co-workers, and, if you have a partner, what his involvement will be. (See chapter 10 for some thoughts on partnerships). Remember, the tone you set for the working atmosphere can make your new business into a great place to go to work or a daily ordeal. The side benefit of creating a new venture is that you can reinvent your management style along with your creative style, if your old style does not suit your purposes. In defining the roles of your new team, you can empower yourself and those around you by allowing everyone the chance to be creative and be a part of the new

successes you are about to realize together. You can devise a new, leaner operation in a new environment that reflects what you want to get done and how you want to do it. Remember that your new physical space needs to express your new approach, so make it professional, comfortable, and conducive to the work you need to do.

Your Finances

Obviously you will have to put a price tag to all of this. One of the great advantages of executing a business plan is that you can determine a cost for each component you need to address; then you can total them up and have a comprehensive view of what it will cost to start and maintain your business. I like to look at it this way: all complexities are nothing more than confused simplicities. If you separate all the little confusing aspects, get a good understanding of them, get a price for them individually, and then reassemble them, you will have a realistic idea of what kind of money you are talking about. That way the whole process does not seem as complex, and you can see where you can pare down one element and shore up another to arrive at an understandable bottom line.

The first question of course is how much money will you need to get your new career started? We saw in chapter 9 that you will have to figure out your fixed and variable costs. Will you need to remodel your physical space, get new equipment, and hire personnel to accommodate your new business venture? How much will it cost for marketing, maintenance, insurances, permits, additional commitments, and to plan in savings for emergencies, retirement, and reinvestment? How do you plan to raise these funds? What collateral do you have? Do you plan on going into partnership with anyone and how will they be paid? How much money will you expect to make during the first six months, the first year, the first five years?

The key here is not to allow yourself to get frustrated before you even get started. These are real questions that have to be asked—and answering them honestly can give you motivation. The first check you need is a reality check. If that is in place, then everything else will fall into place.

Defining Your Work

Keep in mind that a business plan is intended to be a road map to success. You may take a few excursions off the main highway, but if you keep focused on your destination you can always find your way back to the main road. It is important in any business, especially a creative venture, to be flexible and available to new opportunities. But a well-formulated business plan will help you keep your eyes on the prize and the means to achieve it. Not all successful ventures begin with business plans; it is just that your chances of success increase with a clear vision of where you intend on going. As the great contemporary philosopher Yogi Berra said, "If you don't know where you're going, you'll end up somewhere else."

One of the observations I made during my interviews was how the photographers perceived themselves and their work, and how that perception formed the basis for their Vision and Mission statements. Some were very clear and definitive, while others were open to letting the work define itself. In general, we don't like labels because labels are too confining. Then again, we need labels to some degree because they help to give an identity to our body of work, and our work becomes more easily recognizable and readily accepted. Each artist has to find his own way. Let me give you some examples.

Ken Merfeld took a philosophical approach that transcended the usual categories in favor of an overall view: "My work is a fortunate blend of what I love to do. I love interesting people and beautiful light and the unexpected. And I am fortunate to have projects that combine all of those qualities. I work commercially but I also do a lot of work that is not commercially driven. I've always been enamored with light and lighting, and I personally have an affinity for the unexpected. I like to challenge myself to push the boundaries a little bit. I shoot other than abnormal things, other than normal people a lot and that just keeps the other side of me kind of going."

Ken Merfeld: Superman, 1981

*Ken Merfeld: Marla, 2003, Wet-Plate Collodion process
as an Ambrotype then digitally scanned*

Pete Turner did not limit himself to photographic terms. When I asked him how he defined himself and his work now, Pete came right out with: "I'm a colorist. That's what I do. People ask me that all the time. I think in terms of color. But again, I like people to know that I still like black and white, my roots were from black and white. Many of my friends do just black and white. But I'm a colorist, that's what I see. I guess it was those postage stamps."

Even if you don't like labels, the world has a way of putting them on you for its own convenience. This is how **Jay Maisel** responded when asked how he defines himself and his work: "Well, I try not to. I mean, I was up at Santa Fe giving a lecture and they had me down as a commercial photographer. And I took a pen and I crossed off the word 'commercial' and left photographer. I mean there would be a guy who would say I'm an annual report photographer, or a fashion photographer, or a street photographer—I'm a photographer. I mean, I'm a generalist. I don't do beauty, I don't do fashion, I don't do underwater, I don't do food; I don't do this, that—but if it can be photographed I'm going to photograph it."

When I asked **Bob Krist** the same question he gave another twist to the topic of being a "generalist," when he said: "I'm kind of a jack of all trades. I do a little writing. I do a fair amount of shooting. The theater training is coming back into play. In the last six years I've hosted two series on photography on television. I host a lot of 'How-To' videos for Nikon. You know, what ever it takes. The label 'Travel Photographer' has stuck on me most often in the last ten years or so, but I spent the entire 1980s doing corporate photography. I've had a lot of labels stuck on me all through my career. I'm pretty good at everything, but I'm not too good at any one thing. I can do a little portrait, I can do a little landscape, I can do a little this, a little that, but I don't specialize outside of the fact that it's travel I specialize in."

When you look at **Pete McArthur**'s work you are struck with words such as strong, meticulous, cerebral, funny, contextual, and brilliant. But when I asked him he defined himself now as: "An experienced, mid-career professional who had a good run in the 1990s and who is in the midst of adjusting to the changes taking place in the photography markets of the last three to four years. I sometimes find myself wondering if maybe my best years are now behind me, yet not knowing what else to do this well, I think of my career more like a jazz musician rather than a rock star. I'm in it for the long haul and will adapt. Another part of what I do and have come to enjoy just about as much and sometimes even more, is teaching. I'd really like to keep doing this as long as I can, since it gets me working with young people, and I think it important to pass along what I've learned to the next generation of photographers."

Sometimes we have to invent a new category if the available ones are too restrictive. This was the case when I asked **Ryszard Horowitz** about his career and how he managed to create and maintain his own classification for so many years. I asked. "So how long did it take you to become recognized?"

Ryszard chuckled and said: "It's amusing to me because I see things being done right now that I did thirty years ago. And I don't mean be a smart ass, but I feel it is really evoking. You asked a very interesting question that has to do with that, you ask, 'How do you define yourself?' I never had any difficulties with defining myself. I made a conscious decision early on not to follow a style, not to follow trends, not to do what is expected of me, and not to emulate people who are called 'hot' at a particular time. Because after a while when you live forty, fifty, sixty years, you realize that people come and go, and people who are famous at a particular moment disappear and nobody knows of them a couple of years later. It's really very unfair and painful but that's the way it is. So unless you create images that are lasting and can transcend fashion, it's pretty much, I wouldn't say meaningless, but it is not lasting. I am really proud to say that frequently I stick into my portfolio photographs that I did several years ago and people don't realize how old they were. And that's good, you know. And again, not that I consciously figure it out how to go

Pete McArthur: Mona

about it, it's just that it relates to the nature of my way of looking at things, and thinking and approaching things."

Douglas Kirkland took a quality-of-life approach to answering the question. His answer embodies the spirit of why all of us have chosen a career in photography. "To begin with, at the top of the list, I am 'lucky.' I've worked hard but I've done it through love and enjoyment. I don't ever want to stop. People say to me, 'Are you going to retire at seventy years of age?' I say, 'Hell no. I'm not going to retire. What

would I do if I retired?' I take pictures. I do that now and they pay me to do it. There is no question that I love photography. I am sure you are the same. I find it difficult to take a vacation if there is not something to do. I am just wound up with pleasure and enjoyment."

"The Action Board" as Described by Dr. David Viscott

Now that you have an outline for a business plan, and now that you have had an opportunity to see how veterans perceive themselves and their work, let's take a look at the topic of achieving goals. I asked Mark Edward Harris if he had planned any of his transitions or if he acted on instinct: "I go a lot by guts. You know people talk a lot about what are you going to do in five years, and this and that sort of thing. I am not particularly great about that, although I do write goals for the next year down. I did hear somewhere, I think it was a study of Harvard graduates, or Cambridge graduates, or graduates of somewhere, that they discovered that the people who write goals down are more likely to attain them. But I tend to do those on a one-year sort of thing. And it's interesting to look back to see which ones came true and which ones didn't, you know it's kind of a neat thing. I do a fairly good percentage. There are two things. One is that I am not writing tough enough goals, or I am a taskmaster enough to make them happen. Do you do that?"

That is an interesting question because I have found that a lot of artists I have talked with like the idea of organizing their work about as much as defining themselves and their work. The myth many artists live by is that they are disorganized, devil-may-care, fly-by-the-seat-of-their-pants creative types. Initially it is easy to buy into this, because you don't have to give very much consideration to anything other than your art interest, and you don't have to "waste" your time on any thing else.

But the truth of the matter is that we can all benefit greatly from some simple way of staying focused on the multitude of ideas that fill our heads. I am sure you will agree that one of the greatest challenges we encounter is that there are so many projects to do that we lose the ability to prioritize and lose productivity in the process. What I am about to share with you is one of the best methods of creative organization I have run across—one which allows you to maximize your time and talents. This process will help you immensely in implementing your plans and increase your creative output. This, like so many other suggestions in this book, comes by way of the late Dr. David Viscott, and I pass it along in memory of his willingness to help all people who dedicate their lives to their creativity.

One day while visiting David at his in-home office, I asked him how it was that he was so incredibly productive. By that I meant he had written something like fourteen books, had a successful psychiatric practice in Beverly Hills, had a daily radio talk show, hosted an Emmy Award–winning television talk program, conducted

lectures and workshops, and was named Father of the Year, among other things. In his matter-of-fact style he said he used the Action Board. Of course I asked, "What's that?" hoping that this would help me get my act together.

He pointed to a roughly two-foot by four-foot cork board on the wall of his office and proceeded to tell me that he had done a study of the creative process and had broken it down into six steps. This appealed to me on a number of levels, because it was about creativity, and it had steps, stages, phases, something tangible, and it was something proactive, which, as you know by now, I love.

Then he proceeded to tell me how it worked. Take a large surface (a cork board, a dry-erase board, a poster board, whatever) and divide it into six columns. Next, label the each of the columns as follows: 1) Idea/Project, 2) Research, 3) Organization, 4) Development, 5) Editing, and 6) Promotion. Like the Transition Analysis (the Five Stages of Creative Evolution) that I described in chapter 1, these six stages don't totally define the creative process, they simply give us milestones during the creative journey so we can mark our progress.

You always have to have a piece of paper in your pocket or purse and be ready to write down any creative thoughts that enter your mind. Creative thoughts include any novel ideas that come out of nowhere, which, if they are not caught, fly off like butterflies, never to be seen again. Once you write down the idea, it gets thumb tacked or taped to the Action Board in the first column, and it transforms from an idea—a concept or abstract thing—into a project, a doable thing worthy of your time and consideration.

If the idea intrigues you, you will find yourself collecting information on that topic and doing research on it. At that point you physically move the paper to the next column titled Research. Little by little you start collecting information about the subject, and you put it into a file, and pretty soon it gets filled up and it requires a box or boxes. You find out what others have thought about it and what others have done, or not done, about it. Your research takes you to areas you never considered before, and your world expands. Just as we examined earlier during our discussion of finding your passion, you now start finding examples of your passion, your interest, all over the place. Your awareness increases and you overhear things, you observe things, you pick up a magazine and there's an article on your topic—you experience things differently.

Eventually you have all this research accumulating and you have to give it some order. You move your piece of paper over to the Organization column. The act of organizing gives you a clearer picture of the work that has been done before. Organizing also helps you state your approach, your thesis, and infuse it with your own character and unique problem-solving abilities. Organization gives us the gift of seeing the larger picture so we can measure our thoughts against what others have had to say on the topic.

At some point during the Organization stage there evolves a commitment, a contract between you and the subject matter, and you move the paper over to Development column. This is the phase during which you "just do it." You get your act together, load up the van, and you go on the shoot; or you sit your rear end down and write the words that accompany the photographs that go into your book; or you write the play; or whatever. This is the time when you let it all pour out of you. You don't stop to edit or refine things, you just let it happen. And as you let it happen over and over again you tap into something larger, something self-perpetuating; something uniquely yours and not yours at all. When you are in your groove, there is something timeless so you don't stop to let any distractions get in the way of the process. Then, when the product of your labor is over, you take a moment to look at it as objectively as you can. That is when you move that humble piece of paper to the next column, which is Editing. Now you go back and use your refinement skills, you critique it, you trim it and shape it the way you want.

But you are not finished yet. The work is not complete until it is shared. Now you can move the paper to the final column, Promotion. If you put your creation in a box and place it on the shelf, if you shove it into a closet, your work is incomplete. Your creation must be shared so it can affect others and encourage them to express their vision. You could just show it around, or hang it on your walls. Or you could have a gallery showing, or show it at the art fair. Or you could even license it or sell it outright, but whatever you do, you have to share it with others. This concept is consistent with the steps of Transition Analysis, in that the artwork must be validated by showing it to others, which then inspires them to express themselves; and that, in turn, stokes the fires of creativity in still more people, thereby insuring that more evolved work will be executed and become appreciated.

Now, an added aspect of the Action Board is that sometimes we start working on something and it just runs out of energy. For whatever reason, some ideas just can't sustain themselves over a period of time. It is okay to leave the paper on the board for a while until the idea strikes you again. Or, better yet, it may link up with another idea and together they form a whole new idea. I am the product of a parochial-school education. There were a lot of advantages to that education and I am very grateful for that opportunity. But one thing the nuns taught me was that I had to finish one project before I began a new one. And since it came from the nuns that I had to do each thing one at a time to completion, it was something of a mandate from on high. That's the way it had to be done, or else. I had a great deal of frustration when one idea didn't pan out, and I felt I had to wring out every ounce of energy from it whether or not I was inspired by the time I got to that point. The Action Board frees me of that guilt, because it lets me know that I can synthesize ideas; what may have started out as an idea for a play can become a book, or a

screenplay, or anything it wants to be. I am happy to say that I have become far more productive since I started using David's Action Board. It keeps me focused, energized, and challenged.

And here's something else. I collect those simple pieces of paper that make it to the finish line in a special folder. When I feel as though I have dried up creatively, I just open up that file labeled "Completed Projects," and I am always surprised that I followed through on so many thoughts that started out as simple scribbling and went on stand on their own.

Whatever method you use—the Action Board, a priorities list, a job calendar, instinct—you quickly realize that nothing gets done on its own. Implementing your idea is the job you were created to do. Recently I asked a photographer who had done an amazing composite image in Photoshop how long it took him to accomplish the finished product. He thought a while and then he said he thought it took him about forty hours. "Forty hours!" I said; to which he said, "But it didn't seem that long because I was so into my work." Doesn't that say it all? When you are in the process, all sense of time fades away, and you take whatever time it needs to be done correctly. Of course you may have client or self-imposed deadlines and restrictions, but you know not to take on jobs where the restrictions are too confining, because you won't be able to do your best work.

Yes, implementation is the sweat-equity element of the cycle of Transition Analysis, and it needs to be respected, organized, and focused. But you must also spread your wings and express that which is uniquely yours.

Validation

How Other
Artists Have Effectively
Created Change

It's almost like I don't have a choice about it. I mean
I have just got to have a camera and shoot. I don't know
why, but I've just got to make photographs. I am wired that way.
—Mark Alberhasky

Validation is the final step in Transitional Analysis. It is the last stop, where we do more than take a look back on our journey. It is also the platform from which we judge how well we perceived our challenge, how well we accomplished our tasks—and we also review what we have learned not to do again. Validation is the proof that the struggle was worth all the hard work. In the Validation stage, we get to bring home the prize and share it with those who matter to us.

The following three people are extraordinary in many ways. That is to say, they have gone beyond their own obstacles and met the challenge of change squarely.

They may not be big names in the pantheon of photographers (yet), but I am confident their stories will give you the encouragement to embrace your passion, to plan for a meaningful future, and to persevere by never losing sight of your goals. They are all people I have had a chance to meet and talk with, and who have reshaped their lives into something more fulfilling than what they had experienced before—something better suited to their aspirations. I believe their stories validate the principles that I have discussed in this book. I must note here that I am including outtakes of their interviews in the original dialogue form with the same or similar questions I initially asked of the other interviewees in this book. There are similarities among all these unique artists, and their remarks may strike a chord in you and provide a note of inspiration in you as they have in me.

Gail Mooney

I met Gail Mooney about five years ago at PhotoPlus Expo in New York after a lecture I presented. She felt there was a project she wanted to do, but that she wasn't sure how to go about it. You could see she had a passion for the subject and she needed some direction and encouragement. But the subtle fire that was in her heart came through as she talked about learning new tools for image capturing and how she wanted to apply them to a special project. The project she focused her energy on was concerned with the blues musicians of the Mississippi Delta, who were getting on in years. Somebody needed to capture their stories of love, and labor, and loss, and grace before it was too late. We stayed in touch, and I watched as she used her personal energies and the resources from the Blue Earth Alliance (*www.blueearth.org*), an organization that provides grants to photographers who "educate the public about threatened cultures, endangered environments, and other social concerns." Here is her interview:

> **TL:** Where did you get your education to become a photographer?
>
> **GM:** I graduated with a BFA in photography from Brooks Institute in Santa Barbara, California; prior to that I studied architecture at Syracuse University for two years.
>
> **TL:** What were some of the events that have caused you to change artistic directions during your career?
>
> **GM:** Many events seemed to happen simultaneously. I have always been a storyteller. I shot a story some years ago that I proposed to *Smithsonian* magazine on swing dancing. It was challenging to illustrate with a tool that inherently had no movement or sound. Of course I used blurred and flash blur effects, but it was still somewhat limiting. Then

about five years ago I read an article on "guerrilla" filmmaking, on how with the advent of high-quality digital video at a relatively low cost, more and more filmmakers were able to execute their movies without needing millions of dollars. The article listed some Web-site links, and one link led me to discover that the AFI [American Film Institute] was having the first DV [digital video] seminar to explore this new medium. I attended this event, which was full of hands-on sessions, discussions with panelists from many different fields, and networking opportunities with others who were interested in this new medium. It really rocked my world, and I spent the next two years attending seminars and workshops to learn more about DV. At the same time the Internet was changing the way people got information, especially with more and more people having broadband connections. Also during this time period, the publishing business was changing. Stories were driven more by marketing and less by the "story." Magazines became more of celebrity rags—not just celebrity type magazines like *People*, but travel magazines, news magazines. Contracts were becoming lopsided and obtuse. And like I said, I was beginning to feel that shooting stills was a bit restrictive. So while one interest of mine—stills—was waning, my interest in the new media was driving me to explore.

TL: How did you make those transitions?

GM: I continued to take workshops in video and video production. I took a couple of workshops at the Maine Workshops one summer and took Dirck Halstead's Platypus Workshop [for still photographers interested in learning video] in Oklahoma. I also took seminars in FinalCut Pro editing and went to many DV conferences. I also initiated a project on my own on the New Jersey Youth Symphony, which my daughter is a part of. I produced, shot, and edited a documentary on the organization.

Another self-initiated project is one that I am still continuing to do work on and is called "The Delta Bluesmen." This is a multimedia project that combines video interviews, performance footage, and still environmental portraits of some blues artists from the Delta area. This was inspired by the people at the Blue Earth Alliance, a nonprofit group that sponsors photographic projects dealing with the environment, social issues, or cultures. I attended a wonderful seminar that they gave entitled "Shoot from the Heart" at the PhotoPlus Expo in NYC one year. It prompted me to take action on an idea that was kicking around in my mind for years, and I turned it into a multimedia project because it seemed like the natural thing to do.

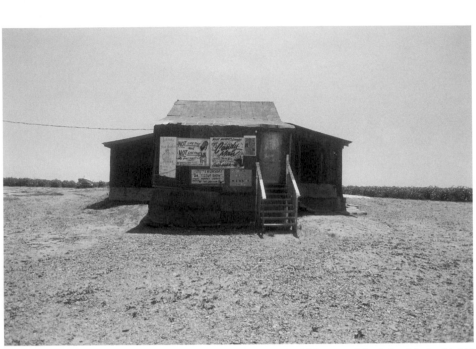

Gail Mooney: Juke Joint, Merigold, MS

Gail Mooney: Sam Carr

TL: Who inspired you to change career directions?

GM: I didn't really set out to change the direction of my career; I was more motivated to adding to my skills and craft. I have been inspired by many people—a lot by the people that I heard speak at the AFI.

TL: Do you have a business partner? Have you had a business partner?

GM: My husband is also my partner in business. He has been my partner since we graduated from Brooks Institute in 1975.

TL: Are you instinctively a planner?

GM: I am a great planner and researcher, and I think I bring this to the producer's role in video where laying out the storyboard is a must. I have a very organized mind and am able to break down projects into manageable logistic steps.

TL: What advice do you have for photographers who are about to start or restart their careers?

GM: Go with your gut and do what you love to do. I have a great story that I love to tell. When I graduated from Brooks Institute, I went to see Jay Maisel for his words of wisdom and for assisting opportunities. I showed him my portfolio from school, which was technically perfect and mostly studio work. He looked at me and told me it was garbage. I had some other work with me that I had produced on my travels and was more journalistic in nature. When I showed him those samples, he told me that this was my better work and wanted to know why I was shooting and showing studio tabletop work. I told him that everyone keeps telling me that if I wanted to make a living as a photographer, that's what I needed to shoot. Then he asked me how old I was. I replied twenty-five years old. He looked me straight in the face and said, "You're twenty-five years old and you're already making compromises." It was a turning point in my life and from that point on I stuck to my heart.

TL: Who are your photography heroes?

GM: Margaret Bourke White, Walker Evans, Cartier-Bresson, James Nachtwey, David Allen Harvey, Jay Maisel.

TL: When you awake in the morning, how do you fill in the following statement: "Today is a great day because today I get to shoot—fill in the blank!"

GM: Whatever I want to.

Todd Johnson

You may remember that back in chapter 2, I mentioned a photographer who, despite the fact that he was making very good money as a car shooter, was feeling there was something lacking in his life because he was gone for such long times on location shoots that he had missed out on a significant portion of his son's first year. The shooter I was referring to is my friend Todd Johnson, and although I have met many people who have expressed similar concerns, Todd's resolution has been uniquely his own and very inspiring.

I met Todd back in 1992 when he volunteered to be a photography mentor to the group of Los Angeles inner-city kids in a nonprofit program I helped start. He volunteered to teach photography to at-risk young people, and he brought a kind of enthusiasm and hope to the program that caught my attention. I could tell he was not some flash-in-the-pan do-gooder with a guilty conscience. There was something about him that told me he was a man of commitment, and I am happy I have not lost track of him since those troubled days in Los Angeles after the riots. I remember when he called me a few years ago and we talked about his concerns about how his career was progressing. Todd, as you will see, is serious about business, but more serious about his way of life and being true to his values. Here is a portion of an interview I had with him:

TL: What did you do before you became a photographer?

TJ: I've been working in photography all of my professional life. Specifically producing photographs hasn't always been my job, and part of my ten-year education plan was to try to work with the photographers who I thought were the best in the industry that I was interested in that time, and to make sure I did all of the jobs that I was going to need to direct somebody in during my career. I worked for Clint Clemens for many years. I did many different jobs for him, naturally starting with assisting, and I was his producer for many years and did location scouting—in fact that's what brought me to Los Angeles. I was here to open a production office in Los Angeles for him. I've done the full range from stunt driving, to car prep, to everything else you need to direct in advertising in the automotive industry. As a kid I looked around and said, what are my favorite things? I like photography, I like cars, and I like to travel. So let's see, I'll be a location car photographer.

TL: But, you had the perception to know that kind of occupation existed?

TJ: Yeah, and I had all my favorite car ads taped up to my wall all the way around my room.

TL: Where did you get your formal education?

TJ: I went to the Art Institute of Boston because it was far enough away from home to give me some distance. And it was, from the schools that I looked at the time, living on the East coast, the best educational route because it is a fine-art-oriented school. It has a commercial program but it is a fine-art-oriented school, and I felt that what I really needed from school was to develop a vision, and a way of seeing, and a way of thinking, and that the commercial would be best learned from the industry.

TL: How do you define yourself and your work now?

TJ: That's something that is currently and constantly evolving, but my first reaction to how do I define myself and my work now is to say that I have a life-first philosophy, that my art and craft are merely an extension of what I want in my life. So, how do I define myself in terms of my work as a product or effect of what I want from my life? My current phase of my life affords me the pleasure of photographing people when they are at their highest point, their zenith, when they are happy, they are full of love, they are full of positive energy, at their weddings, and I am happy to share that in a dramatic way. So the experience I am looking for out of my life in terms of being able to share great things with great people when they are at this great point in their life, and getting to know them and getting to share with them is really what I am looking for in my life and right now it seems that wedding photography, at this sort of level that I am able to do it, is the best way to do that.

TL: I remember when you were shooting cars, and now you shoot weddings and do some car work simultaneously, or in tandem, right? Because I remember our conversations back some time ago about your willingness to explore other areas when you were talking about how much time you were putting into your car shooting, but you had a young son and you wanted to figure out a way to make more time for this once-in-a-lifetime opportunity, and you were going to have to make some concessions in your life. Then shortly thereafter, there were the fires in the foothills of Southern California, and you were saying when you watched people being interviewed on the TV news as they were being evacuated, they didn't say they were taking the latest ad for an SUV; they were taking their photo albums.

TJ: Exactly. And there are so many elements that have gone into this kind of a life change, but the one thing that started it was I was looking at the decision whether to start a family and looking at the sort of schedule I

was keeping—Harley-Davidson was a big client of ours—and we would work on their brochures and be gone for a couple of months, and a month of that was on the road shooting, and that's not something that I think is acceptable when I have a young child at home. So I decided that having a family was something I wanted to do, and that doing the business in the way that I was doing it at that time wasn't going to be an option. One of the directions that was an option was doing wedding photography, where we would know well in advance (nobody has month-long weddings), the projects are pretty concise, and you could plan your life around your schedule for this type of photography.

TL: It's such a personal story, because you are being driven by what is important to you. As opposed to a lot of people who go with the flow and do whatever makes them the most money. You have a very definite appreciation for what you want to get out of life.

TJ: When I was in school I was headed to commercial photography. I was always a little uncomfortable with the idea of committing all my creative time and energy to getting people to buy more stuff. But I made a big investment and was heading in that direction, and I wanted to see that through. But the older I got and in the context of my son coming along, I know that he's not going to do what I tell him is important, he's going to watch what I do, and he's going to see how it works, and he is going to see how it washes with what I say. As a Quaker, I am going to tell him, being completely materialism driven is not going to serve you well in the long run. But then I spend all my time and creative energy getting people to buy Hummers and things—that doesn't really wash. And I had a desire to do something that really seemed worthwhile, and that's another thing I observed with the weddings.

Like you said, there's people who, when there is a fire on the way, if they could grab one thing, what is that going to be? A lot of people would consider that their wedding photographs, and I can think of probably nobody that would say that last great Toyota ad that I have to get on my way out the door. You know you work crazy hours and really hard and next month it's history.

TL: What are some of the events that have caused you to change your artistic direction during your career?

TJ: Of course coming to grips with the events we were just talking about, coming to grips with the materialism aspects of that. But to add to that the industry itself has changed. This is a secondary or tertiary issue, but

Todd Johnson: Harley-Davidson ad

Todd Johnson: Little Church

as I look at the big picture as to how things are changing, I am seeing that over the last twenty years since I have been involved in commercial photography, especially in automotive, there has been this constant war between the creatives and the bean counters, and what I am seeing in the last five, six years is that the bean counters are winning, and they are making it more and more difficult for the creatives to create effective advertising.

TL: And you also credited Ian Summers for his "Heartstorming."

TJ: Yeah, thanks for reminding me. Kind of a funny story, back when I left Clint and I went to start my own business, I was thinking that I needed to be very practical about things. I was going to focus more on studio photography and tabletop and whatnot until I got things rolling, before I went after the automotive. It was clearly going to be a very difficult nut to crack because of the very tight market for automotive advertising. I went to hear Ian speak the one time, and it wasn't a one-on-one or a small group workshop—it was a large group site where I didn't really have a chance to speak with him much directly, if at all, and he talked about the importance of photographing what you love, and I was really inspired by what he said.

I got rid of the studio we had and focused all my energy on the automotive location advertising, and creating a portfolio, and marketing that. And within a couple of years, maybe three years, we had great success, and had an image on the cover of *Communication Arts*, and had a bunch of awards. I saw Ian one time and I said, "You know, I really have to thank you." I recounted the story and everything, and he looked at me in the way that Ian does and he put his hand on my shoulder and said, "Todd, I am really glad that worked out so well for you, 'cause that's not what I meant."

There wasn't an opportunity at that point to find out what exactly he *did* mean, so when my son was born, I was trying to figure out what exactly am I going to do here and how am I going to reshape my life so that all the different elements work. I came across [a notice] that he was going to have a workshop at the Santa Fe Workshops. I always thought about that, "That's not what I meant," and I said, well maybe now's the time to find out what he meant.

I spent the week with just a wonderful group of people in Santa Fe and shared a lot, and discovered a lot. Christine Johnson who is a wonderful wedding photographer out of Arizona was in the group, and that was the first time I had seen really good wedding photography, and I found that industry had completely changed. It was now not only okay but it was becoming the norm to do really good photography, really creative photography in the wedding environment. And that was a huge eye opener. We

shared some of the experiences of that and when I came back to Los Angeles there was a sub-group of "Heartstorming" that started up for a while, and another photographer, John Barber, he's out of Orange County, he's an amazing photographer, and I learned a lot from him and met a lot of other people.

I found that wedding photographers were just really wonderful people, just very giving, very sharing people, and I just hadn't quite found those same people in the advertising world; not in my travels out there, I just hadn't met them. I was really drawn to it and people like that who were a great influence—like Joe Buissink, another amazing photographer, he is more of a wedding photographer to the stars. He's a real visionary and a real warm personality.

TL: You've mentioned three photographers who inspired you. Any there any others who were inspirational?

TJ: I spent eight years working for Clint Clemens, and he set a lot of my foundation in terms of my vision, how I think about photography, and he's not a person who goes along for the show. There may be a big production, but he's all about the photography, and he's an amazing visionary that can create something out of nothing, consistently. He is in many ways even a parental influence at the level that a parent has where you don't really see those influences because you live them, and you don't know that they are from somebody else because they are so ingrained.

TL: What advice do you have for photographers who are about to start out and those who are looking to change directions in their careers?

TJ: In school they never talk about lifestyle—meaning how you want to live your life and how your artwork enters into that. And it seems to come as a surprise to a lot of people when they hit the real world of commercial photography to find that they are on the road working twenty-hour days for weeks at a time. And you are away for long periods of time. So I would encourage people to one, think about what kind of lifestyle they want and to learn a little more about the lifestyle of photographers who are successful in their given direction. And the second thing is that one of the things you don't really learn in school is that business is a much bigger aspect of the photography than photography is. The photography is fun, it's creative, it's energizing, and actually ends up being a small part of what you do. Business knowledge seems to go a lot farther than the creative side. So I would say if somebody is looking at going to school, if they are not going to be able to study business and study their art, that they may do well to just

go ahead and study business and then learn the art and the craft in the commercial world.

> **TL:** When you awake in the morning how would you complete the following sentence: "Today is a great day because today I get to shoot—fill in the blank?"
>
> **TJ:** What my clients feels is the most important day of their lives. And they are going to keep these pictures forever.

So now you see what I meant when I said that Todd has always been serious, committed, and true to his values. By the way, for the last two years Todd was the recipient of the International Photography Awards/Lucie Awards with the first place for wedding photography. Like I said, when Todd makes his mind up, he's committed.

Mark Alberhasky

The last interview I am including in this chapter is another great story of change and perseverance. I first met Mark Alberhasky at the PhotoPlus Expo in New York, probably two or three years ago. I had just finished giving a lecture and he and I talked about his proposed career change. At the time he had been a physician for about twenty years and he wanted to become a professional photographer. Like you, I said, "What?" But he had an excitement in his eyes that underscored his enthusiasm. This was not just some doctor with an expensive new camera. This was a man who had always wanted to become a photographer, and he was intent—no, insistent—on finding out what he needed to do to become a professional. As you will see, I didn't have to prompt him with too many questions once he began this interview:

> **TL:** Yours is a really unique circumstance that I appreciated fully from our first meeting and then while keeping up with your progress.
>
> **MA:** I've been a pathologist for over twenty years. My father was a physician, and my brother is a pathologist, my grandfather was a surgeon— so there is a long tradition in our family. When I was in college that was the question for me. I had started photography as a freshman in college. I saw a guy and he had a fancy-looking camera, and I stopped him and asked him how do you take good pictures. It so happened that he was a photojournalist shooting for the University of Kentucky school newspaper and so he said, "Meet me at this building at 8:00 tonight and I'll show you." With that chance meeting he took me into the darkroom, he showed me how he developed the film, the whole black-and-white printing process. And you know how it is, you see that first piece of paper come up in the developer, and if you've got that inclination you are hooked. And I was hooked.

All through four years of college I spent every spare minute shooting and in the darkroom. By the end I had amassed what I thought was a fledgling portfolio of some promising work. In my senior year, I pursued a special general-studies degree program for pre-med but also for some photography courses and other courses that could get me some aesthetic background in case I wanted to go and teach photography.

You know all too well that the choices you make influence the rest of your life and so I am quite confident now that my photography wouldn't mean as much today if I hadn't done the twenty years of pathology. I am thoroughly convinced that looking down the microscope and studying visual patterns has had a tremendous impact on how I shoot.

TL: When did you decide that you go back to shooting a camera?

MA: I had always dabbled a little bit here and there, and frankly the thing that really drew me back in was when my son started playing high school soccer. The people who did high-school newsletters were always complaining, "We don't have any decent pictures to put in." I thought, I love shooting, and when I was young I was also a tennis instructor. At the facility where I taught tennis we had pro tournaments. I would shoot the world-class pros who were there in the tournaments just because I loved shooting and loved tennis. I was comfortable shooting sports even though I hadn't developed as a sports photographer.

About three or four months after I got back into shooting a couple of games a week, I really was like, "I am not just shooting this. I am loving this! I'm looking forward to getting a camera in my hands and anticipating the moment, and capturing these things."

I had a trip come up that was probably the seminal event. I decided to go down to Bonaire, an island off the coast of Venezuela. And it's a great, great windsurfing venue, because the bay where you windsurf is like waist deep for a mile-and-a-half out. I took all my equipment and I decided, "I am going to windsurf in the afternoon, and every morning I am going to get up before sunrise and I am going to go shoot." I really did say to myself, "Pretend you are on assignment for *National Geographic*."

All these windsurfers with all these colored sails were racing back and forth on this vivid turquoise water, just skimming and flying. I put a couple of rolls of Kodachrome under my hat and took about $3,000 worth of equipment in my hand and took a deep breath and waded out about a half a mile, mid-chest water, feeling in the sand with my foot for every step, and I was right out in the lanes with these guys who were just flying by me. [He chuckles.] When I got home and developed the stuff. I was sitting there

with my younger son, looking at the slides with the loupe and I hit this one slide and I said, "Oh my god!" because you could see the fine print on the sail—it was that sharp a slide. I said to Evan right then—I had never published a photograph before—"Evan, you're going to see this image in print."

I looked at it for a while, and I thought this has got to go somewhere, but I don't know how to do this. I was subscribing to several different windsurfing magazines and I thought, "Well I guess you look up the editor, and call the editor." So I just started making some phone calls, and I called *Windsurfing* magazine and *American Windsurfer* and said, "Where do you guys get your pictures? Do you just get them from guys you hire?" And they said, "Oh no. We'll work with just about any photographer that's got good work." And I said, "Well I've got a killer shot that you might be interested in." They said, "Send us a low-res JPEG, we'd like to see it." So I sent it right off and within ninety minutes I had three magazines wanting it. And I thought, "Aha! There's something to this." It's just a matter of picking up the phone and trying. That picture ended up getting published as a two-page spread in a national windsurfing magazine in the states, and then I called England and they wanted it and they ran it as a two-page spread, and Holland wanted it. That was like a golfer who has just learned to hold a club and he goes out and drives 250 yards straight down his first fairway. I mean I was hooked!

So I just started, for myself, shooting seriously. About a year and a half went by, and I started amassing a reasonable number of images. And I'm not like a stock guy who can just go out and in a week create 250 stock images; that's not the way I work. If I go on a trip somewhere and I come back with fifteen keepers, I am really excited.

I mean I don't know how my guardian angel directed me to do it but you know how Nikon gives you those cards that say fill out a form and get six months of *Nikon World* free? An issue of *Nikon World* came in the mail, and there was an article about a lady photographer by the name of Rosanne Pennella. Rosanne was an attorney and decided she really didn't like law. She ended up on a three-month trip, and somebody saw her travel photography and said, "Boy, you've really got a good eye. You ought to get a good camera." And so she did. She quit her law career and gave herself a five-year timetable to try and pursue photography as a professional. And now she was being profiled in *Nikon World*.

So I read this article and thought, "Well, law, photography; medicine, photography." A lot of parallels there. Maybe this lady was giving some advice, giving some insight into her life experience. So just seeing that article I saw that she had a Web site, and so I sent out a cold e-mail. I wrote

a couple of paragraphs and said I would really appreciate if she could share some insights. Sometimes you e-mail people and they just never respond. Sometimes you e-mail people and you get one sentence back, "Goodbye and good luck. Hope things turn out for you." Rosanne wrote me back a page and a half, two pages: "I get a lot of inquiries from people but something about how you presented yourself touched a nerve, so I am going to take a minute and tell you some of these things." And toward the end she

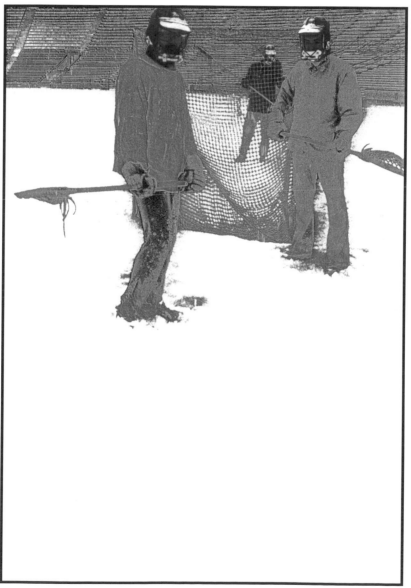

Mark Alberhasky: Dark Guardians

said, "I am doing a lot of teaching photography now, and I'd be happy to look at some of your work and let you know what I think about it. Because there are a lot of people who have dreams about becoming a professional photographer, but really you can have dreams, but if the caliber of your work is not there somebody has to tell you. And it may not mean the end of your dream; it just means you've got to understand where you are in the process." I threw a few more things up on my Web site and said, "Okay Rosanne, here's a couple of Web pages where I have some of my things" She wrote me back and said, "Oh I am so sorry it's taken so long to get back to you but I've been in Hungary shooting the wine country there for three weeks." Which of course drove me nuts—I thought, "Oh my god, you can get jobs like that!"

Mark Alberhasky: In the Key of Bird

But then she wrote me back two or three more pages and she said, "Okay, your work is really, really outstanding, and I don't say that to people lightly. Your work is ready to do it, but you may not be ready to do it." So she said, "Here's what you need to do. You need to go to this meeting and this meeting, and this seminar, and this convention, because you need to enter the photography-industry workplace. You've got to get people to start seeing your stuff."

So she sent me down to FOTOfusion, the workshop in Delray Beach every January. So I made a portfolio, and she helped me hook up with Mary Virginia Swanson. I met with Mary for like two hours before the workshop

started, and she carved things down to like twenty strong images and helped me gather my thoughts.

The first guy I sat down with was Jimmy Colton, photo editor for *Sports Illustrated*. I had two great sports shots in there and he said, "We need shots like this for the opening and closing spread in the magazine every week. Please send me images." When you walk out of the first portfolio review you've ever had and the photo editor of *Sports Illustrated* is saying here's my card, please send me work, it's pretty heady stuff, and I could hardly believe it. It really encouraged me to keep going and keep working, but I still wasn't really sure what direction to go in.

And so a considerable amount of time went by, and I took some more workshops and kept in touch with Rosanne, and she kept encouraging me to do this and that. At one point she said, "You know, you really need to get Nikon to see your work, and so I am going to contact Barry Tanenbaum, the editor of *Nikon World* and tell him he really needs to see your stuff." So I put together a formal Web site, so that by the time they were going to get wind of me there would be something more respectable and formal to see.

Well, six months went by and I didn't hear a thing. And then, wham, one night I got an e-mail from Barry Tannenbaum saying, "Sorry it's been so long getting back to you, but I think your work is brilliant." I mean, I was flabbergasted. I was stunned.

Again a number of months went by, and then in August, I got another e-mail from him saying the Nikon full-line product guy is coming out in a couple of months and Nikon wants to use one of your pictures. Just getting one image in that kind of placement is so unbelievable, I was just walking on clouds. I said to my wife, "I've got to go to New York for this PhotoPlus Expo, because that's when the new catalog is coming out and I feel like I just have to go to this thing."

I made a beeline to the Nikon photo booth—nobody of course has a clue who I am—but I grab a catalog. I figure my picture is going to be on page 265 or 266. So I start flipping from the back, and I am flipping and flipping and flipping, and looking for the small photo, and getting a little disheartened. It was on page two. It was a full page with three other guys, big name guys, it was like "The Heart of the Image"—it was a very inspirational spread, right there at the beginning. It was just magic.

And that would have been enough. I felt like I had won the lottery already. Then I get another phone call from Barry Tannenbaum. I mean, God bless Barry. He said, "I'd like to pick ten or eleven images of yours and then call you up for a phone interview and put a piece together for the Nikon Web site."

The night that he called me to do the phone interview, we get through this whole thing and he says, "Okay Mark, I think those are all the things I wanted to ask you. I am going to turn off the tape recorder now because I have something else I need to discuss with you, and I don't know if you'll be interested in it or not." So I am thinking, "What on earth could he be talking about?" And he says, "Nikon has a new camera that they are bringing out next year." This was in like September. "And they would like you to make images for the product guide to come out with the release of that camera. If they send you a camera, would you keep it for a month and shoot with it?" And so I said, "It just so happens that the second week in December I am going to Mexico for a week on vacation and I'd love to take it with me." And he said, "I'll pull some strings and make sure that your period of having the equipment includes that."

Mid-week Barry called and I had also mentioned that I had decided to go part-time with my medical career until I was only working half time as a physician. So between what I had done in Mexico and that life-changing decision about what to do with my career, because I really wanted to pursue photography at that serious a level. Barry had called to say that the *Nikon World* article was in the works.

As soon as people hear you are a photographer they say, "What kind of a photographer are you?" I have to give it some thought, and my answer is I am someone who likes to make visionary images that make people stop and go, "Wow!" And that's really about all I can say about how I can define the work that I do, because I am just as happy shooting surgeons in an O.R. if the lighting is incredible and there is something exciting about the composition and what's going on with the incredibly bright light and the incredibly dark background. I am as happy with that as I am with the guy who is the skin boarder on the beach or an incredibly gorgeous girl lit with a soft box. I'll just shoot anything that the light is really exciting and makes a very dynamic image. So that's the type of photography I do. And that's probably a terrible answer to give somebody in terms of what kind of professional photographer are you?

TL: Well actually it's probably the most refreshing response I've heard in some time.

MA: You know it's just like you said, it's the recognizing opportunity thing. It is scary though. When I wrote that first e-mail to Rosanne, just sitting there thinking, "I'm going to send this person, a total stranger, kind of personal thoughts about things that I never hardly admitted to anyone else, maybe except my wife, about my dreams."

TL: You touched a little bit on just about everything already, do you have any heroes of photography that have inspired you?

MA: When I started out Ansel Adams was the man. I just loved his stuff, and I've tried to put myself into a mold of going in that direction. I tried the whole-view camera thing. It turned out that it just wasn't me. Jerry Uelsmann, I look at his stuff a lot. He was so many years ahead of his time.

TL: But, as I understand it, you have come up with a very calculated way of splitting time with your brother, so one of you can operate the lab while the other goes off to do what he wants to do. Most people wouldn't have that opportunity. But then again, that doesn't mean they should ignore any opportunity or any chance to consider it.

MA: But you know even if you didn't have a brother, if you've got that drive to do the thing, find somebody else [to help you]. It's almost like I don't have a choice about it. I mean I have just got to have a camera and shoot. I don't know why, but I've just got to make photographs. I am wired that way.

TL: When you awake in the morning, how would you fill in the following statement? 'Today is a great day because today I get to—fill in the blank."

MA: Shoot. If it's a day where I don't have to go to the hospital and I get to put my right brain into gear, and I pick up my camera and the light is good, I am there. And I don't care what it is I am shooting.

Well, if you can't get inspired by that, I don't know what it will take. Gail brought us the gift of passion; Todd the gift of values; and Mark the gift of enthusiasm. And, by the way, the people behind the scenarios I described in chapter 2 (the one who wanted to "accelerate her career"; the one who wanted to move to a more stimulating environment; the one who wanted to leave his job of many years because it had changed; and the one of the lady who had an aching in her heart to be creative) have also taken great steps toward more meaningful careers. Something they all have in common is that when they eventually defined their goals they did not allow anything to get in their way and this chapter has just provided you with the validation that it can be done.

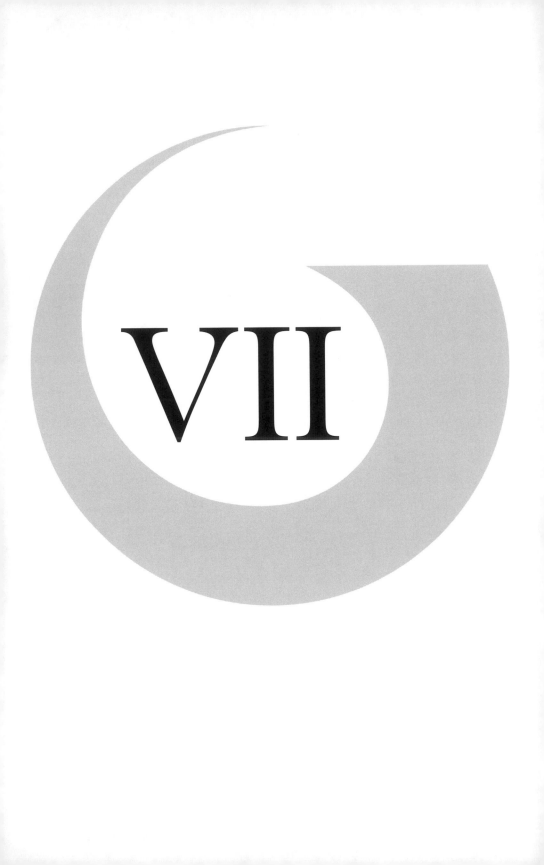

Reflections on the
Photographer's Journey

Photography and the
Meaning of Life

**Today is a great day because today I get
to shoot what I haven't shot before!
—Eric Meola**

From the beginning of this book we have accepted the fact that everything changes, and that those who acknowledge, accurately assess, plan for, and adapt to change have the ability in a large part to control their destinies and validate their successes. Where we run into trouble is when we ignore, fail to plan, and remain static, thereby guaranteeing that the world will pass us by.

Together we have had the good fortune to read the words of proven professionals who have honestly shared their thoughts with us on where they triumphed and where they fell short of their goals. They gave us their view in the hopes that we might find our own way a little easier. They have generously given us their insights, and we are the wiser for them. I am sure you will agree that vicarious learning beats the tar out of the learning lessons the hard way. In this chapter we will

look at things that have changed in our profession and in the world; and we will get a last visit with some of the photographers interviewed as they talk about what photography means to them and their lives to encourage you to continue contributing to our visual literacy. But first a little story (you didn't think I would let you off that easily, did you?).

Back in 1993 I gave one of my first professional lectures, titled "Photography and the Meaning of Life." I delivered it to a large group of photographers under the sponsorship of the Advertising Photographers of America/Los Angeles. I talked about building a career in photography, on being mindful of the changing marketplace, and the importance of being involved in the community by using our talents to help at-risk youth so they could understand how to build a creative vision. It was fairly well received, so I was surprised a few days after the event to get a call from the President of APA/LA saying that a couple of people wanted their money back. I was dumbfounded until I realized that apparently those attendees who wanted their money back thought that by the title of the lecture I was going to help them turn their businesses around, and do it while giving the secrets of the meaning of life.

I learned a lot from that experience. First, I learned you can't please everybody, yada, yada. Second I learned that the title of my lecture was too overreaching and I could never live up to its promise—besides I am still working on that one myself. But, interestingly enough, the third thing has brought me to this particular point in time. What I learned most from this circumstance was that there was a large group of people who *did* get something out of it, and as long as those people existed I should continue to investigate, to ask questions, to seek answers to questions about how we all evolve and the roles that art and creativity play in that evolution. In other words, as I analyzed how we make effective, meaningful transitions, I was actively reinventing my career.

Life Imitates Art/Art Imitates Life

So why am I telling you this, and why have I gone and titled this last chapter, "Photography and the Meaning of Life"? Well, I have discovered something about the topic in the last decade and especially while writing this book. I have come to appreciate more fully that life in general, and photography in specific, are not the same as they were ten or twelve years ago. The field of photography is more wide-ranging, with more people having more access to more image-capturing and image-manipulating tools now then ever before in the history of mankind. That accessibility has caused people the world over to see more of the human condition, good and bad, than we have ever had the ability to see. Likewise the audience is

hungrier for imagery now than in the past, and they want to see it sooner, and they want to move on to the next big thing quicker than before.

The point is that we who have the capability to represent the world and the way it works have a larger responsibility than ever before. We can use our tools and our talents for good or for misguided purposes, and we must be mindful that more emphasis has to be placed on our ethical foundations in how we execute our form of art. However we reinvent ourselves, we must never forget that our images have the potential of forming lasting impressions that create standards, move societies, and can either reinforce or erode prejudices. One of the great byproducts of working on this book has been meeting and talking with so many great people and finding out how responsible they have been throughout their careers, and how they understand the value of how they assist people in interpreting the world.

In a few short years we have witnessed the mind-boggling proliferation of digital cameras. And technological convergence has opened the doors to cameras in phones, watches, on computers, and places we are not even aware of. The impact of photography is being felt from Baghdad to Boston. The world over, our lives have been modified by megapixels. Because many still believe that the camera doesn't lie, we who are dedicated to capturing the moment have a monumental responsibility to the viewing public to operate in good faith.

And as the medium changes so does the world around us. Mark Edward Harris added this item on how the events of September 11, 2001 had an impact on his work: " September 10th, 2001, we had very good meetings with the ad agency for Northwest Airlines, and it looked like almost a definite go that I was going to have a shoot in six countries and three states, or something like that, and they were going to make a decision and said if we can get it done for this number it's yours. Well, you know, on September 11th I woke up, and I got the call that said don't get your hopes up, this is going to change things. And so it did."

Photo-Manipulation

Another thing we must keep in mind is that our responsibilities do not end when the image itself is captured. With the advent of image-editing software, we can make a Buick out of a cube of butter. A car-shooter friend of mine told me that he is losing advertising work to artists who create computer-generated artwork. Once they create the algorithms and put a metal skin over the wire frame, they are set to make a new car model do anything they want. Now, hold on, don't get panicked. If there is one thing that was stated many times in this book, it is that nothing remains the same, and we have to be smart enough to move effectively with the times.

Because he has been at the vanguard of image enhancement for so many years, I asked Jerry Uelsmann where he sees photography heading:

Nothing is permanent except change, and we are moving into a digital era, and this is definitely where photography is headed. So all the writing is on the wall. Just go to any camera store and try to buy film and paper—it's relegated to one little shelf in the corner. The technology is going to change, but the basic problem of coming up with an image that resonates with an audience and with the creator of the image, *that* is an ongoing problem that exists forever.

Today there is much more acceptance of what I did because of Photoshop. Many young people are attracted to my work. They are surprised to discover that I have done it in the darkroom. The point would be that those options exist as a more viable alternative in this day and age than when I started working with it because there is an acceptance. But there is still the problem of coming up with an image of consequence, even though the technical ability to do it is more readily available. At the same time I've lectured to computer people and I always say, "Say something good about Photoshop—It gives you an immense number of digital options. Say something bad about Photoshop— It gives you an immense number of digital options." Too many choices can often be counterproductive to the creative process.

[My work is] much more organic, in that I am not going to wake up tomorrow with a different head on my shoulders and suddenly there's some radical shift in my work. But as you age there are more subtle changes, because your perspective on life changes and the things that you value shift slightly. And I think that all of that, if you are working authentically, creeps into you work.

I knew I could trust him to talk about values and vision. Like so many of the people I talked with, he found that the more he heeded the call of his passion, the more authentic his work became. The relationship between who you are and what you do becomes clearer if you are willing to keep an open mind and an open heart.

Today is a Great Day Because . . .

I wanted to close this book on a positive note, and I can't think of a better way than to share with you some of the responses I received from the people I interviewed to the question I asked each of them as I wound up their interviews. The question may

not rank up there with the litany of questions James Lipton asks of his guests on *Inside the Actors Studio*, but the responses from people whose work we have long admired are upbeat and hopeful, and we can now reflect upon their words. So here's the question:

"Today is a great day because today I get to _____."

Eric Meola: Shoot what I haven't shot before!

Jay Maisel: Shoot whatever I want.

Dean Cundey: [Do] anything that would allow me to be creative. My life is about creativity.

Douglas Kirkland: Funny you mention this because I was in Milan and I had a friend sitting there who is in his early thirties who realized he did not like what he was doing. He totally revised his life. He quit his job and changed everything. So what I like to do is think of the possibilities. Possibilities come from all of these things that I have mentioned. I have a shoot coming up, a big one, but I am looking forward to the one next week because it is going to be quite interesting. It is going to have a lot of people around and have a lot going on. I have to focus on each job. Don't half-prepare; have everything you need available. And at the same time be adaptable and be able to, when necessary, make changes.

Barbara Bordnick: Shoot something that will surprise me.

Bob Krist: [Go] someplace I've never seen before. That's the lure of travel photography.

Pete Turner: Shoot something I really want to shoot. You should always have a couple of projects you are in love with, or because I'm going some place I want to go, someplace I've never been before.

Mark Edward Harris: That's a very good question. This brings up something I've thought about and had a discussion with a friend the other day: An expression that I hate is, "Thank God it's Friday," or "hump day." Or when people start getting anxious on Sunday because the next day is Monday. I look forward to Monday. Or when people are looking forward to their retirement. I mean how sad to have to think in those terms. I know it's a cliché but there's no time like the present. People really need to find things that they can enjoy on some level. I would say that regardless of what I am shooting I do wake up pretty much every day feeling fortunate that I am able to do what I do. I also use the word "fortunate" as opposed to "lucky" because luck is pure chance, and fortunate is that you put in some effort and there are other things that have conspired in a positive way. Definitely, freelance for all these years is not easy, but I am very fortunate to be doing this.

Phil Marco: First of all, because I am alive, and because I have another opportunity to express myself, to be inspired and possibly to create a memorable image or make an important statement or contribution. Those are the things that lift me off the bed in the morning and I look forward to them. And I realize how very fortunate I am to feel that way.

Ken Merfeld: Shoot something interesting, probably unusual, more than likely an intriguing personality, and the collaboration will have the possibility of resulting in some kind of magic that was not in my life before. Always magic.

Ryszard Horowitz: Shoot myself in the foot. [He chuckles.] It is interesting that you ask because when I work on a project, when I have an idea that is kind of evolving. And sometimes I work for several days or even weeks on a picture, I very often go to bed with it. Sometimes I have good dreams, good thoughts, sometimes I remember them, sometimes I don't remember, but then frequently I wake up with something fresh that I can bring into what I am working on. In other words, when an image resides in my head it never leaves me. It evolves and I may be sitting in a movie theater, or reading a book, or going to a concert, or napping, the thing is constantly with me, it's not something that is passing. That is important to me. When I wake up and get up and feel really engaged in something it makes me so much more "up," or happy, as opposed to when I scratch my head and worry about what is going to happen next, how will I pay my bills? [He laughs.]

Jerry Uelsmann: At this age, every day is a gift, so I try to utilize my days and appreciate my friends. I have little quotes in my darkroom and all around, but one of them is "The only death you die is the death you die every day by not living." It's a simple statement but that's the point, it's up to you. You have to use your time effectively. I've said many times, there's no uninteresting things, there's just uninterested people. You have to generate your own interest and this is something that takes some time to do. When I was teaching I had to be at certain places at certain times. I just completed a book project that took a lot of time. And some days I go in the darkroom, some days I just spend the day looking at contact sheets and try to figure out things to try and then go in the darkroom the next day. In a way the nice part of it is I don't have any pressure. I don't have to have the images done by a certain time, or sent off or anything like that. I don't have a lot of [shows], but three or four times a year I have plenty of time to prepare for that, so I just keep trying to generate new images.

Nick Ut: You know a photographer like me is always ready in case something happens, you just shoot. That's all I need. Very often I tell the news photographers, sometimes you have a good story and good pictures. Sometimes in two days you get

nothing. Not everyday. Some pictures end up inside the paper and it's so boring. I covered Robert Blake; my picture was on the front page everywhere. You enjoy it when your picture is on the front page. You say, "Hey, that's my picture!" And you enjoy it.

David Fahey: I spend ten hours in my gallery and it seems like an hour, and I am not going to be bored, and I am going to have an interesting conversation with an interesting person. And I am going to learn something I didn't know yesterday. And I will feel better about it at the end of the day when I am going home. I literally walk in, blink twice, and it's time to leave. And as I was telling you, I usually stay after 6:00 sometimes till 10:00, and I am just sort of cleaning up. I can't do that in the middle of the day because there is so much going on. That's very exciting. I've had people who I think lead exciting lives tell me they think my life is the most exciting thing they've ever seen. I'd say I am one of the luckiest people out there simply because it's really been about enriching my spectrum of experience, and that happens here every day. Not only are the artists pioneers, innovators, fresh thinkers, but the collectors can be the same. You are dealing with successful, affluent, engaging people that have arrived at a point in their life where they want more, they want a spiritual experience, or an aesthetic experience. Or they want to interact with a world they are not a part of. Consequently you get to meet these people, you get to benefit from their world, and that's equally exciting. So you get the best of both.

Well, there you have it. At least one meaning of life, if you are a photographer, is to look forward to the magic that waits for you every day when you pick up your camera. Don't let anyone get you down; don't give them the satisfaction. Continually challenge yourself; you may as well do it before the world sneaks up on you and forces you into action. The people we have read about were as varied as you can imagine, but they were all creative, intelligent, thoughtful, perseverant, aware, consistent, opportunistic, enthusiastic, informed, irreverent and yet respectful, humorous, technically astute, inquisitive, open, evolving individuals who had seen the world from all kinds of different points of view and still managed to remain overwhelmingly optimistic.

So, after reading about them, how do you feel about yourself and your capabilities; how do you measure up? Are you ready to make the move or is there still something missing? As you have seen you will embrace change only when you prepare yourself, and when you are ready to accept it. Remember the lessons of the cycle of Transition Analysis. First you have to recognize that something has to be done, then you must assess your talents, follow that with creating a calculated plan

the world from all kinds of different points of view and still managed to remain overwhelmingly optimistic.

So, after reading about them, how do you feel about yourself and your capabilities; how do you measure up? Are you ready to make the move or is there still something missing? As you have seen you will embrace change only when you prepare yourself, and when you are ready to accept it. Remember the lessons of the cycle of Transition Analysis. First you have to recognize that something has to be done, then you must assess your talents, follow that with creating a calculated plan for success, and then put that plan into action. When all that has been done, then you can evaluate your plan by acknowledging the milestones you have accomplished. You can share the success with others so they might be encouraged to find the greatness in themselves.

My job is not over with the ending of this work. My job continues to be to make sense out of what we normally take for granted and put it in a context that helps people find out who they can truly be. My vision statement is to help good-hearted people fill in the blank to the statement, "Today is a great day because today I get to _____" in their own unique and responsible way. I execute my mission through my lectures, writings and consulting. You can reach me at *tonyluna@aol.com*.

Oh, and by the way, stay in touch.

About the Author

TONY LUNA is founder and president of Tony Luna Creative Services. He has been Artist Representative and Executive Producer for Wolfe and Company Films for the past thirty-three years working with a wide variety of clients on editorial projects and memorable advertising campaigns for VISA, Apple/Macintosh Computers, Kawasaki Motorcycles and Jet skis, Honda Motorcycles, Denny's Restaurants, Taco Bell, McDonald's and Disneyland Resorts. A graduate of California State University at Los Angeles, Luna was an Adjunct Professor at the Art Center College of Design and a lecturer at the Art Center/Cal Tech Entrepreneurial Fellowship Program. He lives in Los Angeles.

Index

Books from Allworth Press

Allworth Press is an imprint of Allworth Communications, Inc. Selected titles are listed below.

Photography Your Way: A Career Guide to Satisfaction and Success, Second Edition
by Chuck DeLaney (paperback, 6 × 9, 304 pages, $22.95)

The Photographer's Guide to Negotiating
by Richard Weisgrau (paperback, 6 × 9, 208 pages, $19.95)

Starting Your Career as a Freelance Photographer
by Tad Crawford (paperback, 6 × 9, 256 pages, $19.95)

The Photographer's Guide to Marketing and Self-Promotion, Third Edition
by Maria Piscopo (paperback, 6¾ × 9⅞, 208 pages, $19.95)

Profitable Photography in the Digital Age: Strategies for Success
by Dan Heller (paperback, 6 × 9, 256 pages, $19.95)

The Real Business of Photography
by Richard Weisgrau (paperback, 6 × 9, 256 pages, $19.95)

ASMP Professional Business Practices in Photography, Sixth Edition
by American Society of Media Photographers (paperback, 6¾ × 9⅞, 432 pages, $29.95)

Photography: Focus on Profit
by Tom Zimberoff (paperback, with CD-ROM, 8 × 10, 432 pages, $35.00)

Business and Legal Forms for Photographers, Third Edition
by Tad Crawford (paperback, with CD-ROM, 8½ × 11, 192 pages, $29.95)

How to Shoot Stock Photos That Sell, Third Edition
by Michal Heron (paperback, 8 × 10, 224 pages, $19.95)

The Business of Studio Photography, Revised Edition
by Edward R. Lilley (paperback, 6¾ × 9⅞, 336 pages, $21.95)

Please write to request our free catalog. To order by credit card, call 1-800-491-2808 or send a check or money order to Allworth Press, 10 East 23rd Street, Suite 510, New York, NY 10010. Include $5 for shipping and handling for the first book ordered and $1 for each additional book. Ten dollars plus $1 for each additional book if ordering from Canada. New York State residents must add sales tax.

To see our complete catalog on the World Wide Web, or to order online, you can find us at
www.allworth.com.